THREADS

Also by Julia Blackburn

THREADS
The Delicate Life of John Craske

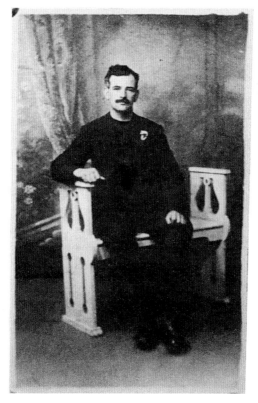

Julia Blackburn

JONATHAN CAPE

LONDON

Published by Jonathan Cape 2015

2 4 6 8 10 9 7 5 3 1

Copyright © Julia Blackburn 2015

Julia Blackburn has asserted her right under the Copyright,
Designs and Patents Act 1988 to be identified as the author of this work

First published in Great Britain in 2015 by
Jonathan Cape
20 Vauxhall Bridge Road,
London SW1V 2SA

www.vintage-books.co.uk

Addresses for companies within The Random House Group Limited can be found at:
www.randomhouse.co.uk/offices.htm

The Random House Group Limited Reg. No. 954009

A CIP catalogue record for this book is available from the British Library

ISBN 9780224097765

Typeset in Fairfield by Palimpsest Book Production Ltd, Falkirk, Stirlingshire
Designed by Peter Ward
Printed and bound in China by C&C Offset Printing Co., Ltd

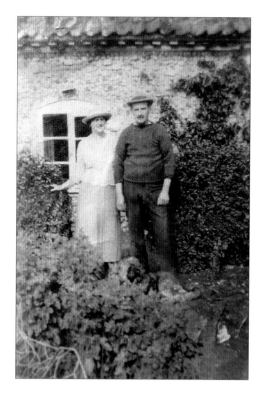

*The individual is only an insignificant thread in an immense
and miraculous pattern.*

Albert Einstein, October 26, 1929

Sunshine in the garden, I eat cherries instead of thinking.

From my notebook, August 2013

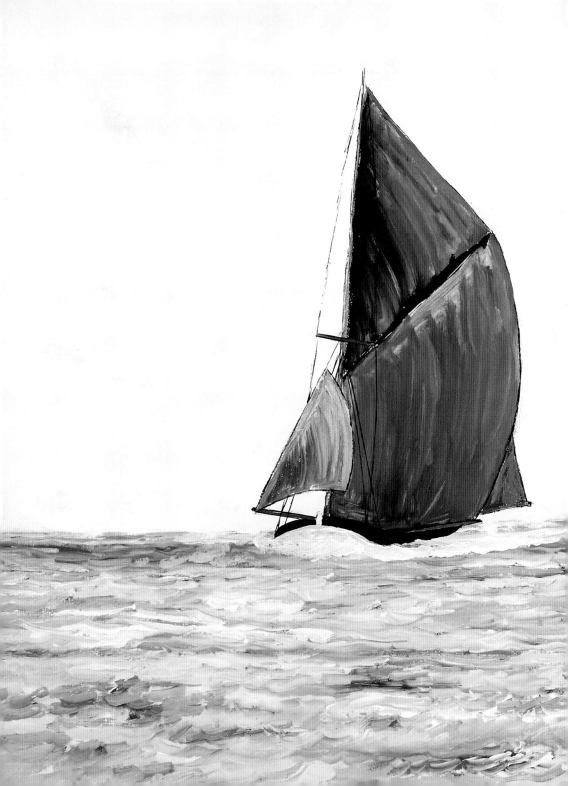

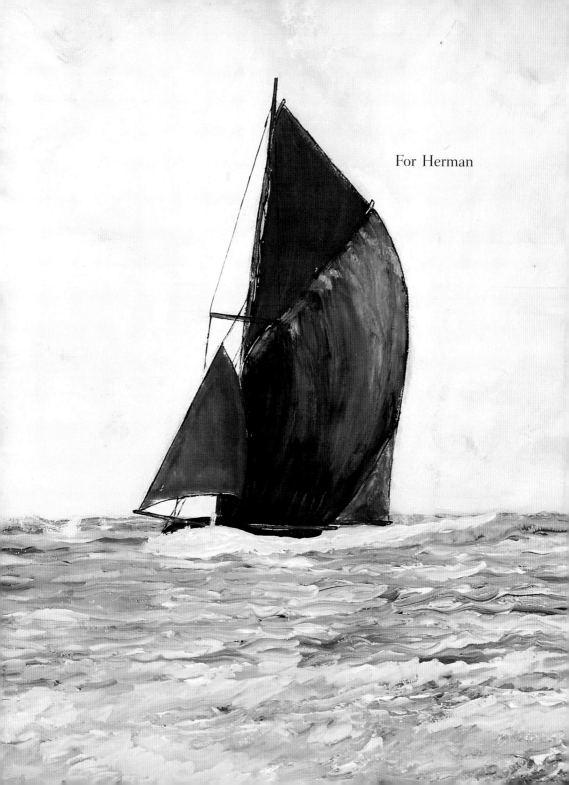

For Herman

Punchline

I am sorry to say my husband has had a bad turn again he is just coming out of it and will write you as soon as he is able.

<div align="right">(LETTER FROM LAURA CRASKE TO
ELIZABETH WADE WHITE, 2 SEPTEMBER 1942)</div>

I'll begin with a joke. I first heard it ages ago, and since then it has rumbled around inside my head as bright and vivid as a little film that plays in an endless loop of repetition. It's a rather odd joke but I think it says something about the confusions of linear time.

A soldier is asked, 'Where is your rifle?'

The soldier replies, 'It's like this, sir. I went out into the courtyard and there was my rifle, in the sunshine, leaning against the wall – gone.'

I used to have a dog like that soldier: a corn-stubble-yellow, greyhound-thin dog called Bark because he never did and he would stand and stare at the places where something had once been: a dish where there was food, until it was eaten; a hole from out of which a rabbit emerged, long ago; a patch of earth that held a buried bone, before it was dug up and taken somewhere else.

And now here am I, searching for a man called John Craske, and often all I can find is the evidence of his absence.

Sometimes
I wonder
Why on earth
I have chosen him
Of all people
To write about.

A Sense of Loss

The whole house was covered with paintings.
Doors, mantelpiece, ornaments, everything that had
a surface that would take paint, had been used.

(VALENTINE ACKLAND NOTES, 1929)

John Craske was a fisherman who became a fishmonger who became an invalid. He was born in 1881 and in 1917, when he had just turned thirty-six, he fell seriously ill. For the rest of his life he kept moving in and out of what was described as *a stuporous state*. This state could be so extreme that he was hardly aware of his own existence for months on end, but it could also be more on the surface, which meant he had no real energy in his body, but could still talk softly and quietly and could do things with his hands. There were better times when he could get up and walk about, although as he grew older the better times became increasingly rare.

In 1923, or thereabouts, he started making paintings of the sea and boats on the sea and the coastline seen from the sea. And later, when he was too ill to stand and paint, he created embroideries, which he could do lying in his bed, propped up with cushions, a piece of cloth fixed to a wooden frame in front of him.

I have no idea and no way of finding out how many paintings and embroideries he made; hundreds, I would think, because once he had begun to follow this road it was what he did with almost every waking moment that he had. So far I have traced about sixty and I'm sure others will emerge rather sheepishly from the walls of private houses, from storerooms and cupboards and boxes. The smallest I have seen is a little

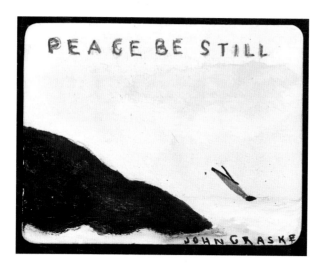

watercolour of a sailing skiff with a paintbrush flick of red sail, rounding a headland and leaning into the wind, and the man who showed it to me had only just found it, when it dropped out of his grandmother's prayer book. The biggest is the not-quite-finished embroidery of the Evacuation of Dunkirk, which is just over eleven feet long and twenty-five inches wide.

John Craske might have been famous for what he did, but fame is a haphazard thing that needs to tick certain boxes and fit what is wanted at a certain time, and so although he exhibited in London and New York and was reviewed and talked about while he was alive and shortly after his death, and although examples of his work were collected by people whose opinions seemed to matter, the memory of him has since faded, much as the threads on an embroidery fade when they are exposed to direct sunlight. And because he was not established as an important person, the little scraps of evidence of this man's particular story got shuffled about from one pile of papers to the next, from one folder to another, and many of them have since been thrown away or casually mislaid.

I cannot find what has been lost, no matter how often I search for it. All I can do is to hold a few facts and images in my mind's eye and let myself drift in whatever direction I am taken. Maybe that is already a way of getting closer to my subject, because John Craske knew a lot about drifting and I need to keep alongside him.

I cannot find what has been lost, no matter how often I search for it. All I can do is to hold a few facts and images in my mind's eye and let myself drift in whatever direction I am taken. Maybe that is already a way of getting closer to my subject, because John Craske knew a lot about drifting and I need to keep alongside him.

3
FLAT BATTERY

SEPTEMBER 2011

Dear John i am very sorrow to have keeping you
wating for me to ancer your letter the reasing is i
have been trying to get the number of the ship for
you i have arsk old Jarnimay Campil and he did
not know what it was

(LETTER TO JOHN CRASKE FROM MR FARROW, C. 1930)

It was Emily who said, 'What about John Craske?'

I'd never heard of him.

'He was from here,' she said, 'East Anglia. Sheringham, on the coast, although he moved inland later.

'He was a fisherman who became a painter and embroiderer,' she said. 'I think he's much better than Alfred Wallis down in Cornwall, or at least he's just as good, a bit different, less savage. Wallis was taken up by Hepworth and Nicholson and all the St Ives lot, but Craske's been ignored.'

Emily is a painter and the wife of a painter and the daughter of two painters. The long corridors of her mind are filled with all sorts of information about painters and their paintings and she can wander easily from Romanian votives done on glass to Russian miniatures on vellum, from Giotto to Freud via Stanley Spencer and the village he used for the Last Judgment with a gaggle of white geese stretching out their necks towards the hope of eternity, alongside the local butcher and the greengrocer.

Emily told me about the Craskes at The Red House in Aldeburgh,

which is only a twenty-minute drive from where I live, and at the Snape
Maltings music centre in the next village along, where Jacqueline Du
Pré and Rostropovich played the cello and Imogen Holst played the
piano and a huge Henry Moore sculpture looks out across the marshes.

'Sylvia Townsend Warner, the writer,' said Emily, who is almost as
well informed on books as she is on paintings. '*Lolly Willowes* who was
a witch and *Mr Fortune's Maggot*, you must remember him, the rather
creepy missionary in a tropical storm on a South Sea island somewhere,
and *The Corner That Held Them* about medieval nuns who never stop
quarrelling, and that's very good on the Fen landscape, which can't have
changed all that much since the fourteenth century: the grey sea and
the huge easterly sky. Warner collected Craske paintings and embroideries.
She was very protective of him; she felt she had discovered him, or she
and Valentine her partner, who looks a bit like David Cameron, had
discovered him and it was a bond between them. She wanted the work
to be kept in East Anglia where she felt it belonged and so she gave
most of what she had to Peter Pears because she felt he understood her
and her love of Craske, when the two of them met in the early 1970s.
She died in 1978, I think it was. I know that Peter Pears was genuinely
fond of the paintings, but I don't think he knew what to do with the
gift; there was no space for having them on permanent display and they
were fragile and difficult and people who saw them often laughed at
how primitive they were, how simple. These days they're mostly hidden
away; but I'm sure you could have a look.'

Emily also said there was a Craske embroidery at the Glandford
Shell Museum not far from the village of Blakeney on the North Norfolk
coast and quite close to Craske's birthplace. The museum had been
built in 1915 by Sir Alfred Jodrell, of the Jodrell Bank telescope-to-
observe-the-universe family, and he'd also rebuilt the rest of the village,
along with a gloomy Victorian reconstruction of a medieval church as a

memorial to his dead mother, just behind the museum. One of the carved bench ends in the church shows Jodrell's mother's favourite dog, Nimble, and in his garden at Bayfield Hall there are a total of twenty-six tombstones commemorating the other dogs he had loved.

Sir Alfred had been collecting shells for almost sixty years and he kept them stored in boxes until the museum was ready to display them. He and his sister Lady Seale, along with his other sister, Mrs Ind, took on the task of arranging them in glass cases and other items began to accumulate alongside them, including 'a piece of Pompeii', a sugar bowl used by Elizabeth I, a shrunken head, a fossilised mammoth tooth, the skulls of two albatrosses, their beaks the creamy yellow colour of old amber, and a very fine Neolithic axe head which had emerged out of

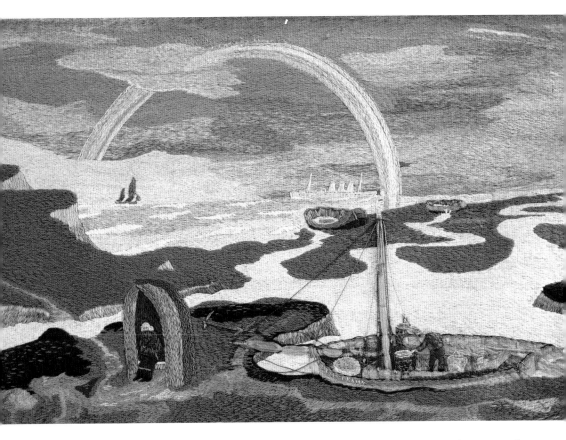

the sand on the Blakeney estuary. Emily said that when she first visited the museum as a child, Craske's embroidery *Panorama of the North Norfolk Coast* stayed in her mind like a vision of a not-quite-lost paradise.

'You must go there, it's a cabinet of curiosities, similar to the Pitt Rivers in Oxford, but tiny. Shells everywhere: around the mirrors and as a sort of decorative border on the walls and they've got a left-spiralling whelk – the only one ever found in all the world. Everything is higgledy-piggledy in the original cases and the Craske is pinned up above the cabinets all along one side. It must have faded a lot because it's not protected from the daylight. It's about twelve feet long and quite narrow

and it's supposed to show the coastline from Cromer as far as Overy Staithe, with harbours and inlets and mudflats and even a shipwreck, although he added all sorts of incorrect details, like a row of pudding-basin hills that certainly don't belong; and there's a wonderful rainbow.

'I don't think people take embroidery seriously,' said Emily, her mind now rummaging independently into new territory, 'or at least they didn't, especially not when it's been done by men, but think of sailors' stitchwork and the Bayeux Tapestry and all those medieval virgins with unicorns in walled gardens filled with flowers and lascivious rabbits.

'Craske understood the sea,' said Emily, who has done a lot of sailing and also understands the sea. 'He really knew how a boat sits on the water, how it moves, what the wind feels like, the swell of the waves, the danger, the isolation.'

I began by telephoning Snape Maltings Concert Hall. Emily knew the general manager because he is married to her friend's daughter and when I got through to him he was very helpful and a bit apologetic because indeed the work was not on show, but we made an appointment for me to come and have a look.

I went with my daughter-in-law and we waited as we had been told to wait in the postcard and gift shop and then the young man arrived and said he had everything ready for us. He led the way to a curiously claustrophobic complex of rooms that was something to do with the Friends of Snape: where they could gather and drink at a bar and sit on soft armchairs and sofas and where there was very little natural light or artificial light either come to that and no view of the world outside, just a sort of enclosed yard. The Craskes were all ready for inspection, stacked up in a long line, their faces turned to the wall.

The young man said, 'There you are. I think they are wonderful,' in

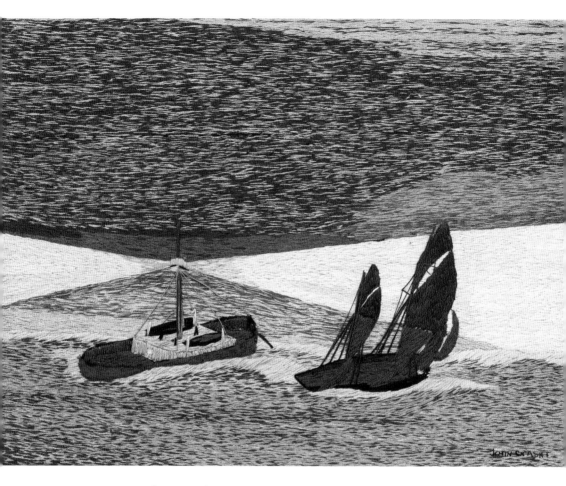

a voice that mixed triumph with despair because he clearly didn't enjoy seeing them like this, so uncared for. He said we could let ourselves out through a back door when we were finished and he explained how we must lock it and take the key back to the gift shop, and then he left us to get on with things.

One by one we turned the pictures round and carried them into the corner of the room that had the most natural light. They were all cheaply framed and one had the glass broken right across it. But never mind:

looking at them I felt I was meeting John Craske and learning to see what it was that he saw.

I cannot begin to explain how much the pictures impressed me. They were images of the sea and boats on the sea and the coast seen from a boat, but they were also images of life itself and its precariousness and how we struggle to keep afloat and to stay alive in the face of fear and uncertainty. All these fragile vessels: tossed by waves and sometimes almost engulfed by them, out there in the vastness of the ocean. Some were pinpointed by the angled glare of a lighthouse like the eye of God staring straight at them, others had smoke billowing from their funnels as they tried to plough a way through a storm. I had the sense at once that it was all true: the tilt of a boat in relation to the swell of the waves and the strength of the wind; the rigging, the billowing of the sails. I remembered that Sylvia Townsend Warner had said that John Craske worked with the intensity of someone speaking under oath.

All the pictures – both the embroideries and the paintings – were signed in careful capital letters, as if the man who had done them wanted to be able to claim them as his own in case they were stolen or mislaid. None were given titles, but some had the year of their making included on the prow of a boat, beside the boat's name and registration number.

I had brought my camera with me, but the battery was flat and so my daughter-in-law took some photographs on her mobile phone. They were not good, but they were good enough and I doubt if my camera would have done

anything better, especially because I don't know how to avoid the concentrated dazzle of a flashbulb on glass. When we were done, we put the pictures back in a line, more or less as they had been, with their faces to the wall, then we let ourselves out and locked the door and gave the key to the lady in the gift shop. Then we went and had fishcakes with a poached egg on top in the rather smart café and we flicked through the images on the little screen of the mobile and I felt I had made a beginning.

4

What is There

OCTOBER 2011

the ship was lost it was febuay 10 1893 and the
number I can not say but i know it was up in the
800 Regester or very near i should say about 782
that as near as i can say. (LETTER FROM MR FARROW)

As a next step I thought to go and see *The Evacuation of Dunkirk*.
Craske started it in the spring of 1941, after hearing about the Dunkirk
landings on the wireless that he kept next to the bed where he lay. He
worked as hard as he could, but it was a struggle because of his ill
health. Around the middle of August 1943 he was admitted to hospital
and he asked for his coloured wools and silks, his darning needles and
his embroidery needles and the long cloth roll of the still unfinished
embroidery to be brought in with him, but not long after he arrived he
lapsed into a coma and died on August 26, which was a Thursday. There
was a patch of embroidered sky that still needed to be filled in and I
couldn't help thinking that, in the act of dying, he had leapt through
this blank space and into some looking-glass world on the other side.

I had previously got hold of a few photographs of the embroidery,
but they were only rather fuzzy details of boats on the sea and bombs
falling from aeroplanes and lines of men in uniform moving across the
beach towards the thickly stitched edge of the waves that lapped the
shore; so I was excited by the prospect of being confronted by the thing
in the flesh, as it were.

I knew it had been kept at the Castle Museum in Norwich ever
since it was given to them by Laura Craske in 1944. I also knew that

over the years it had suffered from moth and damp and general neglect and had only rarely been seen by the public. It was currently stored in the basement of the Textile Department, which was in the process of being moved to another building; but after several phone calls and emails I arranged a time and a date for viewing it.

When I arrived, I was taken to an upstairs library filled with books about the mysterious art of knitting and sewing and cutting and embroidering and its long history and practice. I sat expectantly at a table and after a short wait the woman in charge of my enquiry appeared, wearing white surgical gloves and carrying a large white cardboard box which she set down in front of me. She lifted the lid, which gave out a sad little sigh as the air was released, and she carefully raised the thin sheet of tissue paper that covered what lay beneath.

I was confronted by a piece of embroidery that had once been part of a long strip until the day when it was cut – goodness knows when or by whom – into two sections, perhaps so it could be fitted more easily into the box that held it. However, the embroidery was not by John Craske. It had been made in 1901 by someone called Lorina Bulwer who was an inmate in the Female Lunatic Ward of the Yarmouth Workhouse.

There had clearly been a misunderstanding. I explained that I had been expecting to see *The Evacuation of Dunkirk*. There was a flurry of apology and explanation. It was in a storeroom and because of the move it couldn't possibly be brought up at present. Maybe in six months . . . The woman who . . . The box in which . . . Restoration . . . Relocation . . .

The embroidery I had before me would have been nine feet long and eighteen inches wide. It begins with an image of two figures in frock coats and strange hats, free-floating words spinning around them, and then it launches into a long embroidered rant done in black capital

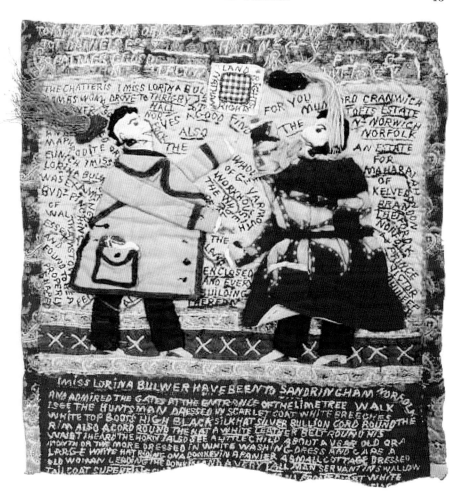

letters and without punctuation. Lorina explains that she has been examined by Dr Pinching who found her a *properly shaped female*. She says, *I am Princess Victoria's daughter . . . I have been to Sandringham Norfolk and admired the gates at the entrance of the limetree walk I see the huntsman dressed in scarlet coat white breeches white top boots high black silk hat . . . a white leather belt round his waist.* Her mind spins and soars as she tells of hermaphrodites and eunuchs, of a man

who fell head first into a tub of bread dough and of the surrogate Prince of Wales who murdered a woman and ate her with sage and onions.

I was very impressed by the stitched voice of Lorina Bulwer and I thanked the assistant for showing it to me, even though I had no use for it beyond the fact of curiosity. Now more than a year and a half later, I still haven't had a chance to see Craske's embroidery, but I gather it has been taken out of storage and is being restored.

What else is there to go by? I've got a photocopy of the first page of a letter from him. It's the only example of his handwriting I've so far been able to trace, apart from the stiff signature done in capitals, but the letter is written in pencil on a small piece of lined paper and the quality of the photocopy is so bad that I can hardly read it: he seems to be thanking somebody for something and saying that he doesn't feel very well and that's about it; the next page is missing.

As well as the pictures at Snape Maltings, I knew that The Red House in nearby Aldeburgh, which was the home of Peter Pears and Benjamin Britten for many years, also had some work by Craske and a Craske file in their library, which I was eager to see. I made an initial phone call and explained a bit more in an email and I eventually booked an appointment for a visit.

November 2011 and there I was in the archive room. I had signed in with my name and address and the exact nature of my request. There was a sense of confusion in the air because preparations were being made for the Britten Centenary celebrations; all the rooms in The Red House were being refurbished and everything was a bit upside down. But the archivist was doing his best to help me. He brought in a pink cardboard folder and put it down on the table in front of me. 'This is

what we have,' he said and he returned to his place on the other side of the table.

The name John Craske was written on the front. It contained five letters from John's wife Laura, all written to Sylvia Townsend Warner and her partner Valentine Ackland and dated from between 1944 – the year after John died – and 1949.

In one letter Laura says she has had the chimney mended and Mrs Harrod and Mr Betjeman have been to visit and she has got herself a budgerigar as a pet; *it is only a baby bird*. In another letter she feels unwell, but the doctor has told her he is not surprised after all she has been through. She says she misses her husband very much and mentions some of his pictures that she still has with her in the house. I made notes and moved on.

Next came two typed pages transcribed in a phonetic version of the Norfolk dialect with all the spelling mistakes intact. They were part of an undated letter sent to John Craske from a Mr Farrow of Grimsby, and he is telling what he knows about the sinking of a fine big ship called the *tommy Campble*, which sailed out of Grimsby Docks in 1893.

There were other items in the file, but what caught my attention was a small sheet of notepaper with the word INVOICE typed at the top. It was dated *January 15 1954* and requested £3 and 10 shillings to be paid for the cost of four and a half hours of typing *My Life and the Sea* by John Craske. The amount of time taken seemed to indicate quite a long piece of writing. I asked the archivist if he knew where the pages were. He said he had never heard of such a manuscript and since it was not in the file he had no idea where else to look.

Some months later, in a private collection of papers, I came across a letter from an American woman called Elizabeth Wade White, addressed to Peter Pears at The Red House and dated 1971. She had

been a keen collector of Craske's work and over the years she did a lot to help him and his wife financially. She had recently visited Peter Pears to present him with several items from her collection, and while she was there she had also consulted the Craske file in the archive.

> *What I was very much disappointed not to find, was a typed copy of the MS of Craske's reminiscences, called by him* My Life Story of the Sea. *This was a longish piece of direct and simple writing, as I recall it, with a number of simple anecdotes about storms, rescues and so on, but not much about his actual painting. I know I had one or more copies made of it.**

I became rather obsessed with *My Life Story of the Sea* and I searched for it wherever there was the slightest trace of John Craske. In the Dorchester Museum, which holds a Sylvia Townsend Warner Archive, I found a copy of a letter from Peter Pears to the same Elizabeth Wade White, dated September 24 1971.

> *Dear Miss Wade White,*
> *It was a great pleasure to see you again and to spend such an agreeable hour and consume such a good lunch . . . I have looked through the Craske bag with much interest – how touching the letters are, from both of them – how sad the recurrent theme of illness . . . I will try to sort out the papers in due course. You do appear to have worked* <u>most</u> *valiantly for John Craske and we all must be grateful for what you did for him.*

*John Craske's account of his life as a fisherman seems to be called by a different name by whoever is referring to it. Craske's actual title is *My Life and the Sea.*

I sent this information to the archivist at The Red House and he passed it on to another archivist who passed it on to someone else. I understand that although they are still very busy with the centenary, they are doing their best to have another look for what has been lost, but I still have the impression that they are not hopeful about finding anything new.

I am left with the image of a *Craske bag* in my head. I see it made of strong brown paper, a bit crumpled by the passing of time, but still resilient. It's as big as a supermarket bag or even bigger and it's stuffed like a well-fed belly with dozens of letters and a few photographs and of course the text of *My Life Story of the Sea*, which runs to several pages. I pick up a carefully addressed envelope with almost reverential care. I pull out the neatly folded sheet of paper it contains and spread it out on the table before me. Now at last I can examine how this elusive and long-since dead man shapes his letters, chooses his words and strings them together one with the next. And with that I can begin to understand something of how he thought, how he saw things and what sort of a person it was who inhabited his frail but resilient body.

But then the *Craske bag* and everything it contains begins to fade before my eyes and I am reminded of that old blues lament from the 1930s which Big Bill Broonzy used to sing with a voice like a steam train: *It was just a dream, Lord! what a dream I had in my mind. And when I woke up, not a thing there could I find . . .*

Stars on the Ceiling
APRIL 2012

so now John i am very Glad to say that we are
Boath well as can be expected at present we are
getting on now i have just past my 77 Barthday so
we have a lot to be thankfull for i hope you and
yours all well you can give our love to yours
Father and all that are in the famely.

(LETTER FROM MR FARROW)

That was ages ago, six months at least or perhaps more. I am losing
track. There is so little to hold on to at the centre and so many tangled
threads stretching out in all directions. I follow one thread and it breaks.
I follow another and it leads into a precarious landscape where there
are no instructions, no signposts.

I make contact with strangers. I try to be polite and hope they will
like me enough to answer my questions.

'I think John Craske had untreated diabetes,' I say. 'Could you describe
what it would have been like for a very poor person to suffer from that
condition in the 1920s and 1930s, before the development of insulin. He
might also have had a benign brain tumour, but I suppose that's outside
your field.'

'John Craske lived very close to Roughton Heath where Albert
Einstein was staying in a wooden hut in September 1933,' I say, and then
I realise I don't quite know how to continue with this line of enquiry.

'I know it has nothing to do with the man I am writing about, or at
least only indirectly,' I say to the circus woman I met by chance in Great

Yarmouth, 'but have you still got your grandfather's diary entries, from when he put the Elephant Man on show in London?'

'John Craske said he had dreams of the sea when he was in coma,' I say to someone who has recently emerged from such a state. 'I hope you don't mind me asking, but did you also have dreams?'

Some people take me by the hand and steer me carefully through the nature of their own speciality, until I am teetering close to the edge of understanding. Others are dismissive because they are too busy, too professional, too shy, or simply because they feel it's none of my business. The circus woman is suddenly protective of the Elephant Man, as if I want to steal him from her. The archivist at the Hebrew University in Jerusalem in snappy: 'Einstein,' she tells me in an email, 'did not learn to ride a bicycle until 1935 and so your information about him bicycling along the cliff path near Cromer is clearly false.'

I suppose the trick is to trust the process and to not mind when you reach a cul-de-sac of one sort or another and to not get in the way when things seem to be going well, even though you don't know where they are heading.

I've been helped a lot by my friend John. Not John Craske the fisherman whispering insight and revelation over the gap of time that divides us, but John whom I first met in 1967 when we were both at university and I was studying English Literature and he was studying Philosophy. We talked a lot, mostly about philosophy because I could never think of much to say about literature, and I remember he was very keen on rational thinking, while I only understood any thinking in terms of the visual images it produced in my mind. He tried to explain Wittgenstein to me and I was impressed by the thinness and elegance of Wittgenstein's two little books which between them had such an impact on the philosophers of the modern world. I read the books rather quickly and as if they were poetry and the only recollection that remains

with me is something about a man who was born in a red room and spent all his life in that red room and did he understand the concept of the colour red. I even made a drawing of the man in the red room, sitting in an armchair and looking exhausted.

John and I lost touch for many years and now he's living in North Norfolk, in an industrial ghost town called Melton Constable, which went through a dramatic decline after the Middle Ages and then re-emerged in the late nineteenth century as an important railway junction in the days when steam trains were transporting wet and smoked fish and all sorts of people between small villages and big cities in the East of England.

Melton Constable was at the hub of this boom in steam-powered traffic: a town enlarged and purpose-built to accommodate all the railway workers, from the humble mechanic to the less humble ticket collector, up to the very grand station manager, and everyone was given a house tailored to fit their place within society.

John's house is close to the bottom of the hierarchy. Families of mechanics, shoulder to shoulder along the street, with four tiny rooms, two up and two down, and an outside yard, and water was only brought indoors much later. In the next street of ticket collectors, the rooms are one step bigger and the stairs have proper banisters and the cast-iron fireplaces are more ornate. Across the main road and off to the right, you come to the manager's red-brick mansion, surrounded by high walls and approached by the warning rattle of a gravel drive.

When the trains stopped running, the town lost its function and at the moment most of the houses seem to be occupied by Albanian and Russian immigrants who plant huge satellite dishes like epiphytes on their outside walls so as to receive television communication from a faraway homeland. They write messages on their doors in a Cyrillic script and grow cabbages and breed chickens in the battered patchwork of

allotments. The women are more inclined to learn English than the men, who are more inclined to curse and to earn a bit of extra money by selling drugs – crack cocaine mostly.

John has a deep voice and a reassuring presence. He was on friendly terms with the Albanians next door until there was a problem with the placing of their satellite dish and since then they have built a high wooden fence separating his back yard from theirs; like the prelude to a long and bitter civil war. Across the road lives a tall, quiet, retired and retiring man who was a wood turner by trade, but who now breeds rare and almost lost varieties of butterflies and moths, which he releases in areas where he thinks they might survive and sometimes they do. Opposite John's back yard there is a woman who wears wonderfully bright coloured coats and spends a lot of time in Barbados and she has a tenant who looks more like John the Baptist than anyone I have ever met and he is the owner of a small boat which he sometimes takes out on the estuary at Blakeney, about ten miles away.

John abandoned the rational philosophers in favour of Tibetan Buddhism in the early 1970s and over the years he has become an expert on the movement of the moon, especially in relation to early pre-Christian temple sites in Malta. In order to watch the moon more closely, he cut a hole through the wall in his bathroom, so that he could see it waxing and waning without the interference of a sheet of glass and never mind if the cold air is pretty sharp during the winter. He has made maps covered with stars and the intersecting lines that connect them to each other and he has written learned papers on the subject of conjunctions and coincidences. The ceiling of one of the upstairs rooms shows the constellation of stars in the western hemisphere, the sky painted dark blue and the stars in a variety of primary colours according to the perceived intensity of their brightness.

Six years ago, the local council cut down the line of cherry trees in

the street of ticket collectors because they were growing so well and people complained they were taking up too much daylight and were lifting up the pavement with their roots, making it awkward to park. The council agreed to let John have the cherry tree wood and with the help of the butterfly and moth man he cut it into logs and planed it into planks and left them to season for a while until they were ready to be made into blocks that would fit comfortably in the hand. John sanded the blocks for hours on end and then he had a set of poker chips which he painted with symbols of moon and sun, square and star. He keeps them in a wooden box and more or less once a week, especially during the winter time, friends from around and about come to play poker, with a lot of wine and the banging of wood upon a round table and no money.

Since starting on Craske, Herman, my husband, and I have been to see John quite often. We sleep in the room with the stars on the ceiling and a coal fire in the grate; we have learnt the rules of moneyless poker and John has introduced me to all sorts of people who might know people who might know something about John Craske. I met a woman at one of the poker games who told me her mother met Einstein in Vienna in 1930, but didn't like him or his wife or his violin playing and said so very bluntly, in an interview that she gave in 1999.

John introduced us to his friend Margie, an artist who lives close by. She is familiar with Craske's work and she collects stones and shells and fossils and all sorts of bones and she has the scapula of pigs and cattle on display in the front room of her house, lying in front of the Victorian fireplace in a great white heap, so that they look like ancient cooking utensils or gentle weapons. She also has lots of thin skeletons of fruit bats and the thick and somehow thoughtlessly blundering skull of a warthog, both tusks intact, and a Bushman perfume pot made out

of a gourd which still holds traces of a strangely evocative scent that seemed familiar even though I have never smelt anything like it before. Margie and I discovered that we share a fondness for a book called *Specimens of Bushman Folklore* by Wilhelm Bleek, a nineteenth-century linguist, who made a study of the Bushmen and their language. The Bushmen he talked to had no concept of linear time, but, just like Einstein, they spoke of the future and the past as something that was taking place in the present moment. They told Bleek what it felt like to be a springbok: the black stripes so strong on each side of your face, the weight of the horns on your head and then the sensation of being shot with an arrow by the man who is about to shoot you dead, once he has got up in the morning and gone to look for you.

On one visit John took us to the Shell Museum in Glandford and as well as the faded embroidery they have a beautiful Craske painting of a black-sailed schooner in a storm.

The woman who lives next door and has the key to the museum, which is only open in the summertime on account of it being difficult

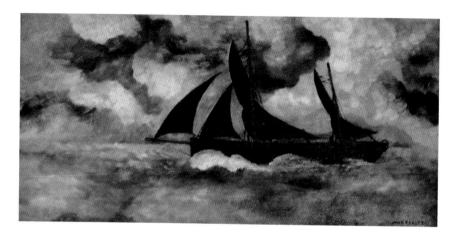

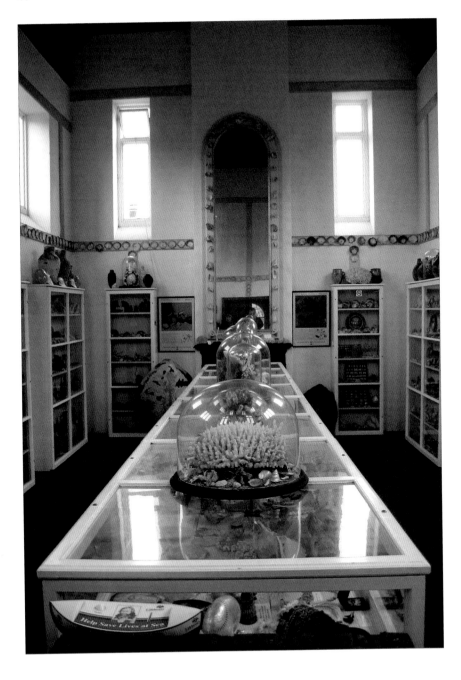

to keep it warm in the winter, told me that a relative of John Craske came by two to three years ago or it might have been four. Betty Craske was her name and she said that when she knew her uncle he spent all his time in bed and he had long grey hair and she was frightened of him, but she liked the pictures he made. I was very excited to think that there was someone called Betty who could connect me directly with recollections of the man she

called Uncle John, but by the time I had found out where Betty was living and how to make contact with her, she was ill and on the edge of dementia and had no interest in talking to a stranger about her childhood memories.

The woman with the key allowed me and John to both have a try at taking some photographs, standing on a chair in order to get closer to the embroidery and to the schooner, but the results were not very good. I did, however, get some nice pictures of the albatross skulls and of the museum interior in all its odd and intricate glory.

After the Shell Museum, we went to the church at Cley, just a few miles along the coast from where Craske was born. It is a huge building belonging to the days of medieval wealth from the herrings that were salted and smoked and transported to all corners of the known world, as close as London, as far away as Russia. It floats like an ark among

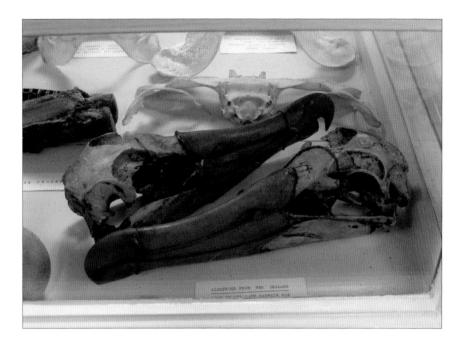

the soft green waves of the churchyard, and the tombstones outside and the flagstones on the floor inside are filled with stories of death by drowning:

> *Here lieth the body of William Shepherd of Wisbech who by*
> *a sudden and violent storm on ye 16 day of March 1720 was*
> *forced on the shore of ye bay of Salthouse where himself and*
> *most of his ships crew lost their lives and the ship was*
> *wrecked His body was privately taken and buried in sand but*
> *being discovered 14 days later was taken up and here decently*
> *buried in this place aged 20 years*

John and the bone collector had been chosen to make an art installation in the church as part of an annual festival. Together they hung the glass refracting prisms taken from old cameras and binoculars on threads and

wooden frames, some inside the deep vaults of the star-shaped windows and others above the arch of the entrance porch. The prisms were placed so as to catch and refract the light of the sun and cast little rainbow patterns on the fifteenth-century columns that reminded me of the trunks of dead trees in an ancient forest, and then the rainbows slipped like will-o'-the-wisps over the whitewashed walls and onto the worn black and grey stone slabs of the floor. They grew and diminished and changed shape according to the surface that held them and the result was a small everyday miracle. John said the people who came seemed to enjoy it very much.

Little Auk

OCTOBER 2011

> i hope John that you are well and all of you and
> when the vorge is over we shall All gain the
> harbour where the Sarges will seace to Roal.
>
> (LETTER FROM MR FARROW)

This is a story that seems to belong here. It was a Sunday. The sun was shining and I and Herman and his daughter and his daughter's boyfriend who had come to stay all went to the village of Walberswick, which is where the sea is closest to us in this part of Suffolk where we live.

We parked in the muddy car park that seems to get bigger each year to accommodate a growing crowd of summer visitors, but in the winter it's still as bleak and empty and beautiful as it ever was.

We went over the footbridge crossing a tidal creek inhabited by numerous crabs that have grown accustomed to being fed bacon offered to them on a hook and line. In return, they accept the minor inconvenience of being hauled out of the water, dumped in a bucket, counted and laughed at, before being unceremoniously returned to their natural habitat.

Then we followed the path that leads to the dunes that divide the land from the sea. Marram grass and the last of the purple sea asters and lots of rounded flint pebbles and the pale, half-burnt trunk and splayed roots of a tree that seems to belong here, sometimes shifting the weight of its body into a slightly altered position after a really big storm.

Over the crest of the dunes and to the left is the Blyth estuary and

the river that divides Walberswick from the town of Southwold. When the tide is low like now, the wooden groynes along this side of the river's mouth are very black and skeletal and even on a quiet day there is the sense of the fierce outward pull of the tide and the speed of the cross-currents where the sweet water meets the salt. In spite of the warning notices, people still get swept out and then they can't get back.

We started to walk across the expanse of sand exposed by the tide and in the distance, close to the lapping edge of the waves, I saw a small shape that looked like a bird but I couldn't work out what sort of a bird it might be. It was about the size of a rook, but more upright and as round-bodied as a penguin. Whatever it was I thought it must be dying, because it had just toppled over onto its side and it lay there, flapping helplessly.

When we got closer we realised it was a Little Auk, a bird that spends most of its life in open water and only comes on land when it is nesting on rocky cliffs in the Orkneys or other northern outcrops and islands. It gazed at us vaguely and then as if out of politeness it stood up with an effort and wobbled on its webbed feet and fell over again and pecked at the sand with its big beak. It showed no sign of fear and as always when a wild creature is so tame and trusting, you have the brief sense of returning to some original state, before death and danger walked in to disturb the quiet.

I squatted down and picked it up, surprised by the solidity of its body, and it rested calmly in my hands and jabbed softly with its beak on the sleeve of my jacket as if hoping it might prove more edible than the sand. I put it down again and it stayed on its feet for long enough to shuffle towards me, standing there and looking up expectantly as if I was about to do something both useful and sensible.

We realised the Little Auk was eating sand because it was hungry and in its wobbly state any passing dog could grab it like a bit of flotsam

and that would be that. None of us knew what to do. My stepdaughter and her boyfriend volunteered to keep guard, while Herman and I went in search of some sort of help, but we knew the only shop that might have something nice for a Little Auk to eat was closed. 'This is nature,' I thought. 'It has no room for pity or for mercy and the weak must die because they are weak . . . This is nature,' I thought, 'fragile and endangered by the encroachment of human beings, and we must at least try to save one bird.'

Within the moment of that second thought we saw lying on the sand in front of us a small, bony and perfectly fresh dead fish, its mouth extended into a funnel of surprise. I picked it up and returned to the Little Auk and lifted it up and offered it the fish, which it swallowed in one easy shuddering gulp. It waggled its head expectantly and waited for more of the same.

I set off in a vague but determined search; over the bridge and into the village, where a grey-haired couple were sitting in their front garden in the sunshine close to the pub, drinking a bottle of white wine and looking slightly sozzled and very friendly.

'Do you happen to have a fresh herring or mackerel?' I asked them and I explained the problem. They said very sorry, but no, they had none, although I was most welcome to a glass of wine, and then the woman remembered their neighbour had caught a lot of herring the day before and she could go and ask him. She came back shaking her head because the neighbour was out, but her husband knew where the front-door key was hidden and off he went and returned triumphant, holding one fat herring. The woman cut it into chunks with a sharp knife and she put it in a plastic bag and I took it to the Little Auk which was still on its feet, waiting patiently for more food to appear.

As soon as I picked it up it lunged at the first chunk of herring and took a second, a third, a fourth piece; the fish almost as big as the bird

and the pieces disappearing down its throat in quick succession. When the last bit with the tail on it had been swallowed, the Little Auk gave a ripple of what I suppose was pleasure and suddenly looked much fatter and sleeker and more wide awake.

I tried setting it down in the shallow water, but it kept being buffeted over by the smallest wave and rolled helplessly back to the shore, gazing at me morosely because of our joint failure. So I removed my shoes and picked up the Little Auk and waded out until the water was above my knees and then I hurled the bird out to sea, as far as I could manage.

It landed with a plop and disappeared without trace, but just when I thought it had drowned in a watery grave, killed by a misguided act of kindness, it popped up on the surface like a cork and, waggling its head from side to side, it set off, paddling at a tremendous rate, and going north, towards wherever it was that it felt most at home.

I told this story to a friend who has done a lot of sailing and, as if in response, he began talking about what it was like to spend several weeks at sea. He said something changes in your head because you and the boat you are on are nothing but a tiny and insignificant speck within the vastness of the ocean and yet you feel yourself to be all there is, poised at the centre of the universe, with the sun watching over you by day and the stars and moon racing alongside you during the hours of darkness. And if there are sudden mists or storms or other dangers, then you are confronted face to face with your own isolation and helplessness and you have to combine the energy of survival with a submission to the present moment and whatever destiny it holds for you. A sailor, said my friend, learns the rules of navigation, but in a crisis he must learn to let go of all rules, so that he can trust his own intuitive response to the situation.

He said there is a weightlessness to being out at sea, carried along by air and floating on water, making you feel as if you do not have a

body and the whole world is without any solidity. And when you approach the land again it shocks you because it smells so harsh and visceral. And when you tread on it, it's like waking up out of a wild dream of freedom and falling back into a clumsy earth-bound existence.

John Craske, whose actual life was suspended by illness, continued to go to sea in his mind and in the images that floated through his mind like little boats, far away from the safety of the shore.

Peter and Freddie

DECEMBER 2012

Just a line to you John and all at Dereham i hope
that you are all well as it leaves me and all here
present thank God for that. (LETTER FROM MR FARROW)

Gilbert White, the gentle-hearted eighteenth-century vicar of Selbourne, who had robins flying through his sitting room and house crickets singing at night by the hearth in his kitchen, was always busy trying to understand what living creatures did and where they were when he couldn't see them and what mattered to them and what didn't matter. He spent a great deal of time observing the small events that took place in his garden and the landscape around his garden and then writing everything down. He thought that swallows must hibernate during the winter months and so he searched for them everywhere, even examining the muddy banks of his pond in case they were hidden there. He had a tortoise called Timothy and because he wanted to know if Timothy could swim, he lowered him into a water butt and he sank down to the bottom like a stone and so he was lifted out and no damage was done.

Gilbert White wrote about the solitary horse in a field which became friends with a solitary chicken; the two of them pottering about together and enjoying – if that is the word – each other's company; the horse always being careful where he put his feet. We work with what there is; we make do with what we have. If we can, we find a way of dealing with illness, with loneliness, with anything else that hems us in.

*

I had often heard about Peter and his parrot, but I met him for the first time just last week, on December 12 2012. He is the brother of our neighbour Mickie and they do look quite similar, or at least you can guess they are from the same family.

Peter doesn't live near here, but he comes to visit at least once a year. He drives a low-slung silver car with a sculpted bumper and raised side-wings, something that would have suited Captain Scarlet if the Captain had abandoned Outer Space in favour of travelling around the roads of East Anglia.

Peter is a big-bodied, tall man in his late forties and he has a shaved head and a maze of tattoos on his arms and a flat black disc fitted into his left earlobe which might be made out of ebony and a silver ring clipped through the skin above his left eyebrow, very visceral and like an arrow shot through the heart by Cupid. Until recently he lived with his parents, but then they died and now he lives on his own in a caravan.

But he's not really on his own because he lives with a small and brightly feathered Colure parrot called Freddie. He bought Freddie seven years ago from a nasty man who didn't understand anything about birds and the man said that Freddie was a male and good for nothing. For several months Freddie lived up to his reputation and remained silent and angry and nervous. But finally he relaxed and began to enjoy himself and as a result he produced his first egg inside the shirt Peter was wearing, while Peter was lying down and watching television; as if that was the safest place in all the world and perhaps it was. By then it was too late to change his name into something more feminine. Freddie laid her second egg in the palm of Peter's hand, while they were both watching television.

Freddie is relentlessly loud and demanding but without any coherent words, although she can imitate the sound of a sneeze and she screeches something which I was told was an approximation of her own name

whenever she feels she is going to be abandoned. She has a cage which she is sometimes put into, but given a choice she would rather spend every hour of the day and the night somewhere on the surface of her owner's body. She shuffles from one foot to the other on his shoulder; she grasps his ear with her beak so she can climb up its outer edge and she taps on the black stud before continuing up the side of his face as far as the eyebrow, using the stability of the silver ring like a mountaineer's belay. She stands on the summit of the bald head, her feet slipping sideways, and she shrieks in triumph and makes a brief dash into the air and returns to the head. She climbs down the same way she climbed up, but this time Peter pulls open the front of his shirt and she attempts to remove a button, before nudging her way down onto his chest, which I suppose might also be covered with tattoos. This is where she sleeps at night, or during long television programmes, lying on her back with her feet bunched up.

Freddie doesn't like to be reprimanded and if Peter tells her she is naughty she sits on his shoulder and rubs her head against his cheek until he says she is not naughty. She is afraid of the dark and has sometimes flown out into the night air by mistake, only to come racing back to the safety of electric lighting. The two of them go under the shower together, although Freddie avoids getting drenched by switching shoulders when she needs to. When he was living with his parents, Peter stayed on the sofa downstairs, keeping the light on for the parrot's sake. He had a sheet which he tucked behind the back of the sofa close to the wall, so he and Freddie were in a sort of tent.

Freddie is by nature jealous and does not like anybody who is not Peter. I avoided looking into her round red-rimmed eye because I felt it might be seen as a challenge. Apparently the Polish woman who lives somewhere close to the caravan was attacked and blood was drawn. As well as removing the buttons from shirts, Freddie can also unpick the

stitches on zips. She drinks coffee and tea and stirs the sugar with a spoon held in her beak. She eats whatever Peter eats: kebabs, Kentucky Fried Chicken nuggets, chips and hamburgers mostly. If the food is put on the table in one of those cardboard boxes, she dives into the box and shuffles about under the chips and the nuggets, looking for the best bits. She also eats the insulation around the door and the windows in the caravan and she tried to eat the plastic curtain rods, but she could only scar them with the marks of her beak.

She babbles at Peter without pause as she paces around his body and what I want to say is that he is someone who is not lonely or odd, because he has a parrot; just as John Craske was not lonely or odd because he had his work and the dreams which fed into his work; just as his wife was not lonely or odd because she had her husband to watch over, even when he was not aware that she was watching.

Family Histories up to 1905

now John Jimmy Crask sad to me that want to
know about the las trip i had in the tommy
Campble a fine big Ship one of the best that i ever
saild in out of Grimsby she was a very stadey ship.

<div align="right">(Letter from Mr Farrow)</div>

Fishermen walked on the unfamiliar element of land with deliberate
strides, arms held out penguin fashion as if the ground might suddenly
tilt beneath their feet. Those who could afford them wore heavy leather
sea boots with steel cleats on the heel, a steel half-moon on the toe and
studs on the sole for tramping up and down the shingle and you might
think the boots were especially designed to fill up with water and pull
a man down to the bottom of the sea as quick as a hangman's drop. It

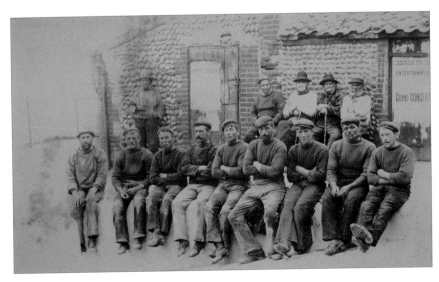

was considered bad luck to learn how to swim, because that would only make you fight against your own destiny when it came to fetch you. 'We're used to being drowned,' they said and the churchyards are filled with their stories:

TO THE MEMORY OF

CUTLER CRASKE

AGED 49

AND OF HIS YOUNGEST SON

NATHANIEL AGED 13

WHO PERISHED AT SEA IN A HURRICANE

29TH NOVEMBER 1836

WITHIN SIGHT OF HOME

(tombstone in Sheringham churchyard)

Fishermen looked out towards the sea, ignoring the land at their backs, and a stranger was someone from the next village. The women knitted thin strands of unwashed and oily wool into the tight sweaters known as ganseys which would identify a dead body as one of their own, washed ashore far from home. Every town and village had developed a particular pattern: rings and furrows on the waistband or the neck showed how many children and grandchildren a man had, anchors were for the hope that he might return safely after each trip and zigzag lines were perhaps something to do with lightning not striking the boat, or the confusions of married life. The running chain stitch represented the herring, the fish that had kept them going for so many centuries.

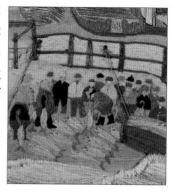

The main fishing families along this

stretch of the coast carried nicknames that made them like a secret society, separate from outsiders who had nothing to do with the sea. 'Old' and 'Young' and 'Boy' were often added to the nicknames, to mark the different generations. In Sheringham there were, among others:

Lotion, Click, Buttons and Bows for BISHOP
Tippoo, Coaley and Demon for COOPER
Latter-Day and Bread-alone for COX
Dingy, Cutty and Silky for CRASKE
Buffalo, Mad Jack and Plug for EMERY
Butterballs, King Kong and To Ro Ro for GRICE
Jockey, Saffron and Honey for GRIMES
Butcher, Maggot, Spider and Belcher for JOHNSON
Twell, Pongo and Stilly for LITTLE
Gay Lad, Gofather, Nimshy and Young Blooming for PEGG
Downtide, Joyful, Teapot and Squinter for WEST

The Craskes had been based in Sheringham for as long as the records can be traced: all fishermen and fishermen's wives and daughters. John's father Edward was born in 1850, the youngest of twelve children, and he went to sea at the age of eleven. In 1875 he married Hannah Sarah, whose grandmother was said to have been an African slave; maybe a slaving ship was wrecked along that stretch of the coast and some of the men and women survived and stayed on, but it's equally possible that it was Portuguese or Spanish sailors who brought their dark hair and dark skin into the family. Hannah Sarah was tiny, with a thin body and enormous hands. She and Edward had eight children.

Already by the 1870s there were too many fishermen working from this one overcrowded beach; their little boats cluttered close together, no room to land them safely, quarrels and fights breaking out and not

enough good fish and prices low. So, like many other poor families, Edward Craske set off in an open boat, with his wife and children, pots and pans and bits of furniture, crossing the Wash and coming to land at Grimsby Docks where there was more chance of work, more fish, more money to be made. He'd been based in Grimsby when he was out longshore fishing before he was married and there were all sorts of Craske relatives living there who could probably provide a bit of a space in one of the new terraced houses built to accommodate a fast-growing population in this town that needed as many extra hands as it could get. The Grimsby fleet was catching one-third of the fish landed in England and Wales and alongside the real fishermen there were many young boys from city workhouses and orphanages and charitable institutions from across the country, apprenticed by smack owners and made to work so hard it often killed them. They'd go out for two or three weeks at a time to Spurn Point or beyond, and then they'd be back for a couple of days, before going out again.

In 1881 the Craskes were back in Sheringham for the birth of John, their third son. Like his older and his younger brothers, John grew up to be a fishermen, and when he had just turned eleven he went to sea. I was told that he went into Icelandic waters, fishing for cod on one of the Big Ships, but I'm not sure if he really got that far. I do know that in 1901 the family returned to Grimsby, and then by 1905, the father had decided to give up the struggle and along with all but two of his sons, he broke with family tradition and moved inland to the market town of East Dereham where George Borrow who lived with the gypsies of Wales and Southern Spain was born, and where John Cowper who kept tame hares in his front room went mad and died.

Edward Craske set up a little fish shop on Norwich Street, selling wet fish and smoked fish and John and brother Robert and brother Edward helped with the business and they all lived in tight little houses in Norwich

Road, not far from the new railway station. They went round the neighbouring villages selling fish from baskets carried by a pony and when the business grew, they had the money to buy a cart and later the money to buy a van, the family name written on its sides. I wonder if they all missed the sea or was it just John who longed for it with something like homesickness.

A lot of this information comes from Trevor Craske, whose grandfather was one of John's brothers. Long before I started my own particular search, Trevor and his wife Liz had been consulting genealogical websites and army records and museum archives, tracing their relatives and the circumstances of their lives and deaths and talking to anyone who might be able to add another detail to the story. They have given me copies of papers they think might help and copies of all their photos as well. And now every time they come up with some new lead, Trevor lets me know in an email.

Occasionally our paths have crossed. Last year I met an old fisherman called Billy in Sheringham and this year Trevor wrote to say that they had met him too. And when I went to Grimsby to see if I could find any Craske relatives, I learnt that Trevor and Liz had been there thirty years ago, 'investigating in a casual way, the Craske location in Grimsby/ Lincolnshire'. They tried to find the street where the family had lived, but it no longer exists because that whole area has been turned into blocks of flats. They visited Saltfleet or Saltfleetby and 'seeing a boat stranded by the low water, we wandered across to it, to find that an aged man was on board, *waiting for the tide to come in.* We talked of our search and he told us he knew of the Craskes who worked in the longshore boats early in the nineteen hundreds.'

In a Grimsby census record for 1871, they found a reference to John Craske's father, *unmarried fisherman, born in Sheringham.* He was working on a ship called *New Admiral*, docked at the Fish Docks, and the master of the boat was a Robert Craske and there was a Christopher Craske on board as well.

Trevor was born in the late 1950s, several years after John Craske's death, but he knew of other relatives who had met him and might remember something. In February 2012 I had an email about Cousin Betty, the one who had visited the Shell Museum and had talked to the woman in charge about John the artist who made the embroidery that hung on the wall, fading a little more with each year that passed.

'At last, this evening, I've just been able to talk to Aunt Betty,' wrote Trevor. 'She sounds fine, but says she was very young when she called in on John and so has limited recall . . . When she visited he was often asleep. He had a fish pond in the front garden in the shape of a whale, made from concrete and covered in shells. His brothers Ted and William, my grandad, had helped him with the construction. She thinks there was also a carved shark under the front window, perhaps that was carved

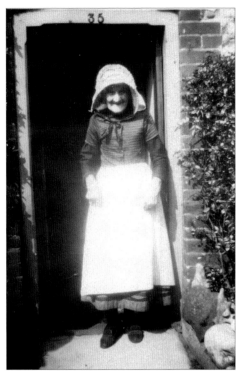

out of driftwood, but she's not sure. She cannot recall John's way of speaking, or what and how he viewed things.' There was talk of me meeting Aunt Betty, or at least having a telephone conversation with her, but then she went into a sharp decline and within a little while Trevor let me know that she had passed away.

In January 2013, he sent me a photograph of Hannah Craske aged seventy-nine, standing in the doorway of a little flint-built cottage in Sheringham, her enormous hands limp at her sides. He told me he had made contact with another of his father's cousins, Doreen. 'I asked if she would be willing to chat with you and she is more than willing for you to call and, if you wish, to call on her.'

Doreen was born in 1924 and she had gone along with Betty on those same visits. When I phoned she was friendly enough, but very preoccupied because she had recently broken her wrist and needed a lot of help with practical things and a new carer was just that minute arriving.

Doreen said it must have been before the outbreak of war when she last saw John, because after the war started she was sent away to live somewhere else. She went to the house at 42 Norwich Road in East Dereham along with her sister Betty. She didn't think she saw John's

wife Laura, but she had been told Laura was a very private person and so she was probably somewhere out at the back, in the kitchen. John was there all right, pottering about in the front room. His voice was soft and it was difficult to hear what he said, but anyway he didn't have much to say. She felt he didn't want to be bothered with a visit.

She remembered that every space on the walls of the room was covered with small pictures and embroideries: fishing vessels and that sort of thing. He didn't show her his work or speak about it, it was just there. Still she was very impressed by what she saw and she thought maybe that was why she took up embroidery herself, later.

'I suppose he was slow because of the diabetes and maybe he had some sort of trouble with his brain,' I said to her.

'I don't know about that,' replied Doreen with an edge of impatience in her voice. 'I understood it was a mental thing. He was just depressed, that was why he often stayed in bed.'

When I asked if I could drop by to talk some more, she said I had better wait until the middle of next month, after the plaster had been removed from her wrist. She'd already written down some of the family history and she'd be happy to show that to me and the box of family photos; she'd been wanting to get the box down anyway, to go through it, see what it held.

She said her father was a tailor by trade and the box had been his; it was for taking suits to customers. He'd been in Russia during the First War, catching rabbits and deer because there was nothing else to eat, and he was always cold in the snow, with no place to keep warm, and that was why when he got back he developed the TB that killed him.

Her father taught her how to sew and under his supervision she made a pincushion out of a bit of white satin cut from the armhole of a waistcoat lining and she embroidered it as well. But then he died, ten

days after her ninth birthday, just when she was getting to know him. 'I hope I'm not boring you with all this,' she said. 'Of course not,' I replied, with thoughts of a little girl making a pincushion almost eighty years ago, her father watching her, already sick, already aware that he hadn't got much time left.

I tried to arrange a visit to Doreen later in the month, but when I phoned her again she told me the same stories she had told me before and said she had no energy to go through the box of photos so there was no point in me coming round.

Trevor and his wife were family and that was different. They went to visit and took her out for lunch. 'Yesterday we met up with Doreen. She has searched more of her old photographs, but none were of the extended Craske family other than those of my grandad. So, no further resource about John there.'

Laura up to 1918

we left the docks on Wenesday 18th of Febeuray
it was very fine so we could not get out to work
the next day so we work some lines on the Friday
and that night was the Rofest night that i ever
was at sea. (LETTER FROM MR FARROW)

Laura was born in a little house on the Norwich Road in East Dereham
and she and John spent most of their married life in an almost identical
house in the same road, just a few doors along. She reached the age of
seventy-six and died one morning in the kitchen of that house; bluebells
and the whale pond in the front garden; the budgerigar in its cage; her
husband's pictures on the walls and on the furniture and anywhere else
they would fit and a whole lot more done on postcards and stuck in an
album; the chimney recently mended; £1438 in the bank.

Her maiden name was Eke, which as a verb means to use or consume
frugally, although it is also a Norfolk term for the quantity of bricks that
a man can carry on his shoulders.

She was tall and strong-bodied, with square shoulders, her black
hair cut in a severe bob. She wore steel-rimmed spectacles and she was
shy and withdrawn by nature, although she could be very determined,
especially when it had to do with looking after her husband and keeping
him alive, when everyone said he would surely die.

She was a devout member of the Salvation Army and she believed
in a God who watched over her and John from one year to the next; a
God who was always willing to provide some sort of small miracle if
they were really in need.

The two first met in August 1905 when he was twenty-four years old and had just recently moved to East Dereham.

Much of what is known about John Craske, comes from Laura's account of his life and their life together, which she wrote in 1929.

She started by making notes of the main events, writing in blue biro on three little sheets of letter paper. She then produced a much longer version, which was turned into twelve pages of typewritten transcript. Both these texts must have been done at the request of the poet Valentine Ackland, whose big moon-face still reminds me of our current Prime Minister in every photograph I see of her.

Laura also mentioned a few details of her and John's life together in the letters she sent to Valentine and her partner Sylvia Townsend

did boats & paint

"Diabetic"

Aug. 1928.
Came home again to live

Dec 1928.
first needle work. Started
mantle borders.
Then a picture. which Miss Ackland
bought when she called sit. her.
mother. John being in a stupor
at the time
from this time he did painting
& Needle work.
& he continued to have stupors
during which time he was
subject to (special) stupors
His last work was dunkirk

Laura Craske.

after Co; home we went to Grimsby
was his eldest brother took him
to sea. for three months
Suddenly he seemed to wake up.
& asked "why am I here"
This is not our home.
we came home the next day.
I prayed much that God would
help us to open the way for us to
get a living
april 6th 1919. I opened the shop in
Norwich Street in answer to prayer
april 14 1920. relapsed
did a little painting
got better again

Aug. 1921. relapsed
left home went to Blakeney on Coast.
Tried again did painting & broke
1926
July. relapsed
... went to Hedley.

Warner and later to their American friend Elizabeth Wade White. Here then is Laura's first biographical outline, the words on the page and the thoughts in her head going hand in hand:

1881. born at Sheringham

His father a fisherman, his grandfather, also great-grandfather at Sheringham

His home was a Christian home

There were nine (9) children, three (3) sons chose The Sea, John being the third son . . .

He left The Sea 1905 (August) starting a fish business in Dereham

Married July 22 1908

In business he worked until called up 9.3.1917 (1914 War)

9.4.17 he was in Croydon War Hospital with a bad attack of influenza. 10.4.17 he was in Hospital Royal Herbert at Woolwich, there the American doctor told me he had Abscesses of the Brain and would not recover

He did recover but was stuporus. In all he went to seven hospitals. I could not say he did any work whilst in the Army

Oct 27 1918 He was at Norwich Asylum. I undertook the charge of him. An orderly brought him Home. He was discharged from there Oct 31st 1918

'Harmless Mental Stupors'

After coming home he went to Grimsby. His two eldest brothers took him to Sea for three months. Suddenly he seemed to wake up and asked, 'Why am I here? This is not my home.' He came home the next day

In the longer version that must have been typed up by Valentine, Laura didn't elaborate any further on her husband's early years but began with

the word *FIRST* and with that she slipped into the present tense of memory.

> *It is August 1905. I have been at home attending to my mother. I go to assist in the Salvation Army Saturday Nights Open Air Meeting in the market place.*

And now she looks for him, looks for her husband, until she can see him as young as she ever knew him to be:

> *There is a soap-box in the centre of the ring upon which a tall strange young man in fisherman's blue jersey stands, his black curly hair is ruffled by the breeze. He is nervous. But he starts to sing: 'On land or sea no matter where/Where Jesus is, 'tis Heaven there.'*

I would like to ask Laura about the strangeness. In the handful of photos that have survived, John Craske looks calm and handsome, but distracted, as if his mind is elsewhere. I wonder if his parents accepted their son's strangeness as something that was handed down the family line, along with black hair and big hands, or did they see it as something shameful, an aberration that must surely pass? Was he already silent as a child, unwilling to speak even when spoken to, his voice slow and halting, and did his brothers tease him then, just as they teased and challenged him when he grew older? Perhaps it was his strangeness that first attracted Laura to him, made her feel safe in his company.

Laura and John were married in July 1908, three years after their first meeting. By then the Craske family had opened a shop for the sale of wet and smoked fish, and fish and chips, and as if she was answering the criticism of all those who had blamed him for being lazy or difficult, she says, *He was always very energetic – now he kept working from morning till night, week after week. He had no half days off, month after month,*

year after year. We had one week's holiday between 1908, up to the time he went into the Army (1917). He would be up not later than 6 o'clock in the morning and generally was working up to 11 at night. He was very business-like and very just . . . At this time we had two ponies. I remember going with a basket on each one, calling at each cottage . . . I wish you could have spoken to the people around here; for miles my John was known.

Laura wants to make it clear that her husband was unselfish as a child and he remained unselfish *right through the thirty-five years we were together*. He was a good man. He loved everybody, he was slow at passing judgement and he kept all his promises, she said.

In the early days, before he was struck by illness, he was especially kind to the sick and elderly and Laura goes to some length to illustrate examples of this kindness, again as if it is in answer to the criticism that came later, when he was so helpless. During a hard winter, when he was with the fish cart, he gave fish every week to a woman and her husband and their two sons, because he saw they were hungry. Once John met a fisherman dressed in a blue jersey who was walking all the way from Great Yarmouth to Grimsby and he not only gave him food, he also gave him his own coat, even though he had no other coat for himself.

After a while they moved to a village a few miles from East Dereham and there they had a fish shop of their own. *We used to cure the fish as it came in season. This is the list as far as I can remember:*

Haddock, smoked; Codling, smoked; Whiting, smoked; Herring Pouch, smoked; Herring, bloatered; Herring, kippered; Mackerel, kippered; Cod's Roe, smoked; Sprats, smoked; Crabs, boiled; Lobsters, boiled; Crayfish, boiled; Winkles, boiled; Oysters.

It was a busy life, but Laura says they were happy. It was cold in the winters, working with her bare hands in ice and salt water, and after the fish had been salted, it was heavy on the arms to put them on spits and lift the spits up onto the beams for smoking.

In October 1914 they lost a pony. In December they went back to East Dereham where John's parents and his brothers lived and they moved into the house at number 42 Norwich Road, the same address that is on top of the pages she is now writing. In March 1917, the doctor examined Laura's side, which had been hurting her for the last five years, and he said it was torn from reaching up and she was not to do any more smoke-house work. In that same week, her husband went into the army.

And now she feels the need to defend him from the accusation of cowardice that was offered so easily to men who were not risking their lives for their country. *He was working very hard*, she says. *He was out all day every Sunday in the training corps and he did route marches two or three nights during the week. At the first medical examination he was given a C.2. and at the second a C.3.* But then a Mr and Mrs William Case from near the station complained that John was not doing work of National Importance and that was what made him leave home, to prove them wrong. He was stationed at the Britannia Barracks, Norwich, March 9 1917. Mr Case, the photographer from Church Street, Mr Johnson the grocer and Mr Wright the outfitter were there with him.

After a fortnight he was sent to Croydon where he met a man he knew called Mr Broody of Brinsley Green. John wrote a letter to Laura every day that he was away from her.

On April 7 1917, Laura was with her sister in the fish cart when she received a wire from the hospital saying he had 'relapsed' and she must go to see him. She doesn't mention what he was relapsing from, or what signs the illness showed.

She arrived at midnight, but by then her John had been moved to another hospital in an ambulance. He was sent to a total of seven different hospitals and he ended up as a patient in the Thorpe Mental Asylum near Norwich, mostly in the company of soldiers whose minds had been disturbed by what they had seen and heard and suffered on the battlefield.

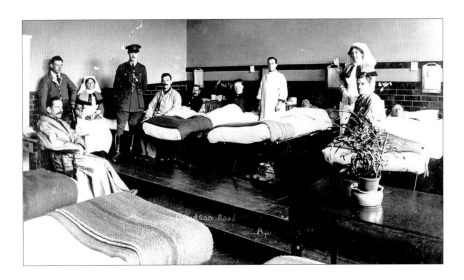

The hospital reported that John Craske, fish merchant, had had a bout of influenza while he was at Croydon and then he had suddenly collapsed during a training session. The description of his condition, dated October 29 1918, stated that he was dull and stuporous, without concentration or memory, and he could not remember his name or his age, although he did manage to say that he was missing his brothers and sisters. He was diagnosed as having a brain abscess. His father and one of his brothers was said to suffer from the same condition.

He was discharged from the army on the grounds of being permanently unfit with a 70 per cent degree of disablement: *a harmless case and his family will accept him home.* Laura came to collect him. *I found him there*, she said.

He arrived back in East Dereham at nine o'clock in the morning on the last day of October 1918. *I was alone with John*, says Laura. *How quiet he was. He could not bear the smallness of the room. He wanted to be in the open all day long. He wanted to go to sea. The sea was on his mind.*

Mary and Einstein

APRIL 2012

came on that afternoon and it cam on ti snow and
it Blue a havey Gale and we could not see the
lngth of the ship it was a night it was terrible
rugh youy could here the see roaring in the
darknes. (LETTER FROM MR FARROW)

The sky was grey and the air was cold and Herman was busy working
in his studio and so I went on my own to the little seaside town of
Sheringham where John Craske was born and I stayed for a few days
at a bed & breakfast on the chalk cliff known as the Beeston Bump. I
am not used to doing anything much on my own and I rather enjoyed
the unfamiliarity of floating within my own solitude.

During the last World War, the Bump was something to do with
national defence and tunnels were burrowed into it and there were radio
antennae bristling from the rabbit-cropped grass and deep bunkers made
to withstand enemy attack. There was even a cannon for firing at the
enemy, but when it was tested the force of the explosion caused it to
break through into one of the tunnels and a dummy cannon made out
of wood was erected instead, surrounded by barbed-wire fences so that
no one could look at it too closely. I could see no trace of tunnels, or
bunkers, or rolls of barbed wire, although the soft edge of the cliff had
been broken off in great chunks and so maybe all evidence from the
past had dropped down onto the shingle below, to be carried away by
the tide.

I walked along a narrow muddy path, staring out towards the horizon

and the Arctic somewhere far beyond that dim line, while taking care to avoid the dog turds that lay about in little heaps in various stages of decomposition. In the far distance I could see the triangle of a sailing boat: a fleck of human activity surrounded by the grey immensity of water, and for a moment I seemed to be looking at one of Craske's paintings, done with a shaking hand on a thin scrap of paper.

I turned off to the right, down concrete steps that took me to a boarded-up Ladies and Gents lavatory built like a suburban home from the 1930s. Someone had crossed out the word Gents and written Men instead, but the Ladies had not been transformed into Women. The steps arrived at an esplanade – if that is the right word, it sounds too frivolous for the thick flat slabs of concrete backed by sloping walls of concrete that must have been erected in the 1950s in one of many attempts to try to protect the land from the battering of the North Sea. Herring gulls and the occasional black-backed gull lifted awkwardly into the air, only to plonk themselves down again a few yards further on. Solitary cormorants kept perfectly still, perched like sentinels on curious metal structures sticking out of the water, whose purpose I couldn't unravel.

There were patches of graffiti on the concrete walls: a simple fish, a raggedy-haired girl called Sylvie and an eager penis which reminded me of the one Herman and I had seen drawn on the wall of the bakery in Pompeii. Further along the graffiti were replaced by proper murals that must have been commissioned after earnest discussions with the local council until they all agreed on what they wanted: a family having fun on holiday; a shipwreck being explored by lobsters; seabirds standing in a line and big fat seals chasing herring. According to the signature in the bottom right-hand corner, the murals were made by a man called Paul Seal.

And there was Einstein, just beyond the seals. He was sitting on golden yellow sands with a mug of tea in his hand. His legs were folded

sideways under him. His grey hair was long and windswept. He was wearing a black suit, a white shirt, black shoes and a large striped tie and all in all he was dressed much more smartly than you might expect from him, especially for a day on the beach. He looked slightly bemused, either because of the clothes or because a photographer had caught him by surprise, but he also looked relaxed and very much at home.

It couldn't just be chance, there had to be some reason for him being here, but I had no idea what on earth could have brought Einstein

to Sheringham. I walked up to the tea shop just above him. It is called
The Whelk Kettles and is a strangely elaborate building with red-brick
edges peppered with little flints. I lifted the latch on twirly metal gates,
went across an empty courtyard filled with upside-down chairs and
entered through a heavy wooden front door that was partially open. It
was like stepping into a castle: there was wood panelling on the walls
and dark wooden beams across the ceiling – all done in the Elizabethan
manner – and logs were burning brightly in an ancestral fireplace. I

ordered coffee from a waitress who was dressed in black with a white apron and I began to feel as if I had strayed onto the set of a Hammer horror film and soon the arc lights would go on and the director would give an order and in would come Dracula, his face as pale as a ghost and blood on his hands.

I was sitting at a little round table close to the fire. A woman with long grey hair cut in a girlish fringe came in through the door. She moved very slowly, her back bent almost at right angles to her frail body, and she sat herself down opposite me. 'This is where I always sit,' she said by way of explanation. She said her name was Mary and she was born in 1922.

'I love the sea,' she said, stirring lots of sugar into her coffee. 'I was a very good swimmer, at least the men told me so.' And she gave me a funny sly smile, so that I could briefly see the grey hair turning blonde and golden in the sunlight and the curiously shattered face became pretty and flirtatious in spite of the mask of age.

I asked Mary about Einstein. She replied that The Whelk Kettles had been three cottages where the whelks were boiled in copper kettles, tons and tons of them, because there were lots of whelks to be had from a sand bank out at sea, much further out than where they get the lobsters. But all that stopped in 1930 when the cottages were bought by a wealthy German called Sir Edward Meyerstein. He had them knocked down and got himself a weekend home, using teak wood salvaged from a navy frigate that had been built in Calcutta but was shipwrecked close to the shore here, grounded on the same sandbank which the whelks favoured.

Edward Meyerstein was a good friend of Walt Disney. In fact, Walt Disney came to stay and he designed the wrought-iron gates leading into the courtyard, which perhaps I had noticed, with jellyfish and lovely mermaids and twirling seaweeds.

'No one believed that Hitler would lose the war and we would win it, but he did the wrong thing by turning his mind to Russia,' said Mary. 'Meyerstein was a Jew, just like Einstein, but Einstein lived in a tiny wooden shed up the hill at Roughton Heath, near the crossroads. He was there in 1933 and he stayed for a long while. He hid there and went to Cromer quite often and talked to the fishermen. I heard he came to Sheringham, too, but I never met him. He walked from Roughton, or biked, or the fishermen might have come and collected him. Everyone said he was a nice man. He played the violin and the piano. They got him the violin from London, but the piano was already here somewhere.

'These things are all coming back to me,' said Mary. 'The whole five years of the war this place was full of troops, every empty house full. They held dances and all that and we were just old enough to go to a dance or two. Our lives were much more interesting because of the war. I was in a sandcastle-building competition and my friend won the prize for the best sandcastle and Mr Meyerstein's housekeeper Gwyneth gave my friend the prize, which was money, of course, because Mr Meyerstein was a millionaire. And then he left and went to America and so did Einstein; maybe they went together.'

I asked Mary what she knew about John Craske and she said she'd never heard of him. There was Nathaniel 'Oldfather' Craske and 'Bounce' Craske and George Craske who was drowned in 1914 and Jack Craske who was drowned in 1931 even though they managed to save 'Sparrow' Hardingham who was with him in the water, pulling him up from the waves by the hair on his head. But not the John I am asking about, unless he was 'Ninny' Craske, although she didn't think that was likely because 'Ninny' never made paintings and never was ill. 'Go and see Old Bennett, he might know more. He's just up the road. He's got lobster pots in his front garden,' she said.

Old Bennett

APRIL 2012

At about 8/clock that night the Ship Cought a
Great Big sea wich Came on Bord and it fell on the
ships Courter and it Broak the ships courter down
and planks Brook from the starn post of the ship.

(LETTER FROM MR FARROW)

So I went to find Old Bennett; the lobster pots filling his little front
garden as if they were pretending to be flowering shrubs. I knocked on
the door that had no bell and I felt I was coming to sell something:
double glazing perhaps, or eternal salvation with the help of a few prayers.

'Mary told me to come,' I said when Old Bennett appeared and he
invited me in without asking what she had told me to come for. He led
me along a narrow corridor and into the kitchen at the back where there
was a friend of his whose name I forgot to write down. Old Bennett
was small and thin and the friend was big and fat and the two of them
kept giggling like schoolboys, but they were friendly in their way.

I explained I was trying to find out about John Craske and they
knew of lots of Craskes in the village, but not that one and because
they hadn't heard of him they seemed to doubt he had ever existed; he
was a creature of my imagination.

'So what else d'you want to know?' they said, grinning at each other.
I said I wanted to know about fish and that made them raise their
eyebrows and giggle some more because it was such a foolish question
to ask of fishermen. 'Can't sell herring,' said Old Bennett's friend. 'Big
shoals of 'em, no one wants 'em.'

'Crabs?' I said hopefully.

'Sheringham crabs are better than Cromer crabs,' said Old Bennett emphatically. 'Used to hibernate in November, go into the sand about a foot under for three, four months. Mild winters now and you hardly get any rough trips and crabs have changed their times. You find 'em behind the chalk reef. Lobsters also like the chalk and burrow in, but with lobsters you got to find where they go. Record catch this year, we were getting one hundred pounds a day.'

'Whelks?' I said then, as if that was more to the point, and it was true I was intrigued by whelks, the snailiness of them and the strength of their twirled shells.

'Whelk grounds are further out,' said Old Bennett. 'Whelk pot with a cod head in it. They'll eat anything, whelks. They travel about the sea looking for dead meat. Find a new whelk bed, get a boat full and then nothing. Human bodies . . . a boat turned over and three men drowned and they was full of whelks.'

I felt suddenly prim and awkward, hearing the rattling of thick shells knocking against each other within the safe containment of a human ribcage and seeing the great mass of them not wanting to be interrupted at their feast.

'I had better be getting along,' I said rather abruptly and I shook the two men by the hand. Old Bennett led me to the front door and told me I was welcome to come back any time. I had wanted to ask him more about herring, but I felt it was a difficult subject, because, as he said, no one wanted them.

When Old Bennett showed me out, he told me I could go and see Billy who lived just a few minutes away. He might know more about my man John Craske. And so off I went to knock on the door of another stranger.

Billy was also unbothered by my visit. He let me into a very well-

ordered sitting room, twirly carpets on the floor, polished brasses by the gas fire, rows of glittering glass ornaments on glass shelves and pictures of boats on the walls. Billy had been a lifeboatman for upwards of forty years.

'We're all fished out,' he said, even before I'd offered any questions. 'I went to sea with my grandfather before I left school. He said there won't be the crabs and the lobsters or the fish, it's all the trawlers now . . . During the war they were used for defence vessels and so the sea restocked and we were catching fifteen, sixteen-pound cod easily. I carried two fish up and their heads were on my shoulders and their tails were in the sand. They take sea bass now, but we threw it away, thought it was dreadful stuff . . .

'Herring catching,' said Billy. 'You hung half a mile of net out and the fish caught themselves. The gills held them to it and it was like sheet silver, hauling them in. You needed the light of the moon. Others used lamps, but we used the moon because they'd swim up to it.'

I found the moment to ask about John Craske. 'My great-great-grandmother was Granny Craske and her son's daughter was my great-grandmother Augusta,' he said. And then, thinking some more, he added, 'When you said John Craske, I thought you meant John Silkie Craske, who lived up the road from here. Old Silkie. The other John, I heard, was a troubled man. He started in a mental hospital.

'When I was courting my late wife – she came from Cley – we went down to Cley to see the water. Her parents had a little boat. You could drift out with the tide and drift in, in the evenings, six hours or more. And we went out walking. We walked up to Glandford and the museum has all them foreign shells; they ain't Sheringham shells. There were all these pictures and quite a lot about him there.

'Grandfather said of the other John Craske that when he came back from the war, he was in Wiveton, worried about illness.'

The conversation came to a halt and I was hungry, so I thanked Billy and went and had a bacon sandwich and a mug of very strong coffee in a café close to the abandoned lavatories. The café had a shelf-like table along the window facing the sea, where you could sit and stare towards the horizon. A room at the back sold second-hand clothes and lampshades and cast-off toys and old shoes worn down in unexpected places by the story of other people's feet. I sat there for a long time, weary from the strange effort of one-sided conversations and uncertain as to how I could use them.

At four o'clock that afternoon I had an appointment with a woman called Ena who was ninety-six years old and had given birth to thirteen children. Her father was John Craske's cousin. I had heard of Ena because she was the mother of the friend of a friend of my friend John and in the way that such things work, I had been given her telephone number and told she was expecting me.

'I have been expecting you,' Ena said when I phoned. I could hear no trace of the ninety-six years in her voice. And now here I was and a tall, big-boned woman opened the door as soon as I drew close to it and welcomed me inside her very ordered and tidy house. When I complimented Ena on how well she looked for her age she said she felt well enough and still liked to go dancing when she got a chance.

We sat facing each other at her kitchen table and before I had time to ask a question she told me I had better get a pencil and paper because she was full of so many memories, she hardly knew what to do with them. The earliest one was of 1918 and the bonfire they lit on the Beeston Bump to celebrate the end of the First World War. She must have been three years old and the fire was lovely, so big and bright.

Ena had been born on what she called the wrong side of the blanket. 'I was conceived in June 1914, and we declared war in August and my natural father, who was a Craske, went and signed up in the navy and

never came back till 1918.' Her mother was only fifteen when she fell pregnant, so she was sent off somewhere when her belly got big and brought back late at night in a handcart with the baby all wrapped up and hidden and Ena was raised by her grandparents. When the war was over, her father married her mother, but she never lived with them and until she had turned fifty she still thought her mother was her older sister.

The grandfather was a kind man; he had blue-black hair as smooth as satin and that was because he had Spanish blood in him, from a Spanish whaler that struck a sandbank and the men stayed and settled down. 'When I went to Spain,' said Ena, 'the doorman at the hotel saw it straight away. "*Buenos noches señora*," he said to me, while to my friend he said, "Good evening, madam."'

Ena's grandfather told her lots of stories and they had merged with her memories so closely that each time she spoke of him she seemed to be talking about herself. He was just seven years old when his father was tipped out in the sea while trying to push the boat round; he broke his back and died soon after. So then the boy went wild from grief and because his mother couldn't do nothing with him she sent him off as a cabin boy on one of the Great Boats bound for Icelandic waters and the cod-fishing grounds. He was still only nine when he went to Iceland for three months codding and they brought the catches in to Grimsby or even further up the coast and then they'd go back out again.

He was paid in golden guineas, said Ena, and when he had earned enough money to buy his own boat, he came home. He'd learnt to tap-dance. A lot of fishermen could tap-dance, but he could do it beautifully. He could dance on the lid of a chest, light and fast with a noise like gunshot. People loved to watch him and they'd bring him to The Two Lifeboats whorehouse so he could entertain the women and their customers. His mother would come looking for him, 'Where's my little

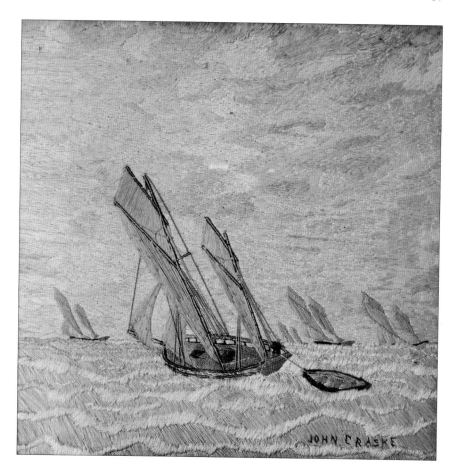

Dick? Have you seen my little Dick?' she'd say. But someone had already hidden him behind a settle with the sides up and so she couldn't find him. 'And that was how he came to be known as Little Dick,' said Ena.

 She went to find some pictures of Little Dick, standing in the doorway of a house called Ivanhoe beside a thin wife who had one of those impossible nineteenth-century hourglass waists. They are looking away from the camera into some far distance and there is a curious awestruck expression on both their faces. Little Dick has a big black

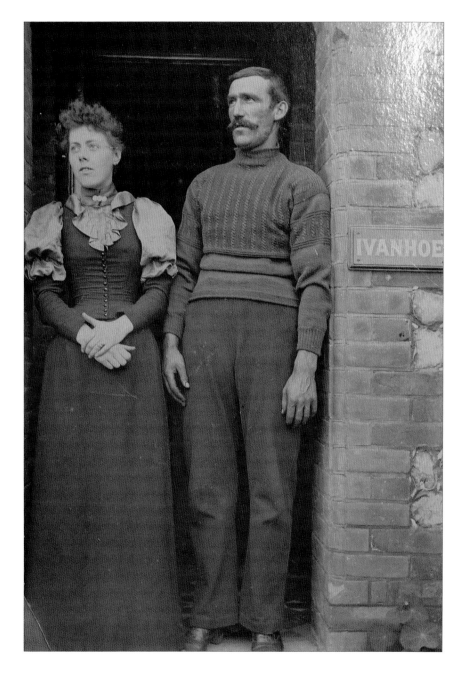

moustache, long limp arms and enormous hands; 'Craske hands, just like mine,' said Ena, showing me hers so I could see for myself that this was true. Little Dick made me think of the photograph I had seen of John Craske as a young man. It was not just that they had the same long pale faces and thin bodies; they seemed to share a sort of wistfulness as well. I told Ena that they looked very similar and asked what she knew about John.

'We called him "Ninny" Craske', she said, as if the name brought him into focus. 'He had the same blue-black hair as my grandfather, they looked so similar and "Ninny" wasn't podgy or anything, but lean, and I can remember him when he did the painting and that sort of thing. He did embroidery and suchlike in his bed and my grandfather spoke of him and said how clever "Ninny" was and how he weren't so well.'

As I was about to leave, Ena told me that her second husband was the first person to enter Belsen concentration camp in 1945, just after the liberation. He was driving a lorry with a tank filled with fresh water, because the water in the camp had been poisoned. He came through the gate behind a military vehicle and he stopped and got out and there was no one there except the dead bodies and the smell was terrible. 'What do we do now?' he said to the man in the military vehicle.

'He was a good husband,' said Ena, remembering him, 'and he had never spoken of it till a little while before he died. It was something private he'd carried with him and I suppose he needed to get it off his chest.'

Praise Song for the Herring

OCTOBER 2012

> We tried the pun out water which was coming in
> from ships starn and it began to fill the Cabben so
> much that before the men could get their oil frocks
> on Caben floor Brook up and the men had to come
> out fast as ever they Could. (LETTER FROM MR FARROW)

The herring used to congregate in great shoals for the spawning season in spring and again in autumn and they always kept to the same areas from one generation to the next, so the fishermen knew where to find them. In 1887 the naturalist T. E. Huxley worked out that if there was one herring in every cubic square foot of such a gathering, that would make 500,000 herring within a shoal one mile square and three fathoms deep. Some shoals were eight miles long, which meant at least four million herring were moving just beneath the surface of the sea, all shifting direction in the same rippling moment as if they were part of a single organism.

Herring, along with mackerel, sprats and pilchards, have their home in the upper layers of the open sea. They feed on plankton, the tiny plants and animals which are like the grasslands, great drifting clouds of the stuff and the shoals of fish quietly grazing.

Seen from above, the blue-green of their backs looks like the rippled surface of the sea, while from below their silver bellies blend with the bright glitter of the surrounding water. They are caught at night and trapped by their gills in the long floating drift nets, their presence betrayed by the light of a lamp or by the moon glinting on their backs.

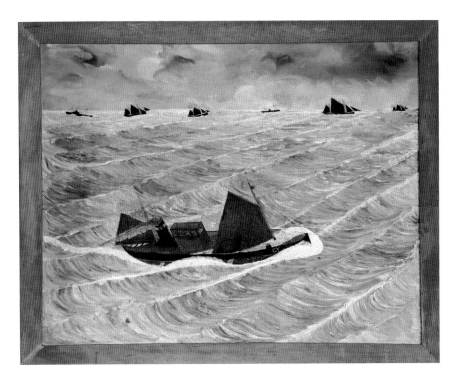

From the Middle Ages until the mid-nineteenth century, herring were a staple food for rich and poor. As soon as they were landed, they'd be sprinkled with rough salt and stirred with a shovel, to delay the rotting process. Before being boiled, they were soaked in water for at least twenty-four hours. Apparently the archers at Agincourt went into battle on breakfasts of salt herring.

Three herring a day provided all the protein and fat a man needed and a fisherman could eat six or eight of them and required nothing more and tended to have a dried herring or two strapped to a string around his waist in case he got hungry while he was far from home. In early photographs of the cottages in Sheringham you often see a bunch of herring hanging from a hook by the front door, just as others might have garlic to keep witches at bay.

I tried to imagine that mass of life as it once had been, hundreds of thousands of herring moving in shimmering unison, like starlings in the sky. The light of the moon drawing them closer to the water's surface, the light glancing on their bodies so that it looked as if the sea was burning with white flames. And then there'd be half a mile of drift net suspended in a long aurora borealis line and when the nets were pulled in it was like drawing flakes of silver out of the water.

The man who sold the tickets in the little Great Yarmouth museum that had once been a medieval prison was sitting very stolidly behind a desk at the entrance and he hardly looked up when I came in. But when I asked him about herring he suddenly rose to his feet and spoke about the fish and their history, as if he was an actor playing the part of Chorus in a Greek tragedy. Among many other things, he told me that in 1911 eight hundred million herring were caught and brought ashore at Great Yarmouth between the months of September and December. And then around that same time they began to move to different locations in the sea to spawn and their numbers went into decline. 'Write it down!' he said, because he saw I had a notebook in my hand and he watched as I wrote.

After the museum I went to the library where the café served Portuguese black cabbage soup and *empanadas*. Upstairs in the local history section I found a book called *The Herring and the Herring Fishery* by J. W. de Caux. It was published in 1881, the year of John Craske's birth. I was so impressed by the almost biblical passion that went into the description of the appearance and nature of the herring, that I used Mr de Caux's words in this Praise Song:

And if the Fin-Rays
May be classed as Bones,
Then the total number of his Bones
Amounts to four hundred and seventy-eight.
And when he is caught in the MOONLIGHT
Or the early DAWN,
His Belly is of silver,
His Back and Sides are every shade
From light blue to dark green
And his whole Body is iridescent
For Hours after his DEATH.

For it was believed that a mighty army of HERRING
Followed certain of their Number,
Larger than the rest and called KINGS
And these Leaders were held in such respect
That FISHERMEN set them free
When they were found in the Net
Lest the Nation might lose its way
And never return to its Usual Haunts.

For according to the Fishery Commission
In their report of 1879,
One hundred and twenty million HERRING
Are taken every year
By MEN, BIRDS and FISHES,
In the SEAS adjoining the United Kingdom.
For I have seen hundreds of millions of HERRINGS
But I have never yet seen ONE
That measured more than fifteen and a half Inches
In its Length.

Two Worlds
1880s–1920s

and Caben light went out and we was in Darknes
and the snow was so thick we could not see the
length of our Ship which was filling with water.

(LETTER FROM MR FARROW)

In 1887 a new railway line was completed, connecting Sheringham to
the outside world. This meant that almost overnight a small fishing
community that knew everything about the mood of the ocean stretched
out before them but had never bothered to take notice of the activities
in the land that lay behind them was suddenly overrun by a new race
of wealthy, supercilious and enthusiastic strangers.

People declared that the air in this little seaside town was so bracing
it would bring colour to the cheeks of any tired city dweller. The sunshine
surely lasted longer here; the rainfall was minimal, the sea was a brilliant
blue, the nightingales sang through the night from the fragrant bushes
that grew among the sand dunes and during summer weekends there
were four or five trains coming in every day from London's Liverpool
Street Station.

Second-home builders and property developers sniffed the money
that was in the air and made plans. Squire Upcher who lived on the
hill in the more genteel part of the town known as Upper Sheringham
was the owner of almost all the land and almost every house between
his own stately dwelling and the sea. He had the power to decide who
to sell to and how the town was to be tranformed and he was determined
that this new resort was not to cater for what was called the 'rollicking

class'; there would be no rowdiness in the streets, no 'nigger minstrels' or other such shows on the beach; just the dignified enjoyment of quiet and restful recreaton. Under his instruction and his watchful and possessive eye, the sea wall, which had previously covered a length of twenty-nine yards, was now extended a further two hundred and fifty yards, thus providing 'a most pleasant promenade, from which a fine view of the ocean may be obtained', never mind that the fishermen lost much of their access to a safe landing place.

The Sheringham Hotel, built on Upcher land, was ready for occupation by 1889, with one hundred and twenty en-suite bedrooms, a ballroom boasting a 'first-class orchestra' during the main holiday season and a dining room that could seat upward of two thousand guests. And ten years later, the even bigger and more luxurious Grand Court Hotel had erupted like a vast and lugubrious red-brick palace, four storeys high, stone facings surmounted by two lines of dormer windows, twin domes at the corners. It was managed by Squire Upcher's German friends, Mr and Mrs Louis Holzinger, who changed their names to Hollings with the onset of the First World War, although it didn't help them much and they still were forced to leave.

The Grand was built close to the seafront, adjoining the eighteen-hole golf course which had replaced the wide expanse of sand dunes. It could be easily reached by the squire's new road, so there was no need to go through the smelly narrow streets in the old town and it had its own private entrance to a private stretch of the beach, which was approached through an ornate gateway known as Marble Arch. There were rose gardens and tennis courts, putting greens and croquet lawns and sea bathing from the specially designed hotel cabins, which were pulled out beyond the shallows by donkeys, so you could plop into deep water most conveniently and with a minimum of embarrassment. There were electric lights in all the hotel bedrooms and two *ascenseurs* to save

guests the effort of walking up the stairs and no extra charges were
made for baths, or attendance by members of staff, or for the evening
dances and entertainments.

Families would book the same rooms, year after year. They'd arrive
accompanied by their own liveried servants and nannies for the children,
who were put up in separate quarters and were charged special low rates
since they didn't need to dance or drink or listen to music, nor did they
eat so much food. The fathers could easily nip down to work in London
during the week, returning at weekends, while the mothers chattered
and dozed and ate through the days and their children played on the
wide stretch of sand that emerged miraculously from the sea when the
tide was low. There were donkey rides and Punch and Judy shows and
photographers and lines of canvas deckchairs and changing huts and
windbreaks and little tables to hold the sandwiches and the lemonade.

'The women were so bored,' said old Ena of the thirteen children,
who used to deliver gowns and evening dresses to The Grand from the

drapery shop where she worked as a teenager. 'I'd ring the delivery bell and go in with this big box and they'd be waiting for me. They had nothing to do except spend money.'

The fishermen and their families observed the people of the land. For those who had a respectable cottage with such modern conveniences as water and a lavatory, there was the possibility of renting it out during the summer months, while the owners lived in a shed in the garden if there was a garden, or with relatives somewhere close by if there wasn't. The fisherman's wife might even become the extra servant for her city tenants: she could clean her own house for them and cook for them, if they had no cook of their own. The sons of the fishermen might earn a bit of money taking visiting children for rides around the town in goat carts.

But the fishermen themselves did what they had always done and went on fishing for the diminishing fish and shellfish and selling them more and more cheaply because they were competing with the trawlers and their low prices. And because the sea was as treacherous as ever, they went on drowning a few yards from the shore in their upturned boats, and losing their pots and nets and even the boats themselves during the winter storms. They supplemented their meagre incomes by collecting flotsam and jetsam from local wrecks, while their wives helped with mending nets and pots and they knitted the sweaters that told the coded story of a man's family, the living and the dead and the place he belonged to.

The fishermen mostly maintained their distance from the new strangers and spoke all the more loudly in a dialect that sounded like a foreign language. Early in the morning or late in the evening if the weather was right, they slid their boats out to sea from the bit of the beach with a slipway that still seemed to belong to them, and when they came back, caked in salt, their eyes dazed and their fingers cut and

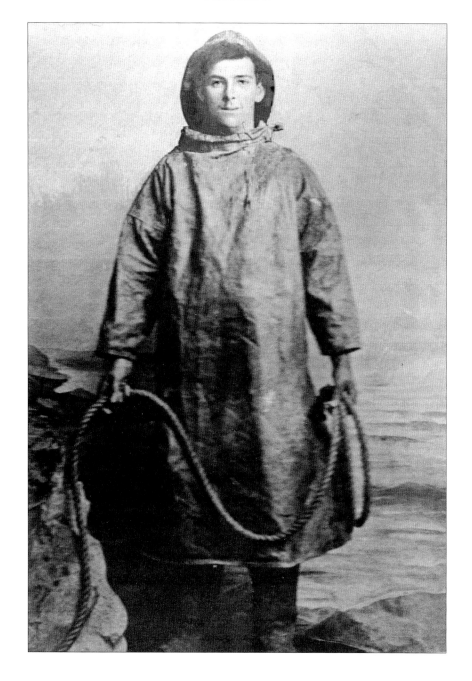

blistered from the lines, their wives were there to welcome them and to help them with the work of collecting the fish or the crabs or the whelks and hanging out nets and piling up baskets and boxes.

Sometimes the tourists might come to watch and take photographs. The fishermen stood where they were told to stand, leaning against a boat, beside a flint cottage, or sitting on a lobster pot, scowling or grinning sheepishly when they were told to smile, and looking as wild as desert nomads or aboriginal tribesmen. Most of them wore the big-brimmed sou'wester hats of their trade although some still had Cossack-style fur caps and they all wore oil frocks or *slops* as they were called and those who could afford them had the leather boots that reached their thighs.

A society photographer called Olive Edis, who lived in Upper Sheringham, made beautiful formal portraits of some of the fishermen. She used natural light in her studio and got them to sit very still until their expressions had settled and they had become themselves. You could buy a set of six of her Sheringham Heads postcards for 7d, published by Mr B. Watts, Stationer.

The one surviving photograph of John Craske as a young man was not done by Olive Edis. It was taken in a traditional studio setting with a painted backdrop of a beach behind him and he is holding a length of rope rather listlessly in both hands and the rope looks very light, so maybe it's just a prop made out of twisted paper. He is wearing an oiled frock and a big sou'wester that drapes down over his head like a loose fold of skin. He is staring towards the camera's eye without apparently seeing it and he appears like some strange sea creature that has been hauled from the water and deposited on the shingle of a beach, innocent and blinking in this unfamiliar element.

Hotel de Paris

by this time the water had got hold of the ship and
my bob was Going down the hold to get two mor
oars for the Boat whn he was going to get he hard
the water Going from one side of the ship to the
other side down the hold so couild not git get them
so we had only 2 oars for the Boat in such a
tereable night and it was aful.

(LETTER FROM MR FARROW)

The Sheringham Hotel and The Grand are no longer standing, so I
decided to spend a few days at the Hotel de Paris in Cromer. Again I
went on my own because the weather was cold and Herman was busy
drawing in the warmth of his studio. I booked a three-night package
deal.

The Hotel de Paris is a red-brick Victorian castle of a building, all
towers and arches and pirouetting details, and it stands to attention right
on the seafront, facing the pier and what was called the German Ocean
in the days when the British royal family were proud of their Hanoverian
connections.

You go up the shallow stone steps, over the black and white mosaic
which spells out its name, through the revolving glass doors and into
the entrance hall. Mahogany staircase to your left; chandeliers above
your head; a tinted photograph of Edward VII wearing a top hat and
going briskly up the same steps, looking very pleased with himself.

When I arrived, I asked Rajeev, who was in charge behind the desk,

if there were any documents about the history of the hotel. I imagined him opening a fireproof metal filing cabinet and lifting out a bundle of fading photographs and press cuttings and an embossed leather visitors' book, the lined and shiny pages filled with self-confident signatures. Comments about the weather from the prince and silence from his lady companion; something funny from Oscar Wilde, his lustrous hair tumbled by the wind; Tennyson saying what a truly great pleasure it has been and filling three lines with the sweep of his name and his lordship; Winston Churchill praising the tea and crumpets served in the dining room, although he was of course staying at Overstrand, a couple of miles down the cost. Perhaps even Albert Einstein couldn't resist signing, after speaking to the journalist who was there waiting to interview him in the bar and before he was taken off to a *secret location* on Roughton Heath.

Rajeev didn't know of any old books or papers, but someone from the office at the back said oh yes, there had been lots of them, boxes of stuff, but the last owner got rid of it all just a few years back. Pity really, when you think of it, he said.

The hotel is part of a chain that caters mostly for busloads of pensioners. They turn up with their wheelchairs and their walking sticks, their hearing aids and their packets of pills and they get big meals and evening entertainments and day trips, all for a very reasonable round price. I felt young in their company.

On the first night my friend Jayne, who lives in Cromer, joined me for a curiously 1950s supper of prawn cocktail in a glass dish, a slice of pink gammon surmounted by a very yellow slice of tinned pineapple and then a sherry trifle with custard. As soon as the clattering of knives and forks and spoons was over and the tables had been cleared and pushed to one side, Norfolk's Only Singing Pig Farmer entertained us

with Songs of the Sixties. He was a dapper man, very polished and scrubbed and wearing a silk waistcoat that fitted as tight as a second skin. He stood close to the synthesiser, holding the microphone as if it were a bunch of flowers and he sang *It's now or never, come hold me tight!* and something by Billy Fury but I can't remember what and lots of others, one after the next in a quick enthusiastic succession, the amplifier on full blast and him clearly putting his heart into the job and smiling as he did so. A scattering of pensioners sat around in drifts, but there was no sign they recognised any of the songs.

Once the singing was over, I went to my room and watched a few minutes of *EastEnders* on the television, but everyone was so angry with each other that I turned it off. The window was misted over by salt spray, making the world outside as dim as my own short-sightedness. After a bit of a struggle I managed to open it and then I could see the German Ocean and the sound of it kept me company through the night.

On that first morning I woke just before 5 a.m. and the little room was flooded with an apricot light and there was the dawn as bright as a pre-Raphaelite painting, spreading up into the sky and across the expanse of the sea in great misty stripes.

I walked along the seafront and watched as three fishing boats approached the shore. One after the other they came in to shallow water and then each boat had its own little tractor for pulling it up onto the beach. One man was working on his own, the others were in pairs. They were all silent. Busy. Tired too, because they must have been out long before I was startled by the colour of the dawn.

Later, I wandered through the streets in the sunshine and stopped at a second-hand bookshop. Tucked under a shelf of books on the pavement, they had two cardboard boxes filled with old *Picture Post* magazines from

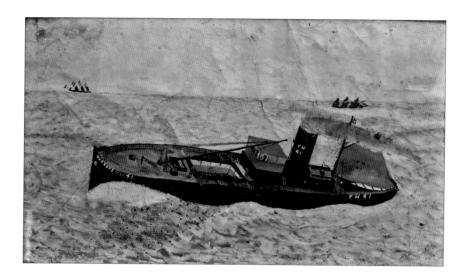

the 1930s and '40s. One pound fifty each, or four for a fiver. I squatted
down and began looking through them, filled with a sense of purpose.

I thought I might find a magazine from August 1943, the month and
the year of John Craske's death; but there was nothing from August,
just July and September. I chose July 15 1939, with a photograph of 'The
New Garbo' on the cover. Inside there was an article on life on a deep-
sea trawler: *It was the steam trawlers that killed the once prosperous inland
fishing industry and the steam trawlers set the little villages crumbling so
prettily and presented the fisherman with far more leisure than he wants
to chat to trippers.* The writer described how the trawler's funnel nets
scooped up everything that moved on the seabed: halibut as big as two
men and cod weighing fifteen stone – which I suppose is the equivalent
of just one man, if he was either tall or fat.

I then took April 1943, because of a portrait of Bomber Harris on
the cover, wearing his Air Force uniform and holding a little duckling
in both hands. The article praised him for the work he was doing,
bombing civilians in German towns, and the photographs showed him

relaxing for a few precious moments in his garden, with his daughter, his wife and the duckling.

I thought I might find something about the Evacuation of Dunkirk: grainy pictures of the men on the beach, the boats waiting, the planes dropping bombs and the strange quietness which is always there in black-and-white photographs, no matter what is happening. You see that quietness in the work Robert Capa did on the D-Day landings, the living men as silent as ghosts and no red blood to disturb the eye. I read somewhere that Capa sent the rolls of film to a technician in America and the man was so excited by the task of developing them that he burnt the negatives and only a few pictures survived. But there was neither D-Day nor Dunkirk in the boxes; someone must have snapped them up.

I took a magazine from November 1940, for the sake of an article written by Rebecca West about Charlie Chaplin in the film *The Great Dictator*, and one dated April 3 1943, which had pictures of pigs being fattened by members of the Fire Service among the ruins of the museum wing of Royal College of Surgeons, *where once the surgeons used to pickle bits of you and me as exhibits.*

I went to visit that museum once years ago. I had an appointment with the man called the Prosector, whose job it was to prepare the corpses to be used by surgeons who needed to understand the exact location of various organs. In the room where he worked at his strange craft, the Prosector showed me the solemn and somehow miraculously beautiful head and shoulders of a dead man, placed on a table like a perfectly crafted statue. The preserving fluid had turned the flesh as grey as stone. Half of the skull had been cut away to reveal the brain, because the dead man had been prepared for someone who wanted to learn how to locate the pituitary – the gland that I think caused so much trouble to John Craske – and I can still in my memory watch as the

Prosector lifted back the layers of grey skin and through the dense convolutions of the brain and there it was in the central area close to the spinal cord: not much bigger than a pea.

The woman in the bookshop had never heard of John Craske, but she thought her aunt might know something about him because she had lived in Sheringham since the 1950s and she worked as a volunteer at the museum. So she kindly phoned her aunt after she had put my four-for-a-fiver copies of *Picture Post* into a plastic bag, but the aunt said she had never heard of him either and that was that.

Mr Hagger's Embrace

MARCH 2013

and as i was turning the ship round so we could get Boat out the ship was filling with water and by the time i had got the ship round before the wind the shp stern was level with the sea and i knew it was only a few minets before the ship wood sink.

(LETTER FROM MR FARROW)

On the day after our 1950s-style supper in the Hotel de Paris, Jayne and I went to the village of Overstrand, where I was hoping to find the son of the poacher who had been one of the men chosen to guard Einstein while he was staying at Roughton Heath. I did find the poacher's son and he was very helpful, but that comes later. What I want to tell now is this story that Jayne told me.

Years ago she was in Suffolk and recently married and she was a painter and her husband was a potter and they had very little money and they lived in a little cottage and Jayne used to ride everywhere on her bicycle. Sometimes she'd stop and chat with Mr Hagger over his garden fence. She liked talking to him. He was in his eighties, very gentle and friendly and humble in his manner. He told her that *hagger* was just the right name for him, it was a medieval word which described people who lived under hedges, people who were the lowest of the low.

He was married once to a younger woman and he used to own a big farm and he was probably happy, but the farm was requisitioned by the Americans in 1943 and they bulldozed it flat and turned it into part

of an airstrip and he got hardly any compensation and his wife left him shortly after.

He went down to London and worked as a wood carver. He carved all the roses around the shop-front windows of the old Harrods building and he showed Jayne his set of walnut planes, beautiful they were, with his name stamped on them in tiny and precise letters. Then he retired and returned to his old village and bought the cottage which had a big orchard at the back and a blacksmith's shop and a smithy attached to it.

One morning Jayne passed by and called for him and when he didn't answer she went inside his cottage and found him lying in bed and very ill with bronchitis. She and her husband got the doctor and, rather than have him taken to hospital, they said they would bring him to their home and take care of him. There wasn't much space, but it could be done.

He stayed with them for six weeks and during that time they went over to his place and put it in some sort of order. He used to cook bacon and eggs on a paraffin stove in the front room and that was his only warm meal of the day. Every month he had a jar of Callard & Bowser mint toffees delivered and he'd eat the lot. He had no lavatory, not even an outside privy, and he would crap on the floor in the corner of the scullery at the back of the house and every so often he would put the excrement into a bucket and carry it out to the marshes. 'But he was very clean, in his way,' said Jayne, in case I might think he wasn't.

Mr Hagger was fond of spiders and the window in the front room where he spent most of his time was covered with a thick mass of spiders' webs. He would sit in an old armchair and stare out through a gap in the webs which the spiders seemed to have left open for his convenience and through that he could watch the birds and see the donkey on the hill.

Jayne and her husband began their work by cleaning away the spiders'

webs, although she thinks now that it was a cruel thing to have done because he was upset when he saw they had gone, although they came back quite quickly. They also painted the walls and cleaned the floors and got him a new bed and a Portaloo and when he was strong enough they brought him home. He was clearly shocked by the changes, but he didn't complain.

By now Mr Hagger had become like a member of their family and he said why didn't they make use of the blacksmith's smithy, they could do it up and live there and wouldn't that be nice. And so they worked on it until it was ready and they could move in. Jayne kept an eye on Mr Hagger and did his shopping and made sure he was all right.

Her mother became ill with lymphoma and when Jayne told Mr Hagger he said at once, 'You must bring her here then!' And so she and her husband turned the old forge at the back of the cottages into simple living accommodation for themselves, and her mother was moved into the more comfortable smithy. Mr Hagger was also not well because the bronchitis kept returning and so they installed a bell next to the beds of both their patients, so as to be able to come to them at any time, in the middle of the night if need be.

Jayne's mother died after only a month of intense nursing, but Mr Hagger tottered on, increasingly frail and bedridden. One morning his bell rang and when Jayne went into his room he was sitting up in bed and making a noise which she recognised as the death rattle. She ran to him and knelt down beside him and he grabbed hold of her in a terrible clinch and wouldn't let go and he died like that, still holding her.

She rang the bell, over and over again, until finally her husband came running and was able to extricate her from the embrace.

They called the doctor and got the death certificate and because Mr Hagger had no relations, it was up to them to arrange the funeral.

Mr Hagger used to enjoy watching the pots being made and he was fascinated with the chemical processes of the glazes; he once said he would like to be cremated when he died and then perhaps the bone ash and the trace minerals could be turned into a nice glaze. It had seemed like a joke, but it had also sounded like a request.

So when the ashes came back, incongruously packed into a plastic Daz bottle with a screwtop lid, Jayne's husband made a clay urn and he prepared a glaze for it out of Mr Hagger's ashes and when the urn emerged from the kiln it had taken on a beautiful clear green colour and they buried it under a tree in the orchard.

'Everything's gone now,' said Jayne. 'The orchard covered a big area and it was sold as a building plot and the cottage and the blacksmith's shop and the smithy were renovated so they look nothing like they had looked when we were all there, although for a while the woman who lived in them grew climbing roses up the walls and never pruned them back until every inch of red brick was completely overwhelmed by roses and that was rather wonderful.'

When I got home from the Hotel de Paris, there was Herman waiting for me with supper ready and he was eager to hear of my adventures. I told him about Mr Hagger and how I would like to put him into this book about John Craske, even though I wasn't sure if the two men could be persuaded to fit side by side.

'You've already got the parrot and the Little Auk,' said Herman, 'so do it – you can always take him out again later.'

The Nature of Truth
MARCH 2013

> so the men got in the boat and they said to them
> have you got anny Baskets or Buys so we could
> put them over to hold the Boat head to the wind.
>
> (LETTER FROM MR FARROW)

While I was in Cromer, I drove a little way down the coast and visited the Sheringham Museum, also known as The Mo, which is built on the site of the old lifeboat house by the beach. They have several lifeboats on show, silent and estranged from their natural habitat of water so that they look as forlorn as wild animals do when they have been shot and stuffed and given glass eyes and pink gums and made to stand to attention on a patch of fibreglass soil.

They also have big blown-up photos of fishermen with distance in their eyes and examples of the clothes they wore and the nets they mended and a collection of wireless sets – *the Graves 'Vulcan' in walnut, for world-wide news and actual voices of the most interesting speakers and personalities*. There's a reconstructed bootmaker's and a chemist's shop filled with tins of tooth powder (*Healthy teeth are a big aid towards keeping fit and ready for any emergency!*) and advertisements for corn plasters and soap and *Camilatone Toneglints Rinse in nine glorious shades*. One wall in the upper part of the museum has a display of original railway posters from the 1900s: happy families and happy seagulls and nodding flowers and dancing clouds, all proclaiming the joys of being by the sea.

The museum owns four John Craske embroideries and his painting

of a boat in a storm, which he did on the lid of a bait box while he was at Wiveton. I don't know how they came to be here; maybe they were a gift from Laura. They are kept in a locked storage room, so you have to know they are there and ask permission to be taken to see them. The storeroom is filled with files and boxes containing the miscellaneous things that local people didn't want to keep, or to throw away.

The pale embroidery of a basket of herring on a cliff above the sea was hung on its side, so I needed to tilt my head to look at it. An embroidery of a lifeboat in a storm, lit up by the beams from a light-house, had an ominous stain on a patch of stitched ocean, as if someone had spilled a cup of tea over it. There was also a small embroidery of white cliffs and little aeroplanes in the sky above and Tony, who was showing me around with a lot of charm and enthusiasm, pointed out the two cannon sitting on the grass of the cliff top like a couple of morose insects. 'Ah!' I said, suddenly knowledgeable. 'The Beeston Bump. Mary told me how they kept the cannon there, until the cliff fell in from the weight of them.'

'That wasn't the Beeston Bump,' said Tony, with more authority than I had. 'It was the chalk cliff to the north, where the golf course is now.' He then went on to explain that John Craske worked as a cook on the trawlers out from Grimsby and that was when he got ill and came home. And so the family moved inland to Dereham and set up a fish shop. He wasn't sure who had told him this.

Downstairs, next to one of the lifeboat carcasses, there was a real canvas beach tent from the 1900s, with a bit of sand in front of it, an elaborate lady's bathing costume hanging from one of the wooden struts, a tin bucket and spade and a plastic crab. The plaque in front of the beach tent explains that

In 1902, John Craske, who was 68, an artist and fisherman
for fifty years, was summonsed to Cromer Magistrate Court for
obstructing the promenade with his boat. Craske's case was
that the promenade and sea wall, tents and bathing machines
were all reducing the space available. Boats were allowed to
be placed on the promenade in winter or in an emergency.
Craske claimed that on the day in question the weather had
been just such an emergency. The case was dismissed. It
illustrates the early tensions between the fishing and holiday
industries. John Craske created remarkable pictures out of
wool. Many were seascapes and fishing scenes. You can see
some of his work in the social history gallery upstairs.

I wonder how a fisherman called John Craske and born in 1844 came
to be combined with the man I begin to think of as my John Craske,
who was born almost forty years later. I suppose I could write a letter
to the museum director, disentangling the two men, but I'm not sure it
matters all that much.

Keith

MARCH 2013

and by this time the ship was sinking very and
they was all but me i stand on the Deck and i
made up my that i wood stand there and Go down
with the ship. (LETTER FROM MR FARROW)

I had recently met Candy Whittome who made a book of interviews
with crab fishermen in Cromer. The book is called *The Last Hunters*
and it was quite an achievement since fishermen tend to keep to
themselves, but she won their confidence and friendship over several
years and they told her about their lives and their thoughts and the
nature of their work and how the world around them was changing so
fast.

I asked Candy if she could introduce me to a philosophic fisherman
in Cromer, someone who could talk about the nature of the sea, someone
who could look at the images made by John Craske and would understand
what it was that he was trying to say.

'Keith,' she said. 'He'll talk if he's in the mood for talking and if he's
not then it's too bad. He has been writing his own stories as well, and
poetry.'

She phoned Keith and he agreed to meet us in the café above the
Cromer Lifeboat Museum. Cups of tea and a view out across the sea.
He came to join us at our table. He has cornflower-blue eyes and a face
criss-crossed with the lines of sun and wind and the same faraway stare
that I keep seeing in the old photographs of fishermen. In his manner,
he was distant and friendly in equal portion, the mood shifting back and

forth without warning; but that was fine by me and I liked the way he spoke and the way he kept silent before speaking.

'Candy tells me you are writing a book. What do you want to know?'

As a way of beginning I showed him a colour photocopy of the Craske embroidery called *Rescue from Breeches Buoy*. He looked at it and said, 'See, he's foundered and he's going to get smashed. That main line there is to get people off with the ring and the buoy is to get 'em out. They'll be all right soon enough. They fired the rope with a cannon – the old arrow system made it hard to aim at the ship, but the cannon could shoot straight. It was a major who thought it up, he must have been sick of seeing seafarers drowning so close to the land.'

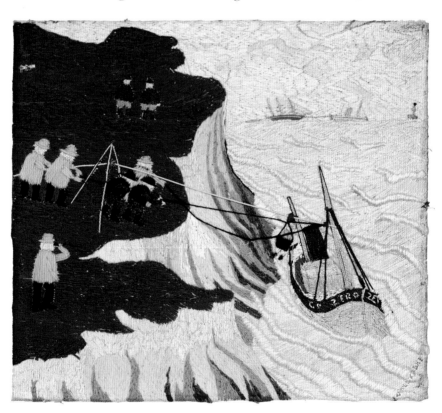

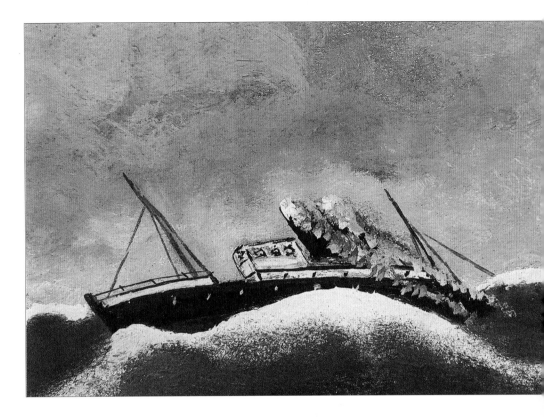

I showed him a another picture, a grey trawler listing among the swelling waves of a grey sea. 'He's been there,' said Keith, with something like tenderness in his voice. 'You can't put that energy out unless you've been there. It's the hardest thing to do, to get a boat right, on the sea, in a painting. A wave is just a piece of energy that passes through a piece of water, but look at it, look how he's got it and he's got the way the elements fuse together. There's no defining line at the horizon. It's low pressure does that.'

I explained the story of John Craske's life and his illness and asked if Keith could understand what it meant to miss the sea; how you might have the need to recreate it in your mind and to find some way of holding

it, holding the images so that they last. 'When I'm away from the sea, I'm always going to sea in my head, little pieces of memory like spider-webs,' said Keith. 'There's something about being out there in nature, it gives you the ability to express yourself. But I think I think too much, always have.'

He spoke of what he called the therapeutic effect of the sea, how it rocks you like a cradle, and when he's whelking in Cromer Knoll after a gale, you get a heavy swell and that's so nice, just steaming through a heavy swell. You miss the movement when you're on land.

Keith said, 'My family come from Ukraine originally. Jewish, but way back. Great-great-grandmother married a Gentile. I lean towards Judaism. My mother has started to tell stories. Uncle was a squadron leader. Another uncle a mathematician. I watched him work.'

His father was a Hungarian doctor who served as a pilot during the Second World War and was based somewhere along the North Norfolk coast and that was how he met Keith's mother who was a Sheringham woman. She bore him a son and he wanted to stay with her but he couldn't find work and she wouldn't leave East Anglia and so he set off on his own to America and there he eventually had another family. Keith has never seen him or attempted to make contact with him; his mother was against the idea. Anyway, what would an American doctor think of an uneducated crab fisherman turning up on his doorstep and trying to explain the connection between them?

Keith remembered when he was four or five years old and he was standing in a field of carrots in the winter and the lord of the manor or whatever he was would come riding up in his plus fours and the men would doff their caps to him and he thought, 'Why do they do that? It ain't right.'

As a boy he was full of questions he wanted to ask the fishermen, but he was afraid to ask them anything because the old men were pretty

brutal, they'd been through the war, they felt the Royal Navy had let them down.

In the sixties, when he was just fourteen, he ran away from school and home and he was out to the Faroes in the winter and that was it and by the time he was sixteen he was off on one of them trawlers, *The Rose*, the one that is now part of the museum at Grimsby Docks. Fourteen days out and a hundred miles from land, deep sea fishing.

They'd come ashore, stinking of old socks and dead fish, and some two hundred of them – the deckies they were called – would get together. You'd wear a forty-pound suit and a silk ruff shirt and a lace tie and bell bottoms and you'd do the town, spend all the money you'd got. Two days of that and then back to the sea and absolute work as soon as the net was in the water. Trawl, trawl, trawl until you run out of provisions. Meat was a grey lump in the fish room and you had to chop bits off it with an axe. Keith said he always had six dabs every morning for breakfast.

We drank tea and he went on talking and I went on writing notes with a pencil in my notebook. Keith spoke of his troubles: a nervous breakdown in 1993 and the end of his first marriage and then his second wife who died of cancer when she was much too young to die and that was not very long ago and his eyes went even more distant with the memory. 'It's a dog eats dog world,' he said. He started writing poems to get out of the despair and when a poem was taking shape the top of his head would get so hot it would burn his arm. He said he saw an oak tree just a few weeks ago and 'that had a poem in it'.

'One of the biggest parts of life is rebuilding your confidence,' Keith said. And then, changing the subject as abruptly as his mood, 'I remember bits of the sea that I fished fifteen or more years ago. There are roads. The surface tells you what the bottom is like. The strength of the tide tells you. You learn the ability to see the land of the sea.

'Every bit of the sea has a name. It's there in your head: Lighthouse

Hole; Hedges Shoot; the Black Hills; the Green Hills; the Roughs at Mundesley because the seabed is so rough there you better make sure you're not on it; Blind Light Hole; the Marls; the Cut – you have to have fished it to have found it: a deep groove in the seabed where there's always an abundance of crabs; Two Skates Nose – we've never seen it but we know what it looks like; Mother Mason's; the Picker – very rough ground there; Harum Scarum and if you can hear the swells break you should be scared; Blind Light Hole and you look up at Happisburgh church and the lighthouse and you line up the summer house and you triangulate it and then you can't see the light and that's the name. It's something about being out there. It's noisy out there; the seagulls, the sea. Being out there, there's no comparison.'

We finished talking and I thanked him, and just before I went I suddenly thought to tell him about John Craske writing *My Life Story of the Sea* and how it had been lost and what a pity that was. I wondered if Keith would write something for me like that, something with that title.

'I'll give it a go,' he said without a pause to think about it and about ten days later I received a text on my mobile. *I have titled your story THE SEA & MY LIVING FROM IT. Hope that's OK. Keith.*

I replied that was fine by me. The next message read, *I have finished the piece. If you text me your address I will copy and send it to you. Keith.* And then, *Have posted paperwork to you hope it's what you want. Keith.*

And this is what he sent me, written longhand and with an accompanying map showing the names of the sea in the area just out from Cromer. I haven't changed anything, although I have made the text a bit shorter and I haven't included the poem at the end, which was called 'The Terrible Maze'.

The Sea and Some of What
I Have Learnt About It

First of all you will never get rich making a living as a fisherman. The environment is cruel on a good day let alone a rough one. The catches can give you massive highs and lows and the adrenalin rush that you get on a rough day is unparalleled to any work on land.

Even as a five-year-old child I loved the sea. I could usually be found playing in the sea or on the beach or hunting for snakes in the sand dunes. After all I came from a long line of seafarers.

I first started learning about the sea when I ran away from home. I am off on the trawlers and I loved it. Off we went

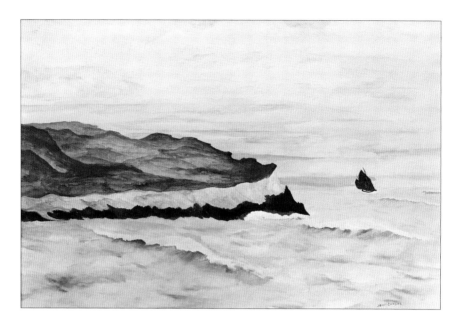

trawling for the Plaice and the trips lasted fourteen days. The trips for cod or Haddock were usually shorter.

As a teenager you are constantly learning. My brain was like a sponge soaking up all knowledge. Learning the points of the compass. Steering the boat. How she worked. How the trawlers were rug. And all the while you worked night and day relentless.

Yet as all this was going on, nature was showing you some of her marvels. Like on a calm sunny day when the water was clear and you could watch the gannets diving down at high speed and catching the small fish escaping from the trawl as you hauled it. Or the shoal of porpoise as they leapt out of the water all in a line so that they looked like a serpent in the distance.

And then the sea itself like glass one day and a raging

monster the next, waves thirty feet high so you crawled all the way to the top where you could see for miles and miles, then racing down into the trough so when you look up all you can see is water all around you.

I think that is where you start to learn your craft as a fisherman, shaped by the work and the environment. You learn to take notice, miss nothing, things like the tiny dot on the horizon that reminds you others are about. You may not have seen another boat for over a week.

Switching from trawling to shell fishing brought me back to the beach. This is where you use your handcraft much more, making pots, darns, repairing nets. Also it's where you hone your seafaring skills, like reading the water's surface so that you can understand what it is telling you.

When you are working from the beach there is so much more to see and you see the land as no landlubber sees it . . . The closeness to nature and the inherent sense of things all about you gives you the tools to survive and make your living from the sea. You learn to make decisions without thinking about the outcome. It's just something you do. The feeling you get when you come home with a good catch and things have gone well all morning, is something I cannot describe. It's like when you look to the East and watch a blood red sun rising up from behind the horizon. It just makes you feel complete. It's as if you are meant to be there.

The Meaning of Words

APRIL 2013

i had hold of the ships rigin and i thort it would
be Better to go like that than to get in bad and all
go down togother. (LETTER FROM MR FARROW)

I was so pleased with Keith's text that I wrote him a letter in a tone
made pompous by my enthusiasm. I wanted to know if he would describe
the nature of various fish and shellfish and could he send me one of
his stories and could he look at the enclosed list of nineteenth-century
seafaring words and expressions collected by Edward FitzGerald, he of
the Omar Khayyam, and a man who had spent a lot of time on boats
and in the company of fishermen along the coast from Great Yarmouth.

Keith replied with a text message that made me feel like a fool: *Hi
I don't think I could write a bit about shellfish and crabs etc it would be
a whole book on its own I know of no local fishermen who has done this,
so at the moment I am not sure what to do. Keith.* But he did send me
one of his stories and he went through the list of seafaring words, marking
the ones that were still in use.

And so now I know that *all sail standing* is when you keep your
clothes on at night, so as to be ready to turn out at a moment's notice
and you did this for fourteen days and nights on the trawlers.

And the surf *barks* and a sailor's apron is *a barn or a berm skin* and
you *better* your nets when you mend them and you *make bold* when you
come close to the shore and the water is in *a brabble* where the currents
cross its surface.

A *brenner* is a squall at sea and the south-westerly winds along the

Norfolk coast *make the swell hollow so they boom on the beach* and *the bore of the tide* is the full force of it and the glinting lights of phosphorescence is called a *burn*. And a *flurry* is the sudden or partial commotion of the sea over a shoal of fish or under gusts of wind and a *frapp* is a bad tangle of rope.

A tide *runs hot*. The sea *huffs up*. The wind turning so as to blow a boat back on her nets *blows against the law*. The short lines supporting the herring net at six-inch intervals are *the norsels*.

The tide is said to have *pinched* when it has left its mark on the sand or shingle. *Proud* means tight or taut, *pull-out* is what the days do when they get longer, a *pup* is an undersized thing, whether a house or a net chamber, and the sea-swell is its *range*.

Fresh herring are put in wooden baskets called *scutcheons*. A *shere man* has a certain share of the profits as Keith had when he worked on a *shere trawler*. *Slake* is the calm on the water's surface when oily fish are swimming below; *the sun wane* and *the moon wane* are the paths of light they make over the sea.

A Story
NOVEMBER 2011

. . . but they all said Come in or the ship will put
us down so i got in with them and it look
imposible for such a small Boa to live in such an
afull night like that. (LETTER FROM MR FARROW)

This is one of Keith's stories. He said he didn't mind if I used it in my
book. He said he'd wanted to write for years and Candy helped him, by
bringing out the talk and the thoughts:

THE OLD MAN AND THE BOY
by Keith Shaul

The old man stood on the prom looking out to sea when the
boy pulled up in his little car.

He looked across as the boy got out and walked over.

The boy, seeing the old man was wearing his oilskins and
his new boat was loaded, asked, 'Are you off to sea?'

They both stood there for a few minutes looking at how
silky the sea was and how the hazy sunshine fixed the horizon
so the sea and sky melted into each other.

Suddenly the old man said to the boy, 'You can come if
you like.'

The boy was astounded. His thoughts raced as he rushed
to get his oilies on. He knew the old man didn't take people
to sea, especially since his wife had died. The old man never

said much about her, but you could see he was still hurting. The boy remembered her too, she was really kind to him when his dad died. Perhaps that was why the old man had time for the boy. They had something in common.

As soon as the boat was ready the old man said, 'Let's go!' He paid one of the others to launch them and they were away.

Once they had cleared the break and were heading the right way, the old man said, 'Right, take the wheel, boy, and follow the coast and keep your eyes open while I get the nets ready and set the boat.'

After about thirty minutes steaming, they were there. The old man said, 'Ease her down, boy, round about a walking pace.'

The old man looked about and said, 'Ease her towards them birds, boy, they are talking to us.'

The boy didn't understand, but he did the old man's bidding.

The old man said, 'Bring her round and steer 300 degrees. That will put us just off the tide, boy. Are you ready?'

'Yes.'

'Right, here we go.'

Out went a marker, then an anchor and then the nets began to fly over the stern. Soon the first net was shot.

The old man took the wheel, saying to the boy, 'We'll head that way, there's a slake on the surface.'

'Righto,' said the boy, frowning.

The old man's eyes smiled, but he said nothing. 'Take the wheel, boy. You know your speed and course. I've got a feeling about these nets. I'm going to double anchor them.'

The boy sort of guessed what he meant.

The old man said, 'Here we go,' and out went the marker, then an anchor. Five seconds later another anchor, then the nets, then two more anchors and a marker.

The old man said, 'Well done, boy. Head for home. You know the way.'

They didn't take long to get back, the little boat flew over the calm sea. The old man took her ashore and backed her onto her carriage.

After they had tidied her down and taken off their oilskins and boots, they stood on the prom. The old man said, 'You can come and help me haul in the morning if you want,' not waiting for an answer as he turned to walk off. 'Don't be late. Launch at 8.30 a.m.'

When the boy arrived at 8.15, the old man stood there, looking at the sea. As the boy approached he said, 'Swell's built up, boy. We'll have to wait. It should drop as the tide flows away.'

The boy was disappointed, but he knew they would go later, the old man would never leave his nets for two days.

True to his word, come midday they got ready and launched. Once they had cleared the breaking swells, the old man told the boy to take the wheel as he prepared the boat for the haul. The boy noticed that no matter what the old man did, it looked so easy and natural. The boy thought, well, after nearly sixty years at sea, if the old man didn't know how it was done, no one would.

Without stopping what he was doing, the old man said, 'Don't mind me, watch your compass!'

In no time they reached the first net. The old man said, 'I'll

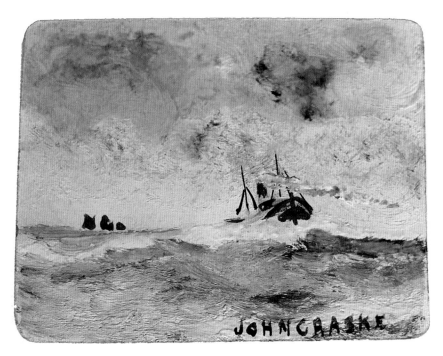

work the throttle and the wheel, plus haul the head rope. You gather the lint, pull the lead line in. All right?'

The boy nodded, not quite sure, but keen to start the haul.

The old man eased the boat into the first marker buoy. The boy grabbed it and started to pull the rope in. It soon came tight on the anchor and as he strained to break it free of the seabed, the old man reached over and with apparent ease broke the anchor free. He calmly handed the boy the rope, which he hauled up to the anchor.

The old man untied it and said, 'Hang it on the rail, boy.'

Then they started hauling on board, the net flashing silver. The bass began to roll in. The boy felt the excitement begin to build, he had never seen anything like this.

The old man's face never changed. He just kept working

the throttle, turning the wheel one way, then another, and hauling the lead rope. Before long they had hauled the first net in.

The old man said, 'Not bad for a start, boy. Let's pull this net into a bin. There are too many fish to take out of the nets here.'

Then off they went to haul the second net. The boy grabbed the marker and hauled up the anchor. This time it broke free with ease. Hauling it in, the boy untied it and hung it on the rail.

As soon as the net started to come aboard, so did the fish: thump, plump, they rolled in. The boy couldn't believe his eyes. The smile on his face was as bright as the sun breaking through on a cloudy day. Soon there were so many fish it was hard for the boy to stand up. The old man warned him, 'Mind your feet, boy, don't stand on them fish and hurt 'em.'

They both stopped and stood up. The old man rubbed the small of his back. The boy flexed his shoulders; his back was hurting and his hands were cramping.

The old man said, 'Right?'

The boy nodded and they started to haul again. Soon they came to the finish of the net. All the while that they were hauling, the swell had built up.

The old man looked around and said to the boy, 'Take her home as hard as she'll go.'

The journey back took longer, the little boat was full of fish and the weight slowed her down. As they neared home, the old man took over. They had to pass a shoal just before they turned to the beach and the waves could be unpredictable there.

The boy said, 'Look at them swells!' He had never been this close to swells like these at sea.

The old man spun the wheel and opened the throttle as far as it would go. The little boat sprang into life and raced to the beach. With a thump they were high and dry.

The old man had already turned the engine off. He smiled to himself. He knew it was a good little boat.

After they had unloaded and driven up to the promenade wall, the old man said, 'Cup of tea and then the real work begins.'

As soon as they had drunk their tea, the old man said, 'Right, let's get on.' He handed the boy a disgorger made from a table fork. 'I'll show you how to get the fish out of the nets, boy. You need a glove on your hand to hold the fish with them spines, bass are sharp.'

They climbed into the little boat, making sure not to stand on any fish. The old man sat on one gunnel and said to the boy, 'Watch as I take a few out and then you have a go, all right?' The boy nodded.

The old man picked up a fish with his gloved hand and slid the two-pronged fork under the mesh of the net and around the head and with a twist of his fork the fish was free. After three or four fish he said to the boy, 'Right have a go.'

The boy picked up a fish. He yelped as the sharp spines pierced his glove and his hand. The old man laughed. It was a lovely deep laugh which the boy had never heard before.

As he got the hang of it he looked up to see that the holidaymakers were gathering on the prom, staring down at all the fish in the boat. It was not long before one or two began

to walk on the beach and to stand peering over the gunnel. The questions began to flow. How long to catch all these fish? Is that a normal catch? What fish are they? The old man ignored them without appearing to be rude, he just left it to the boy.

Out came the cameras. The old man kept his head down as he took fish after fish from the nets. The boy's answers ranged from, 'They're wild bass' to 'I don't know, it's the first time I've been'. He wasn't sure, but he looked up once or twice and thought the old man's steel-blue eyes were laughing at him. Slowly the fish in the nets went down and more and more boxes filled up.

The boy stood up. His back ached and his hands were sore. 'Right,' said the old man. 'Let's load the fish onto my van to keep 'em cool.' This they soon did. The old man got out his phone and rang a number. He said things like 'yep', 'right', 'OK', 'hour and a half', 'bye'.

'That's good, boy, that's them sold.'

'What?' said the boy. Who on earth did the old man know who would buy that amount of fish without seeing them? The old man looked at the boy, grunted and said, 'Right, let's clean her down and get her shipshape.' In twenty minutes she was clean and tidy and ready to be used again.

After removing their oilskins and boots, they stood on the prom. The old man turned to the boy. 'You did well,' he said. The boy knew this was high praise indeed.

He turned to the old man and said, 'Can I ask a couple of questions?'

'Yep.'

'What did you mean about the birds talking to us?'

'Well,' said the old man, 'they were diving into the sea to

catch the sprats that the bass were chasing up and that's how I knew there was fish there.'

'And what is slake?'

'A slake is when there are so many fish that the oil off of them can be seen on the surface. Make sense, boy?' The boy nodded.

The old man's eyes crinkled as he looked out to sea. 'I am going drifting tomorrow if you want to come,' he said and he turned away to walk to his van.

'Yes, yes!' said the boy, punching the air. He knew he had arrived. The old man never took anybody twice.

If he could have seen the old man's face as he walked to his van, he would have seen that he was smiling and thinking, 'At last, someone worth teaching.'

Three Brothers
1918–1919

this is how we ware till one or two oclock in the
morning i mught say that it was wonderfull how
the lord took care of us that that small Boat did
not take in ten Buckets of water all that night.

(LETTER FROM MR FARROW)

When John Craske was discharged from the Mental Asylum Wing of
the Norfolk War Hospital on October 17 1918, the doctors who had been
in charge of him filled out the relevant medical forms. He was diagnosed
as being an imbecile, with no mention of the possible cause of his
condition. His discharge papers said:

Question 21: Give diagnosis and particulars of:-
(a) Any disability claimed or discovered: Mental stupors
*(b) The present condition thereof: Patient is unable to make
 intelligent or thoughtful replies – has no concentration and
 no memory.*

Laura collected him and brought him home to 41 Norwich Road, East
Dereham, where her mother still lived in the same street as several
members of the Craske family.

Her idea was to keep him there and nurse him back to some sort
of health, but his brother Robert, one of the two who was still a working
fisherman, had written to him while he was in the last hospital saying
he could come with them to Grimsby and they'd go out fishing together
just like when they were young and that would surely make him better.

Perhaps John felt his brother was right: the sea was what he needed; or perhaps he kept silent and they made all the decisions for him.

Robert and the other brother Ted came to collect him. Laura went with them to Grimsby, the four of them travelling by train so they could help each other to shoulder the loose weight of a sick man who couldn't always remember his own name or where he came from, or who these people were who kept grabbing hold of him and asking him questions. Maybe the noisy train compartment made him think he was still trapped in a sort of cot with rattling bars on its sides; among the company of grown men who cried like children and made loud frightened noises, while women in white uniforms banged metal buckets and mops and moved squeaking beds and wheelchairs across the linoleum floor.

They went from the railway station to the area where the rows of new red-brick houses had multiplied since he was last here and the docks of stone and steel were growing and spreading. The red-brick Ice Factory could have reminded him of the Grand Hotel in Sheringham, it had something of the same grandeur, the steam of its strange industry billowed from tall chimneys.

When Herman and I went to Grimsby we saw the shattered remains of a past time: the Ice Factory without a roof, the red-brick walls like cardboard cut-outs; the docks broken and abandoned and everywhere the modern confusion of concrete parking lots and fenced-off areas and drifting rubbish and a sense of a lost civilisation. However, the museum did have a real trawler – the one that Keith Shaul had worked on – and it was tethered against the dockside and you could buy a ticket and go on board. The young man who showed us around said that his grandfather had been a trawlerman on this boat and had told him everything about how the ship worked: the stink and the noise of it. Five hundred yards of weighted net swung out on a boom and dropped down and pulled along the seabed, scooping up everything that had its home there.

And then it was hauled back up, heaving and struggling with life and death, and the contents were emptied onto the deckmen, covered in blood and knee-deep in fish, working with sharp knives gutting them and hurling the broken bodies down the chute where they were packed in careful lines among the chunks of ice in the ship's hold.

Grimsby trawlers were converted into minesweepers during the war, but when John Craske was there some of them were back at work in the fishing grounds, although many more had been blown up and sunk, all hands on board. The fishermen who had survived were angry and bitter at how they had been treated, just like the ones who Keith knew, who felt they had been betrayed by the Royal Navy after the second war.

The Craske brothers were not trawlermen; they were used to going crabbing and longshore cod fishing in a little crab boat, setting off before the dawn, and sometimes they'd go out in their uncle's cod smack with a crew of six men on board and provisions to last for a week or more.

So now they went down to the quay and Laura tried to say goodbye to her husband before he was lifted and steered onto the boat and settled somewhere in a corner. Then they were gone, leaving the land behind them and off towards Spurn Head. They must have tried to get John to take part in the work that should have been in his blood, as automatic as breathing. Cajoling, threatening, growing angry, growing quiet, anything to persuade him to return to the person he once had been.

From what Laura said, you get the sense that her husband lay in a dream on the boat; out on the deck in the sunshine, down in the little cabin at night and when the weather was bad; curled up like a half-dead thing, so that his own dizziness and confusion of mind was one and the same with the lurching of the sea, the roar of the wind, the voices of his brothers and the scuttling of the rats. Maybe sometimes he was

aware of the sea, or maybe he was in the trenches being brave, fighting for his country while the guns of the enemy roared around his head.

And still the two brothers must have thought they were doing their best for him. They talked to him even when he didn't seem to hear a word they said, and they fed him on cups of tea and sea biscuits and water pancakes and fried herring and wrapped him up in oilskins and put a sail over him to keep the worst of the weather off him in the daytime and lashed him to the mast when the sea was rough so he didn't tip over the side and disappear. And even when what little weight there was on his body began to fall away, they still felt sure that this was for the best.

And so he slept and dreamt and rolled about in the hold and on the deck alongside boxes and kettles and piles of coiled rope, the smell of fish inhabiting his clothes, and his skin and his hands and face raw from the wind and the rest of him damp and chill.

Three months passed. *He did what he could,* said Laura when she wrote about this time. *One day it was quite rough, after which – I don't know how to explain it. He knew it was not his home. He knew he wanted to come home.* And so the brothers brought him back to the docks and let his wife know that she must come and fetch him.

Laura took her husband home a second time. He was still very sick and could not work at anything. As she put it, he had *no mind for business.* He toppled over when he tried to stand and sometimes his words slurred in his mouth and so he went silent.

Laura thought afterwards that the experience with his brothers *might have affected him in his weakness*: perhaps they had been too rough with him, too angry at his helplessness, and that had made him worse than he ever was or would have been. But there was no way of knowing for sure. He had been sick before and he remained sick.

Saved by the Sea

1919

the last time i swar the old ship i see a part of the
mainsail and a small Jib on Bowsprit up in the are
the ship sank down sern fust and then we was left
alone. (Letter from Mr Farrow)

By the end of 1919 there they were together again as man and wife, John
and Laura. They had nothing in the way of money and needed to earn
a living and so they turned to the only thing they knew and started
making enquiries about premises for a fish shop.

In her pages, Laura wrote that John asked her if he might *be allowed*
to go out on his own to look for a suitable place, which must show how
helpless he had been and how dependent he still was, even though he
was feeling a bit better and apparently able to walk unaided. It was John
who discovered that number 15 Norwich Street was empty. It belonged
to Mr Clutter the draper and Mr Clutter said they could take it if they
wished. Laura said she felt God was watching over them, giving them
the chance in His infinite mercy to set up a wet, dry and smoked fish
shop.

She did most of the work, but they ran the shop together and
everything went well enough, but another of the brothers, the one who
had been a machine-gunner in the war, was suffering from shell shock
and that was distressing, to see him in such a state. And his father
Edward was not well either, overwhelmed by headaches and dizzy fits
of which no one knew the cause.

Edward Craske died in his sleep in April 1920. John's sister came

rushing in and told him what had happened, without breaking the news carefully enough and as a result *John just Crumbled up*. He continued to do what he could, wrote Laura, but after several weeks they had to admit defeat. *He was indeed ill in mind and body*.

The local doctor, John Duigan, examined him and said, *Well, the old trouble is back and God knows when it will go*. He had no way of making a clear diagnosis of the old trouble, or of suggesting how it might be cured, but he said, *He must go to the sea, only the sea will save him*. He probably wasn't quite sure what he meant by this; just that here was a man who needed to have his mind taken off the things that worried him and since the sea was in his blood, the sea might do the trick.

Laura agreed. There is the impression that she wanted to get away from the family; all of them saying that John was lazy, he was simple in the head, he had never been good for anything. She also wanted to remove him from the closeness of too many thoughts of his dead father who also had similar waves of panic sweeping through him and from his brothers, the one with shell shock weeping all the time and the other who teased and challenged him and seemed to want to steal from him whatever few possessions he owned.

The doctor suggested that the village of Blakeney on the estuary might be a good place to try and so that is where they went. Laura rented a tiny cottage and John's mother came with them to help them settle in, while his brothers visited from time to time.

At first John did not improve. Laura said, *He passed through the same thing many times – very quiet. Sudden turns. Must get outside.*

She must have been at her wits' end, trying to keep up with the restlessness, the confusion, the sliding in and out of stupor. She consulted another doctor at Blakeney and he came to the cottage and examined John and also had no words for the patient's condition, but he did say the cottage they were in was too small and dark; this man needed a

view from the bed where he lay for so much of the time. Laura tried her best and after a few months' delay and a brief return to East Dereham, she managed to borrow the money from her family to buy a cottage just a little way inland, in the village of Wiveton. It was bigger than the other one and it had daylight coming into the rooms.

By now she had a wheelchair for him and as long as it was not raining, she'd wrap him up with rugs to keep him warm and set off early in the morning, pushing him with her strong arms along the back roads as far as the beach at Cley.

They'd take food with them and sit in the sun in a sheltered spot protected by the broken sandbank. If the weather was not suitable for the beach they'd go along the coast road, through Salthouse to the bridge. *John had his chair and I walking. It was a long way from Wiveton.*

Step by step he began to get better. *I used to notice the improvement in him daily. How he enjoyed the coast line, seeing the wild fowl, and I was most happy just to see him taking an interest in things again. Sunsets were a great delight to him.*

Drift

1921–1922

but God had taken care of us in such a dreadful
night and then when it come light in the morning
we swar a larg ship abark from Norway and when
he swar us he Came towards is.

<div align="right">(LETTER FROM MR FARROW)</div>

The kind doctor said only the sea might save him. So that is where they
had come. To the sea. To be saved.

It was many years since he had lived close to the sea, but he could
not remember how many. No strength in his body and no strength in
his mind either. Thoughts drifting without a wind to pull them back to
the shore.

He slept a lot and the illness filled him with dreams. Boats mostly.
He dreamt of all sorts of boats in all sorts of weathers and often his
sleeping felt more real than his waking.

They began in Blakeney; where the fishermen had to wait for
the tide to carry them along the meanderings of the estuary before
they could get into open waters. It's a dangerous stretch of coast
because of the hidden sandbanks and the riptides that could pull a
boat sideways and out at a speed of ten knots or more and then there
was nothing to be done except go with it and hope. But that's why there
was always good fishing here, fish like the mixture of troughs and
shallows.

They arrived in a fish cart pulled by a donkey and driven by his
brother Bob. Mother came with them and stayed for a while. Sometimes

his other brothers came visiting as well, but they only made him nervous, no matter how friendly they pretended to be.

They had a wheelchair with them, lent by the kind doctor, and they had Laura's sewing machine because she hoped to make a few pennies doing repairs. A roll of bedding, a knife, a kettle, you didn't need much to get by.

That Blakeney cottage was called Pightle, a Norfolk word meaning small, as in the runt of a litter of pigs or dogs, and it was very small with just two rooms and the windows so low you only saw the wheels of carts and people's feet going past. Right from the start he didn't like it.

They were at Pightle for few months, or it might have been a few weeks. It doesn't matter. They were there until it became difficult and then they left and went back to Dereham, but that only meant trouble: Laura said he was not respected by the family, not treated right, and his brothers took things that belonged to him. It was true, they did not

understand the illness, how tired it made him, the struggle to keep going from one day to the next. To keep awake.

The cottage Laura bought in Wiveton was unfurnished: bare walls, no curtains, but Laura got their furniture brought over from Dereham in a cart even though she didn't believe it would really come. So then they had a table and two chairs and a bait box and a metal bed frame with a lumpy mattress smelling of mice.

Whenever he had the energy to stand, he wanted to go outside, to be closer to the sea, to the sky, to a sense of being alive. Even when he couldn't stand up without her supporting him, holding him by the elbows, he still wanted to go.

'Must go outside,' he'd say to Laura and she'd get the wheelchair ready.

He liked to be outside when the rising sun marked a many-coloured road of light across the sea. Such unexpected colours: bronze and the

softest pinks and yellows. The sun wane. Laura standing beside him, waiting until he was ready to return to the cottage.

One day he said to Laura, 'I need to be out there, on the water.'

'I have a cousin with a ship's boat he don't use,' she said and because she was always quick to do anything to please him, she went at once to see her cousin and arranged to borrow it.

The cousin said she could use the boat and welcome and he gave her a bit of cloth for a sail and she carried it home with her. She must have put it in the wheelchair to bring it back because a sail is a heavy thing.

They laid the cloth out on the table and he cut it to size with her scissors and she stitched it with the sewing machine.

When it was ready she pushed him in the wheelchair down to the quay where the little boat was moored. He carried the extra weight of the sail on his lap. They fitted it to the mast and he made an anchor of sorts with a hag stone and a hook tied to the end of a length of rope. They knew they would be safe as long as they stayed within the quiet of the estuary.

They took off their shoes and stepped into the soft mud on bare feet. Together they pulled and pushed the little boat into the water.

'You first,' said Laura and he clambered in and sat on the bench where he was close to the sail. Laura took her position in the aft, holding the rudder. *I always did the rudder*, she said later, when she remembered these times.

He did the sails, working with the wind if there was a wind and with nothing at all if they were simply letting themselves go with the pull of the tide. There's a photo of John with his nephew in a little sailing boat. It was a calm day in the photograph, so still that the figures are reflected perfectly on the water's mirrored surface, the real together with the upside down.

They would set out when the tide was high and they would drift with its ebb as slow as anything. They might collect cockles from the banks and they always took a fishing line and sometimes caught a dab or two, the lopsided bulging eyes staring at him as he took them off the hook. The fishermen gave them lugworms or sand eels as bait and if they'd had a good night's work, they gave them herring or mackerel too.

When the weather was rough and cold, they had to stay indoors. Laura was kept busy cooking and sewing and she gave him things to do, because she said she didn't want him to become listless. She gave him a knife so he could carve little boats out of lumps of driftwood and then she gave him old tins of distemper and gloss paint so he could salvage scraps of colour from them, because there was no money to buy anything new. Laura had the idea of getting old gramophone needles that were nice and sharp and strong and he used them as nails.

He made pretty toy boats that would float and bob in the water like

ducks and he painted them in whatever colours he had: black, blue and white mostly and sometimes a bit of red. Laura put the boats on the window ledge that looked out into the street and he wrote a *For Sale* sign on a piece of card, in stiff capital letters. Sometimes strangers knocked on the door and said they would like to buy one for a child.

But still, when he had to remain in the house without the sun and the wind on him, the old fears returned and he knew he was in danger of drifting and he saw Laura watching him, keeping an eye on him, hoping for the best. He tried to stay calm and wide awake, for her sake as much as for his own.

On a few occasions he couldn't keep awake and he felt himself falling down and through into some sort of deep trough and then he would lie there like an eel, his skin damp from the fever. And then when he returned to the surface he told Laura everything he remembered about his dreams and the things he has seen in them.

Out with the Ebb
In with the Flow
JANUARY 2013

and we got about all save and all right and Capten
was ever so kind to us all he said to this that was
the Roughtes night i have ever see since i have
been to sea in all my life and now you must have
some Brandy. (LETTER FROM MR FARROW)

I went with Serena, whom I've known for almost more years than I can
count, down to the mouth of the Blyth estuary, to go out in her Dutch
boat *Gelderloos*, which translates as *fancy free* or perhaps free of money
is more accurate. The boat is not more than nine feet long and it's made
out of fibreglass and painted white and blue and if you forget the relativity
of size, it looks as if a child might float it in the bath.

It was a bright day, with layers of clouds building and shifting across
the spaces of the sky, some of them stretched out as thin as a mist,
others as thick and dense as flesh with their own bruised colours.

There we were, two ladies of a certain age, dressed in jumpers and
jackets, scarves and hats, laughing at our own absurdities as ladies of a
certain age often do. We laughed as we struggled to pull and push the
little boat in its wheeled frame down to the edge of the water, and then
laughed some more as we tried to get it to float, Serena going first and
me following and discovering that my boots were too short when the
icy water poured over the tops of them and sloshed around my feet.

Serena fixed the outboard motor in place and I clambered in and
sat on the one bench and helped a bit by pushing the boat away from

the side of the little jetty until we were deep enough and then she clambered in and managed to get the engine started, but although it made a lot of noise which settled down into a steady mechanical heart-beat, the propeller was not turning and so she turned the thing off and used the oars instead.

Serena was full of talk about her father who was a boat man and the two of them would go out together, just like this. Two military helicopters flew overhead at odd angles and very close, as if they were planning to take aim at us with their machine guns and that also made her think of her father who was something in the war, before he became a Captain of Industry in peacetime.

We passed under a low Bailey bridge and were level with a brick-built water pump with its wind sails gone long ago and here the land on either side changed and became silent and abandoned. There was nothing but the lapping of water against the glistening mud of the banks which looked like Christmas cake, or something else sweet and edible.

Precarious ridges of mud stood out in the estuary, as thin as footpaths but leading nowhere and seeming to be about to melt back into the water. Marsh plants clung to the diminishing safety of these little islands, the tracery of their roots exposed by the effort of holding on.

The sky above us grew bigger in the silence and clouds were piling up and spilling over each other, coloured by the sinking sun in layers of grey-pink, grey-purple and grey-yellow. One cloud was delineated with a bright silver line, as if it was just failing to cover the glimmering surface of a vast mirror.

After an hour or so the upward flood of the tide held its breath for an elongated moment and then it had changed direction and we were being pulled back the way we had come, down towards the meeting of river with sea and now there was no need for oars, except to stop us from banging into the mud banks when we got too close.

I listened to the lapping of water against the boat and watched the enormity of the sky and the clouds moving within it and I felt the dancing energy of the pulling water, as it tried to teach me to let go. A heron with heavy dishcloth wings lifted its body up into the air and dropped back again to land at the same place it had left.

Einstein understood about drifting. He believed in letting the thoughts think themselves without the impediment of words to tie them down and limit their meaning. He said the best place for this kind of thinking was when he was alone on a little sailing boat on a calm lake and he could stay there for hours on end, with a sense of being at one remove from the physical world and the lapping of the water was as close and reassuring as his own breathing. He kept a sailing boat on the lake at Caputh not so far from Berlin, where he had his wooden summer house, before everything changed with the approach of war. He called the boat *Drunken Lizzy*, because she was so unstable. He'd pull out a little way from the shore and he liked it best when the air was still and the land was close and yet he was helplessly becalmed and nothing to be done until the wind picked up and nudged him back towards the shore.

Later, when he was living in America, he had a different boat, equally small and unserious. *Sailing in the secluded coves of the coast here is more than relaxing. I have a compass that shines in the dark, like a serious seafarer. But I am not so talented in this art and am satisfied if I can manage to get myself off the sandbanks on which I become lodged.*

The Watch House

> the men had Branday but i said to him i will have
> some coffee so i had Coffee and so now i must
> Colose with saying God Bliss you all from Mr and
> Mrs Farrow. (LETTER FROM MR FARROW)

I had been talking with my friend John about John Craske and Laura, going out with the ebb and in with the flow on the Blakeney estuary, and he said we should go and stay at the Watch House, because that was the best way of getting to know the estuary and the spit of sand where the seals came to rest. He gave me the phone number of the woman from the garage who had the key and arranged the bookings and even though it was very short notice she had a space available for three nights towards the end of September.

The Watch House was built in the 1880s and can hardly have changed much since then. It sits like a nesting seabird on a patch of solid ground among the mudflats and marshes, the soft sands and noisy shingle that have taken shape around the estuary of the River Blakeney on the North Norfolk coast.

You can look back at the line of the coast from the Watch House, but you are always separated from the land by the last slow gasp of the silted river which fills the estuary to its brim when the tide is high and empties into a glistening basin of mud criss-crossed with little rivulets, when it's low. This means you can only reach here in a boat at the peak of the tide, or on foot if you chose to walk for an hour or more along the beach from the village of Cley.

It's a small, neglected, but still rather official-looking red-brick building. It has no running water, but there are rain butts for collecting rain from the roof and as long as they are full you can use that for washing dishes and yourself, but you need sea water for flushing the outside lavatory unless it is raining all the time. There's no electricity either, so you need torches and lamps and candles. The four tiny bedrooms hold eight rickety metal camp beds between them, but you have to bring your own sleeping bags and pillows and extra blankets and that's along with a collection of five-litre bottles of drinking water and food and fuel if you want to light a fire at night, although you can

probably find driftwood and smooth lumps of sea coal among the sand dunes.

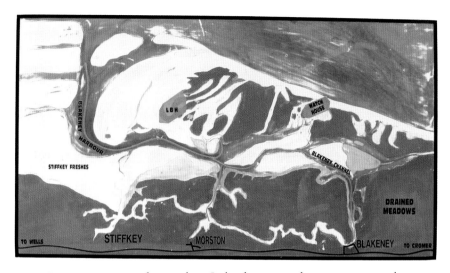

Herman came with me, but I think it was this experience that put him off the North Norfolk coast when a cold wind is blowing. He was one month short of seventy-five, and although his mind was as strong and witty as ever, there was a growing fragility about him, which we would both ignore and then remember suddenly. John had agreed to come with us as a sort of Virgilian guide and, looking back now, I realise his presence was important, in case there was an accident of any kind.

The weather had been beautiful throughout August and into the beginning of September, the sky stiffly blue and the air dry and hot, but on the day of our departure the clouds were moving in and there was a sense of the end of summer and the start of an uneasy autumn.

John had borrowed a boat from his friend Huck, the one who looks as though he might have locusts and honey in his pockets and prophecies spinning in his head. It was a simple and nameless blue and white sailing boat that had lost its mast and gained an outboard motor. It had a plastic bottle attached to the rope that held the anchor so you'd know where it was when it was in use and a plastic bottle cut in half for bailing out, if that proved necessary.

The first and last time I was ever on a boat of this sort was forty years ago almost to the day. I was living in Holland and me and Herman and two friends were supposed to be sailing an old skiff – a rare example of its kind – across the inland lake of the Ijsselmeer, so it could be handed over to an eager maritime museum. It was cold and we were all dressed in heavy coats and woollen hats and big boots. Things began well enough, but the Ijsselmeer is notoriously fickle and a violent wind picked up out of nowhere, making the boat lurch about on the waves, and within minutes the mast, which had not been properly fastened, crashed down across the deck like a felled tree, just inches from where I was sitting. The tip of the mast landed on the rudder, so the boat was going in circles, while the impact of the fall 'caulked the clinkers', causing the tar that sealed the overlapping wooden planks to burst out and allowing water to seep in on all sides.

I could see the land and the houses built comfortably upon it and I could even see the large shape of the museum we were heading for, as well as cars and bicycles making their way along a road; but all that meant nothing because we were unable to move forward and in danger of sinking and we had no life jackets. I knew I'd been spared from sudden death when the mast fell but I also knew I might be heading for a slow death: a feeble swimmer weighed down by her boots and her well-buttoned fur coat.

Someone managed to get the rudder free while the rest of us bailed, using the empty tin cans that emerged miraculously from under the benches like a flotilla of toy ships once the water level inside the boat was high enough. Eventually we reached our destination and tied the boat to a metal ring on the quayside and went to tell the museum that we had arrived, but when we got back, the whole thing had sunk and there was just one submerged flank still visible, along with the ropes that held it in place.

Now, I stepped into the cold water and soft mud of the Blakeney estuary and clambered awkwardly into Huck's boat. I sat obediently where I was told to sit and Herman sat next to me and John sat next to the engine, which had spluttered into life. We were very heavily laden with bags and boxes and rucksacks and plastic bottles, but we began to move slowly forward. The clouds raced overhead, turning the world bright and dim and bright again.

Everything went well for the first forty minutes or so until we were close to the bank on the other side of the estuary and approaching the creek where we were supposed to land, but then because it was a very low high tide, we ran aground in the soft mud and the engine stopped making reassuring chugging noises. John plopped out over the side and with the water above his knees, he began to lead the boat forward as if it were a recalcitrant horse.

He suggested we might get out and help and so we plopped over as well. The mud was as slippery as the first ooze from which Adam was perhaps made and Herman almost toppled sideways and the two of us clearly had no useful function and so we tottered ashore, while John brought the boat in. We unloaded bag after bag and box after box of what seemed like essential supplies and walked up a narrow path between dense clumps of marsh vegetation. The bleached skeletons of little crabs clinging to the tops of the bushes gave an indication of how high a really high tide can be.

And there was the Watch House, tatty and defiant. The key was hidden under a brick where I had been told it would be and we went inside and made our choice of which rooms to sleep in and tested out the rickety beds which looked as though they might be survivors from the last war and peered into the cupboards and lit a fire. There was a gas stove, but no sink, just plastic buckets and bowls that needed to be taken outside. We made tea and cooked eggs, beans and bacon in a

wobbly frying pan. I went up a metal ladder to the look-out room from which you could see such a huge expanse of grey ocean that it was like being upon it, but without the movement of waves.

Later I walked over the shingle ridge separating the house from the sea and down to the strip of sand that was emerging as the tide dropped back. I found two blood-red cornelians that must have made a long slow journey from much further north to get here and a little grey stone with a patch of yellow on it, in the shape of a perfect heart. As I looked towards the water's edge, a seal emerged and stared at me with big brown eyes and then it raised its narrow, sloping and curiously feminine shoulders out of the water and leant right back to stare up at the sky as if it had just become aware of the existence of this other element. It tipped forward to look at me again and in the next moment it had gone.

We all slept well in spite of the rattling window frames and the precarious beds, but by the morning it had turned even colder and the sky over the land was ink-dark and heavy with rain, although out to sea it was clear and blue and a line of sociable fat white clouds drifted above the horizon. Herman and I set off towards the far tip of Blakeney Point. The wind hurled a top layer of dust-fine pale sand towards us in strangely looping patterns: figures of eight, swirls and curlicues. The relentless noise took away all thought, leaving my head empty of anything except the fact of walking.

In the dazzle of distance we could see a scattering of dark shapes that looked like boulders and we wondered vaguely if this was some sort of abandoned coastal defence, but as we got nearer the boulders became seals, hundreds and hundreds of them. They were heaped up on a sandbank just on the other side of a channel of water, and most of them were lolling about and doing nothing, but some were raising up their heads and tails in a sort of stretching exercise that turned them into ungainly croissant shapes, and others were doing rippling seal lollops

along the sand. Every so often a seal slipped into the water, where it was transformed into pure, fluid energy.

We sat and gazed at them and then set off for the Watch House, the wind at our backs bowling us along. It rained in the night and the hammering on the roof combined with the whistling and rattling of the wind was like a lullaby.

In the morning Herman said he wanted to stay indoors, reading and feeding the fire, while I decided to return to the seals. The tide was still high and so I walked across the dunes which rolled around me like the waves of a long-ago sea. A huge muscular hare sprang to life just in front of me and disappeared across the land in wide zigzagging arcs.

As I came out of the dunes and onto the rippled surface of the beach I heard a high-pitched, many toned, dog-howling song carried on the wind. At first I couldn't imagine what it was and then I realised it was the seals singing in a great chorus of longing and strangeness. I reached the edge of the channel that separated us and I sat and watched them with binoculars for an hour or more. I could see their mouths opening in song.

The wind and the rain was even stronger on the next night and we spent much of the day packing our absurd collection of basic necessities and taking them down to where the boat was tethered on the mud. High tide was due at six in the evening and we were ready to set out as the first tremors of darkness were moving in. Once again the boat floundered in the mud, but like heroic Venetian gondoliers we pushed it forward, until we were crossing the estuary with little waves blowing their crests into our faces. When we were back safely on the other side, Herman announced that this was the last time he would ever go camping. 'I'm too old to be brushing my teeth while crouching outside in the rain on a dark night,' he said.

Not Getting in the Way

1990S

Something about the shift from consciousness to
unconsciousness within the structure of the book.
Maybe my voice when Craske is in a coma, or is
that too complicated, or too simple?

<div align="right">(FROM MY NOTEBOOK, SEPTEMBER 2012)</div>

I used to know a retired plumber called Basil. His daughter was knocked
down and killed in a bicycling accident when she had just turned nineteen
and the man who knocked her down was Basil's neighbour who had
been drinking too much on that particular morning and he was charged
with manslaughter and sent to prison for a year.

On the day the neighbour was released from prison, Basil happened
to be in a town he rarely visited and as he walked past a shop window
he saw the man, looking out through the glass. They recognised each
other straight away, the bereaved and the bereaver, and they both smiled
and waved tentatively. Basil said that in the moment of meeting he felt
the anger and the blame dropping away.

He became a healer. It started with that chance meeting and then
he went to visit a friend in hospital and she told him she felt better
from the visit, not just in her mind from his friendly presence, but better
in her body too. Perhaps there was something about the way he had let
go of his own pain which made it possible for him to shift the weight
of pain in others.

I first went to see him because I had a very stiff neck. I kept being
reminded of Jehovah telling the Jews, *Ye are a stiff-necked people*, although

I don't think it was stubbornness sitting on the back of my neck, but a sadness that clung to me like a yoke. I knocked on the door and was let in by a very shy and sometimes stuttering man and there was a tenderness in his manner which brought me to the edge of tears. Basil spoke to me as if I were a child, but a wise child whom he respected. 'You are carrying a lot of weight on your shoulders,' he said, even before I had explained my problem.

He worked in a room with a big window looking into the distance across the wide swoop of a meadow with a horse grazing and the occasional lolloping rabbit or nervous pheasant. Immediately outside the window there was his rather formal garden and a huge bird feeder around which crowds of birds were always busy: greenfinches, goldfinches, tits and robins and the occasional lesser spotted woodpecker, while blackbirds and fat pheasants hoovered up the bits scattered on the grass. The view was very quiet and even the passing of the seasons did not change its constancy.

Basil's method was very simple. He would hold his hands above my head and talk in a soft voice that occasionally broke into a stutter; or he might not say anything. I had my eyes closed because that gave me more concentration. Sometimes his hands radiated an intense heat onto my scalp, but that was not always the case. After a while he would hold one hand in front of my face. At the start of one of these sessions, my mind would be whizzing with thoughts and then the thoughts wandered off and I would watch images instead. I learnt to work on the images, or at least I learnt to not get in their way, letting them take shape without my interference.

It was a difficult time in my life and I suppose in response to that, as well as the stiff neck I had developed a nervous reaction, a nettle rash which would erupt over an area of my body, my face in particular, especially if I was about to go to some sort of public function. I would

wake up in the morning and feel the adrenalin, for that is what it was, pumping under my skin and making it tingle and tighten as it swelled up.

My fear made the adrenalin, and the adrenalin felt like my fear. I had been to several doctors and specialists, but they could do nothing. Now, sitting in a chair in Basil's front room, my eyes closed, but knowing that the meadow and the horse in the meadow and the birds eating nuts and seeds were there, beyond the fact of my looking, I began to allow images to take shape. I saw a tree on a hill and felt the sun against its trunk as if I was the tree and that made me feel strong. I saw a broad bean in the earth in the springtime, curled up like a human foetus and doing a slow somersault in the dark as a wavering root began to grow downwards and a green shoot began to work its way towards the light, and as I watched it, I felt its determination and that gave me courage.

My condition was cured on the day when a shoal of silver fishes in a stream appeared in my mind's eye. They were tiny, thin, shivery fishes and they were all facing the flow of the water and by swimming as hard as they could they were able to keep steady and in the same place. I suppose it was my own fear that I was seeing and how I could control it. After that, every time I felt the adrenalin starting to take hold, I simply remembered the shoal of fishes and with that the fear subsided and my skin did not grow tight and swollen.

I sometimes went to see Basil because I was stuck with my writing. I'd sit there in the chair facing the window and he'd talk a bit. He spoke of the past being like a cliff face that has broken away so that you can see the accumulation of time in the wavering layers of sand and little pebbles, roots and earth. He said he didn't think there was any real separation between the past and the present and even the future was already there, waiting to be discovered. He said the dead – both the ones we had known and loved and others who were connected to us in

some way – were all there in an invisible world that was parallel with our own and they could help us at crucial points in our lives.

Basil would say, 'You mustn't get in the way. Let the book write itself,' and then he would talk of what he called Spirit doing the work for me. My beliefs were very different to his, but I think I understood what he meant.

The James Edward

1923

Craske's exhaustion and what to do with time
when he has so little energy with which to use it.
The prospect of days, months, a whole life without
energy. Only the sea to keep him going because
the sea is alive like no other aspect of the world:
breathing, sighing, roaring, pulling in and out,
never letting go.

(FROM MY NOTEBOOK, SEPTEMBER 2012)

He told Laura he had dreamt he was on Father's crabbing boat and
never mind that Father was dead and the boat was wrecked in a winter
storm years ago, even before the start of the war. In the dream, they
were there together again, man and boy, and they must have set out
from Grimsby because they were working the crabbing pots over towards
Spurn Point when a storm jumped up and the boat lurched and bucked
like a wild thing. 'She was steady built and she got us through all right,'
he said. 'We came home safe, but it were a long night.'

'I'm going to paint Father's boat,' he said and then he kept very quiet
as the boat took shape in his mind and he could feel the sea knocking
against the wooden hull, as if the planks were the bones of his own
body and the sea was his beating heart.

By now the storm had turned so rough he thought the thread of his
life might be snapped off and that would be that and not even a corpse
to bury under a stone in the churchyard.

He could hear the swells break and he knew that if you hear the

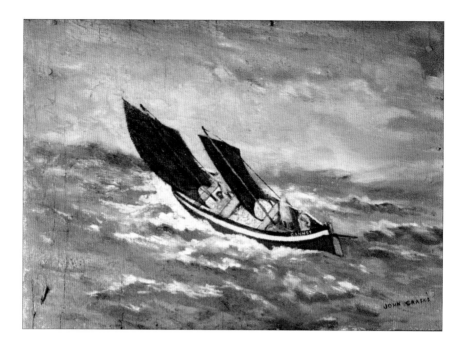

swells break out here at Spurn Point, then you should be scared. But he wasn't scared exactly, just respectful of the seriousness of the sea and how big it was and how small that made him. He felt quiet inside, peaceful, even though a gale was roaring in his ears and the wind was lashing at his face and Father was shouting orders at him about holding on and lashing a rope and being ready for that next wave that was coming at them right now. It was something to do with a destiny over which he had no control. That's what he wanted to put in the picture: the sea and the storm and the courage of the little boat and how he trusted it with his life.

'I'm going to paint Father's boat . . .' he said again.

'Well, you'd better carve it first, so you can paint it after,' said Laura, who was always patient with his repetitions and hesitations.

'No, I'm meaning to do it flat, in colours.'

He gazed around the tiny front room. Laura had put up curtains made from cut-off bits of sail, to keep out the worst of the cold. A few lumps of sea coal were burning in the grate, alongside a white length of driftwood which they fed towards the flame, inch by inch. They kept the sea coal in the bait box, but there was not much there at present, they needed to go out to search for more along the beach at low tide.

'You don't mind if I use this and make it pretty?' he said to Laura and he picked up the box and set it on the table. She nodded her head because she didn't mind anything, just so long as he stayed here, with her.

He could see an energy in the grain of the wood that pleased him; it was like the surface of the ocean, flickering with life.

He asked Laura to fetch him the tins of paint. He began by making the sea, huge and empty, just the size of it and no horizon visible. He did yellow and a bit of black for the troughs and cracks in the chalk on the seabed where the crabs liked to gather and breed. He remembered how you could feel the sudden depth beneath you and it was almost like seeing.

Once the paint was dry, he added the boat. Just a little thing, a crabbing boat, doing its best. The storm was coming up and he did white and flecks of grey as the boat crested through the swell, and white and grey on the edges of foam blown back from the bows by the rising force of the wind. He was painting the boat without thinking about it, just holding the knowledge of it in his mind, balancing his feet against the tilt of the deck, leaning into the force of the wind.

He listened to the creak and flap and thud of the sails. He heard Father calling to him and the deck was huge and slippery as he struggled to keep his balance. For the time that he was busy with the picture he did not exist, or at least he was somewhere else, out at sea.

When it was done, he called Laura to have a look.

'That's something very fine you have there, John Craske,' she said. 'Must be a force nine hitting the boat head on and look at them waves tossing it to and fro and yet it's nothing but an old bait box.'

During the year or so that they stayed at Wiveton, he painted every surface that had enough room on it for a picture. Laura helped him to prepare the inside of the front door with a layer of white distemper and then he set to and covered it with the big boats that used to be gone for months on end in search of cod in Icelandic waters, before the trawlers came with all their noise and smoke. Big boats like the one his uncle went on when he was nothing but a thin child, when he learnt to tap-dance on the lid of a wooden chest.

On the seat of a chair he did a frigate in a storm, the one he'd seen from the Beeston Bump, so close to the land and yet there was no hope for it, and he mixed the red-earth colour of the sails until he'd got them just right and on the other chair he did a trawler, also in danger of sinking with all hands on board and the smoke from her funnel was running flat across the deck because of the wind, but she'd get through all right.

The wooden mantelpiece above the fireplace became the stretch of coast that he knew from when he was a child and all along the window ledge he painted whelks and clams, mackerel and lobster and a bunch of herring tied with string. 'This way we'll never go hungry,' said Laura when she saw the herrings.

Once there were no more flat surfaces in the room, Laura went to the grocery man's shop and brought back a few sheets of brown wrapping paper. He smoothed out the creases with the heel of his hand before he began. He wondered if he could make frames out of bits of wood and then he'd decorate them with little shells and the skulls of birds that he always collected when they were out getting cockles, as if he felt they'd have a purpose one day.

There were still lots of the gramophone needles that someone gave to Laura and they were just as good as tin tacks to hold the frames together.

When he'd done the first frame and put it round the first painting on paper, Laura told him it looked as pretty as a picture and that made them both laugh.

The Art Barn

Birds disappearing among the soft pockets of
marsh plants. For a moment I watch the white
head of an egret and the angular silhouette of a
cormorant and then they have both vanished.
Now the rain is washing the land into the sea and
dimming all the colours.

(FROM MY NOTEBOOK, SEPTEMBER 2012)

I visited the Art Barn twice, both times with an appointment and a bit of an explanation of what I was doing and why I wanted to come.

It's on the right, up a narrow road, and you need to open the gate and drive in and close the gate securely afterwards and then you are in an old farm courtyard, the red-brick buildings beautifully restored and modernised. A few people drift about, watching without doing anything much; others are busy. The farm has chickens and sheep and a cow and a vegetable garden; there is a lot of work to do.

As I got out of the car, a man in his forties approached me. 'Hello, who are you?' he said in a slow, deep voice, the words seeming to come from far away. I told him my name and he told me his name and pulled his hand out of his pocket and held it towards me as if it were a gift and we shook hands.

There were fourteen men and women working in the Art Barn along with three teachers. The atmosphere was quiet and concentrated, everyone busy. I was introduced to John who was producing what he called Cowboy Trousers, which no one could ever wear because the legs

were far too long and thin, as if they were made for a huge insect and the sewing of the seams and the decorations on the cloth were so fragile they would fall apart if they were handled roughly. But still they were nice to look at as objects and they seemed to tell a story, even though I am not sure what the story was. Previously John had made a series of women's breasts out of clay, moulding them carefully into shape and painting them with swirls of colour and then they were fired and set up on display on one of the shelves in the room. They looked like the votive offerings that someone might leave in a church with the hope of a cure.

A thin woman with bright blonde hair and a disconcertingly sudden smile that erupted without warning on her face even when she was by herself, shook me by the hand and then kept hold of my hand as she led me to her place at one of the big tables. She had very few words and they emerged like the cries of birds. She was making rows of little matchstick figures stitched onto a piece of cloth in bright colours.

An even thinner young woman who can't have been more than twenty had just recently joined the group. She wore a black and white dress that touched the ground and covered her shoes, and when she was standing she held herself in a sort of leaning curve which made me think of a tree by the water's edge. She was very nervous and she kept looking around as if some danger might be approaching, but after a while she settled down to drawing green stripes and black dots and with that quiet and repetitive process her whole body began to relax.

A man who reminded me of one of my university professors from long ago had made a spiky molecular structure out of paper and wood and he was colouring it in with felt-tip pens, moving towards the paper in what looked like an angry rush of energy and then stepping back to observe the result.

Mary, who is in her seventies, used to make complex embroideries, but she had recently started on patchwork shapes. I was shown one of

her early works, a waistcoat that would have fitted a very large person. The front of it was stitched in wools into an intricate geometric pattern of colours on which was placed a big flat white face, the features done in straight black lines and beneath it two big hands with red fingernails, so that if you put the waistcoat on and buttoned it up, you would be clasped by the embrace of the hands.

One of the teachers in charge took me up to the storeroom, to look at more of what had been produced here over the years. There were long racks of paintings in all different sizes. There were shelves full of pots and figures and shapes in clay, including some more painted breasts. Even the most chaotic of the images had a power of concentration, a sort of truth, for lack of a better word.

I spoke with James Gladwell, who has been coming to the Art Barn for the last twenty-one years. A quiet man, and he went on working as he talked.

He said, 'Mostly I dream of what I see. I wake up and I remember and I put it straight on the cloth.'

He said, 'I do painting and I do needlework. I like needlework. I use cotton and really big cross-stitch. I used to embroider at school and I like sewing anyway. I did a mermaid and a man and I did the daughter and the mother all with snakes. And one without snakes.'

He said, 'I like painting. I do it with dabbing. My family was a Roma gypsy family. They painted their caravans when they were going to get married, so perhaps that's where my painting comes from.'

I spoke with Chris Angel; also a gentle, friendly person and he stopped his work in order to talk to me. He was excited by the idea of me doing a book. He said had written lots of stories and a play called *The Evil Cinderella*.

He said he thinks of something around the room and then he does what he calls a *bomb-build-up* and that is a basic face and from that he

builds up the picture. Right now he is doing birds. 'Any bird I've got in my brain and I build it up as an imaginary bird.'

I walked around the room admiring the paintings and embroideries and clay work that was displayed. Next to a window there was the stuffed head of a Cayman crocodile with wooden rings hanging from its fierce snout, the mouth slightly open to reveal the lines of sharp and pointed teeth. 'We didn't do that,' someone said, seeing me looking at it. 'That's real.'

I felt a curious kind of contentment from the place, which I suppose comes from the concentration of the work, and also the gentleness with which people were treated and with which they treated each other. A woman drifted in and stood there, mewing like a cat that had lost its kittens, but someone spoke to her in a friendly manner and she wandered off.

There's also the fact that concentration is like a form of meditation and everyone in the Art Barn was absorbed with the thing they were doing and the thing they were doing seemed to be doing itself. And you could see how the process of painting or modelling or stitching was soothing to the mind.

I bought a painting by Chris Angel of two Vikings, their helmets fitting to their heads as tight as well-combed hair, and the horns on their helmets seeming to grow out of their skulls.

When I got home I gave the Vikings to Herman and he found them wonderful. We hung them high up on the wall, so they could gaze down at us, with an expression that was both gentle and savage.

The Elephant Man

OCTOBER 2012

Craske as a little boat on the surface of the sea; tossed about, pulled away from the shore, but still there, still keeping alive. When he emerges from a stupor he bobs back to the sea's surface and when the stupor returns he is shipwrecked and goes down to the seabed.

(FROM MY NOTEBOOK, JANUARY 2013)

In this odd pursuit of I know not quite what, I booked myself in for one night at the Royal Hotel in Great Yarmouth. I thought it got its name after Edward VII came here with his mistress Lillie Langtry, bequeathing his regal title as a token when he left, but that was just my speedy presumption; apparently it started out as the Victoria and then it became Bird's Royal Hotel and Posting House, presumably because Mr Bird was the owner and the property was opposite a building called Palm Court which was the pick-up point for the Royal Mail. After the newly built railway station took on the role of pick-up point, the hotel dropped the Posting House bit, but kept the Royal.

Charles Dickens stayed here for a while in 1847 along with his illustrator Mark Lemon while he was writing *David Copperfield* and he sent a letter to his wife saying Yarmouth was the most *wondrous sight* his eyes had ever seen. The hotel still has *The actual menu of the meal eaten by Charles Dickens*, with his signature to prove it, although I forgot to ask if I could see it.

All the rooms had the names of Dickens characters. I was given

Little Nell, in memory of the waif-girl who died so tragically in *The Old Curiosity Shop*.

Little Nell had been allocated a narrow single bed. There were faded roses on the cotton bedspread and one of the petals was splashed with something that looked like blood but I didn't examine it too closely. The lavatory produced a sort of roaring hiccup when flushed, but still it was nice to be there. I had a view of the back of the hotel's illuminated sign just beneath my window and beyond that there was the grey sky meeting the grey sea, the two elements fused together, which I now know is something to do with low pressure.

The Tropical House was just across the road: a low and rather makeshift building done in brown and bright green imitation logs, with a yellow palm tree sprouting from its roof. According to the notice outside, it contained over a hundred reptiles, including an alligator.

The Summer Palace was to the right of the Tropical House, the skeletal remains of a nineteenth-century pleasure dome, where ladies and gentlemen once perambulated under glass, if the weather was a little cold. The Summer Palace was all boarded up, with *Danger Keep Out* signs and heaps of rubbish accumulating around its edges. It must have been beautiful once: the rustle of bright clothes, the muffled chatter, music, palm trees in pots.

It was a Thursday and I was the only guest. Julie at reception, dressed in black but very jolly with a dash of lipstick and a soft fringe, said I had just missed a busload of visitors from Lancashire who left this morning and they had entertainments and the like, but I could expect it to be very quiet.

Julie has been working here for thirty years and the hotel feels more like home than her real home does. In the winter, when all the rooms are empty from one week to the next, she loves to walk up the creaking staircase and along the corridors lined with old photographs in new

frames. She said it's a pity the roof leaks, when the rain comes down
at a particular angle, and it's a pity that they covered the outside façade
with a plastic-based Snowcem paint sometime in the '50s, because that
has made the stonework erupt in blistered patches, but she wishes, oh
how she wishes, that a friendly millionaire would come along and see
what a lovely hotel this is and then he would make it his own and the
Royal would be restored to its former glory.

Julie found me a bit about the history of the place, including a
photograph of a circus elephant being served a drink in the bar. The
elephant had a front foot resting on the counter and its trunk was thrown
up in an S-shape above its head so the mouth was open and seemed to
be laughing. The barman who had just poured the elephant a drink in
a pint beer glass was dressed in a white shirt, with an Elvis hairstyle
and a slightly nervous expression on his face, even though he was doing
his best to smile for the photographer. Julie said the same barman
dropped by just recently to say hello, but she didn't remember him, he
was way before her time.

When she first started working here, the hotel belonged to a very
nice man who was a bit eccentric. He often lay down on the carpeted
floor to have a snooze and he was the one who got the leatherbound
complete works of Dickens and put them on a shelf in the lounge. I'm
welcome to borrow a copy, so long as I remember to put it back before
I leave.

The nice man retired and sold out to a Chinese couple, so now they
get a lot of Chinese people coming in groups of fifty or more; village
elders mostly, with hardly any women among them. They don't speak
much English and they have Chinese porridge for breakfast, although
some of them try the cooked Full English, but they always have a lot
of trouble with the cutlery. They are taken to educational places by bus:
a fish-finger plant; a business centre, that sort of thing.

I went for a walk along the concrete esplanade beside the sea. A group of ten Father Christmases were posing for a photo with their arms around each other and their beards lifting sideways in the wind. They wandered off in a convivial huddle before I was able to ask them what they were doing so early in the season. I felt as if I'd ingested some holiday-special magic mushroom which had enveloped me in this vision of a *Bladerunner Goes to the Seaside* future. The fact that my mobile had suddenly stopped working made me feel all the more cut off from any world beyond this one.

I passed the Empire Theatre, all boarded up and the last two letters

of its name had dropped off. The Metropole next door was a popular nesting site for pigeons, the red brick covered with white streaks.

I went to the museum which is a converted smokehouse and it smells sweet and smoky and somehow medicinal, as if you could be cured of all sorts of aches and pains by just standing in the foyer and inhaling the scent of herring. They had a stuffed cod in a glass case, taller than a tall man, and a complacent-looking stuffed albatross, far too big for the Ancient Mariner to carry around his neck, even with the twelve-foot span of its wings carefully folded. There was also a large speckled hen, which had been rescued from a shipwreck in 1892 and presented to the coastguard who did the rescuing and who *took much pleasure from the hen* and a mammoth jawbone and models of Victorian fishermen and women and a selection of Bronze Age tools, not far from the hen.

I visited the medieval town hall which is now a little museum and that was where the man in charge of tickets declaimed the story of the herring. I then went on to the library which was surrounded by rather grim council houses and there I bought myself a bowl of Portuguese soup made from black cabbage and potato. The cook was talking to a friend in Portuguese but every so often the words *family credit* floated to the surface of their conversation.

I walked in a vague zigzag and through a little park that seemed to be popular with junkies, until I reached King Street, which might also be in memory of Edward the philandering king. The Georgian houses were mostly turned into fish and chip shops and charity shops, or boarded up with graffiti on the boards. A pub offered beer in five-pint glasses for £6.95p.

I stopped to look into the window of a shop where a dolls' tea set made out of fine bone china was set out on a little round table and there were elegant wine glasses on the table as well, in case the dolls

wanted a change from too much tea. The shop's owner was busy locking the door.

'I only take groups,' she said, looking at me who was clearly not a group. 'But I suppose you can come in for a bit,' and she began the laborious process of finding the right key to unlock the door again.

'Someone jimmied it a while ago and so I had these bars put up, eight hundred pounds,' she said.

I was a bit surprised by the word 'jimmied'. She was a small woman, delicately built with grey hair in a bun and thin strong features. She was wearing dangly gypsy earrings.

I followed her inside. My first encounter was with a toy gorilla about the size of a ten-year-old child, slumped into a Victorian perambulator with a notice around its neck welcoming me to the Museum of Memories. A red-carpeted staircase with banisters on both sides rose behind the gorilla and a life-size cardboard cut-out photograph of Elizabeth II in her coronation gown stood at the top of the stairs, flanked by two life-size policemen cut-outs. A gaggle of teddy bears sat on the red stairs, paying some sort of homage to their monarch.

My hostess was looking for the light switches. She had already put on a CD of piano music and she was telling me several stories at the same time. I did my best to ignore any idea of lineal progression and in that way I was able to more or less follow all the stories together: the tragic death of her son at the age of eighteen; her grandfather the clown, her father the clown, the toy collection, the stamp room and her mother.

Her mother was called Sarah Jane 'Luba' Shaeffer – as in the pens – and she was of wealthy Russian American Jewish ancestry and was obsessed with Edward VIII. She decided that if she could not marry him, then at least she would marry an Englishman so as to dwell on the same island as her king, breathing the same air. It happened that the very first Englishman she met was Arthur Van Norman, otherwise known

as the Prince of Clowns. He was performing at Barnum & Bailey's Circus in Madison Square Gardens.

Sarah Jane 'Luba' Shaeffer married Arthur Van Norman three weeks later and her wealthy parents were so angry they cut her off without a penny. The newlyweds went by boat to England and as soon as they arrived the Prince of Clowns told her she must sell her jewels and pawn her fur coats, because they needed money for food and lodgings.

By now we had moved on from the glass cabinet filled with portraits of Edward VIII on mugs and plates, in china busts and printed profiles, to a cabinet that contained a very white and ectoplasmic bust of Joseph Carey Merrick, otherwise known as the Elephant Man. I recognised him at once.

His actual hat and cape were draped behind his misshapen head along with a notice which explained, *This is a replica of the plaster cast of Joseph Carey Merrick's bust kept in the London Hospital on the Whitechapel Road where Joseph spent the last few years of his short life visited by many celebrities of the day including, most notably, Alexandra Princess of Wales.*

'My grandfather discovered the Elephant Man,' said Valerie. 'They were both the same age and Joseph was a Category One in the Leicester Workhouse, which meant he was on a starvation diet and on top of that it was hard for him to eat on account of his condition. My grandfather was a clown, but because it was hard to get work, he put people on display as well: the Only Electric Lady was his first and then there was the Skeleton Woman and the Balloon-Headed Baby. He had a booth on the Whitechapel Road in London and you paid to come in and he drew back the curtain.

'Joseph made contact with my grandfather because he thought he could become an exhibit, as a way of getting out of the workhouse and earning a bit of money. So my grandfather took him on. He was called

the Elephant Man because he looked a bit like an elephant, but also because his mother had been frightened by an elephant which she saw when the Bostock and Wombwell Circus came through Leicester. She thought it was the shock that made her baby look like that.

'My grandfather wrote the story of his life,' said Valerie. 'The things he said about the Elephant Man were much more accurate than the things said by that surgeon Sir Frederick Treves, who looked after the Elephant Man later. Treves was already old when he wrote his story, so perhaps he got muddled and forgot things, but he told lies about my grandfather, saying he was a drunkard and that he exploited the Elephant Man, which he didn't, they were friends.

'My nephew has all that now, which is not what my father would have wanted,' said Valerie, looking angry with the thought, 'but at least I have my father's story, which he wrote not long before he died. A million words it is, so at least I have that.'

We moved to a cabinet filled with porcelain clowns and doll clowns and clown puppets and on the middle shelf there was a photograph of two clowns together. One of them was Valerie's father, the Prince of Clowns, while the other one, wearing a top hat, was called Hugo d'Arty. Their white-painted faces were criss-crossed with black lines like cracks in the skin and they looked as serious and as ominous as classical *kabuki* players. Valerie said her father couldn't be more than twenty-five in the picture, but to me he appeared infinitely older.

As I was leaving the museum, Valerie said she was a Christian and she believed that our meeting was meant to be. As if in response to this, I said I would very much like to read some of her father's book, especially the part about the Elephant Man, and she said that if I phoned her when I was planning to come again, then she'd bring it with her, but I had the feeling that she wouldn't.

On my way back to the hotel I stopped at a shop which sold second-

hand DVDs and CDs and had a little notice in the window that said
something about repairing mobile phones. The shop was filled with loud
reggae music and girls with half of their hair shaved off and rings in
their lips and noses and three very languorous black guys who kept
laughing at a private joke. I offered my broken mobile to the young man

who was behind the counter and he was very courteous towards me and I wondered if I reminded him of his favourite schoolteacher. He flipped the back off my mobile and fiddled about with it, before returning it to me in perfect working order and with that my contact with the outside world was restored. I had a spoken message on my mobile asking if I would like to make an insurance claim after my recent accident. 'Fuck off!' I said to the voice. A minute later I got a text saying, 'We received your message and based on your reply a stop request has been noted and we will not contact you again.'

I felt suddenly terribly lonely and I phoned Herman as I walked down the street, comforted by his voice and by the thought that I would soon be home again.

Fishing
OCTOBER 2012

The underwater quality of the vegetation so that at times you seem to be gazing down at the seabed and then the dunes become the waves of the sea and the dry rippled sand becomes the sea's calm surface. (FROM MY NOTEBOOK, SEPTEMBER 2012)

As I walked back to the Royal in the early dark there was a night-time stirring in the air. People were drifting around the edges of the amusement arcades, the machines erupting with flashes of light and bursting with electronic voices. A man was trying to catch a fluffy bear in a tank, using the metal pincers that you lower and operate from a series of knobs and wheels. He was not going to catch the bear and time was running out. His girlfriend caught my eye and shrugged apologetically. A shaggy-looking man with a limp came loping towards me from out of the arcade, *Hey! Excuse me! Hey! Excuse me!* his voice shrill and aggressive.

I said goodnight to the Chinese manager who was at the desk sitting where Julie had sat and I went to my room and opened the window so the night air could stream in and read the account of a storm on the North Sea in *David Copperfield*. The window let in a lot of noise. Cars and motorbikes racing full tilt, loud quarrelling voices and shrieks; Valerie in her museum had told me that the Serbs and the Croats have regular knife-fights in honour of ancient blood feuds. After a while the night noises came to an abrupt halt and I slept peacefully until the arrival of rubbish-collecting lorries at dawn; perhaps there were knife-fights and I had not heard them.

I went down to the empty breakfast room and a plump girl pointed me towards one of two laid tables. The other guest had not turned up, she said, so it was just me. I had ordered a continental breakfast and she brought me six thin slices of cold white toast and a bit of butter and a bit of marmalade and a jug of pale instant coffee.

This was the day I had booked to go sea-fishing on the *Sea Quest* which was moored on the river in the old docks, not far from the Pleasure Beach (Great Yarmouth is very keen on pleasure, you find it all over the place). I had borrowed a rain jacket and waterproof trousers and I had fingerless gloves for the cold and a thick woollen hat for the wind and a bar of chocolate to share with my fellow fishermen because I was told that was a good way of showing friendly intentions. I understood there would be five of us, including me.

I had found out about the expedition on a flyer in a fish shop where we stopped on our way back from the Watch House. The woman selling the fish was the daughter of the fisherman who did the trips and she took the booking for me. She told me her father was sixty-four years old and had diabetes, and she gave me a map showing me that I must go past the Pleasure Beach and left at Salmon Lane and round to the right by a lorry park. I reached the quay and a man in overalls, Paul he was called, was standing next to a fishing boat and waving to me.

My four fellow fishermen arrived. They shared a common moroseness with a rather unconvincing jollity, as if they might suddenly blow party whistles and put paper hats on their heads. They explained that they were spending a week in a caravan in a caravan park which belonged to someone's mother-in-law and they had made plans to go out on different sorts of fishing expeditions every day.

'We are keen fishermen,' one of them said, speaking for the group, and they all grinned to show this was true. Another one said he hoped I didn't mind bad language because fishing always brings out bad language and rude jokes and they all grinned again. I said I didn't mind at all, but I could hear the stiffness in my voice because I felt out of place and I knew that a woman on board a fishing boat is supposed to ruin the catch, because they had told me that as well.

'Well, that's fine, then,' they said, which it clearly wasn't.

Black and bedraggled lugworms were lying between layers of cellophane wrappers. Paul said they came from Wales and cost £20 a hundred. A white lump of congealed squid was gently unfreezing in a plastic bowl and three herring, or perhaps they were mackerel – I've never been clear about the difference – were lying in another bowl, red-eyed and with the startled look that seems to characterise all fish out of water.

So we were all set. We chugged down the river mouth towards the sea, passing a mass of flat-faced concrete storage depots. A tall column, similar to the one on which Nelson stands in Trafalgar Square, emerged from among the storage buildings and I think Neptune with his trident was on top of the column but I'm not sure if I heard that right.

The sea was flat. The sky was a very pale blue and there was no wind and no clouds and I felt a bit foolish in my waterproof trousers and rain jacket. I kept the gloves and the hat hidden from view.

I had presumed that we would head straight out to sea, far from the land, far from the known and solid world, but instead we turned a sharp right and followed a line parallel to the coast for some fifteen minutes and then the engines were switched off and the anchor was lowered and the rods were brought out.

I could see what I thought was a convivial gathering of pig houses in a field, but it turned out to be a caravan site. Paul gave me a rod and showed me how to bait it with a mixture of fish, squid and worm. I still have a two-volume Pelican paperback called *Animals Without Backbones* at home – I bought it in the 1960s and among the illustrations there is a grey magnified photograph of the head of a lugworm, a sort of carnival character with a pointy hat and two cut-out eyes. These lugworms before me were silky soft and when I tried to thread the hollow of their bodies onto the spike of the hook, the spike kept breaking through.

I held the rod and reeled out. Everyone was reeling out. The four

fishermen were smoking and joking in a line in the bow of the boat and I stood at the side in order to not get in the way.

Paul caught the first fish. A whiting. Smooth and pale with something a bit wolfish in its face. It did slow sideways twisting movements in order to return to the water and quietly escape from this downturn in its destiny, but Paul held it firmly in both hands and extricated the hook from its open mouth and threw it into a plastic bucket, where it went on gently drowning in the air.

I remember seeing a puffer fish in a net in Normandy and I can't have been more than two because that was my age when we went on the holiday. I saw the puffer fish with its parrot beak and its inflated body and the brave little spines sticking out all over to keep it safe, and then I watched horrified as it lost its puff and its gleam of colour and subsided into being nothing more than a dying thing.

My four companions were full of the spirit of the hunt. They began hauling in a succession of whiting, one after the next as if they were all waiting for their turn in a watery queue. There is something so mysterious about life going about its business on the other side of our sight, under the surface of the sea. And then you pull it through the dividing line that separates one world from the other.

The smaller ones were thrown back, but a fat lot of good that did them since they couldn't survive the shock of being hauled from the deep. I was rather relieved to be catching nothing, but Paul handed his fishing rod to me and told me to bring in whatever was pulling on the line. It was another whiting, but as it emerged from the water I prevaricated and in that moment a black-backed gull swooped down and snatched it from the hook and swallowed the fish head first, tail swiftly following.

Paul was talking of quotas and how stupid they were and how only last week he and his fellow fishermen had caught two tons of cod every day and had to throw back one and a half tons of dead fish. I could feel

a squeaky indignation rising in my throat, but there was no purpose to it. 'The sea is full of fish,' he said, as if sensing my dismay, 'and don't you believe otherwise.' At that moment he caught a dogfish with lemon-yellow eyes and a squirming sandpaper body: its hungry, eager mouth made me think of a baby wanting to suck at the breast. 'We use them to rub down the paintwork,' said Paul to cheer me up from my abstraction, and he held the dogfish in one hand and pulled it along the length of the boat's hatch and then showed me the stripe of colour on its back. He threw it unceremoniously into the sea and it swam away, because dogfish can survive the business of being caught.

The four fishermen were talking about their wives. Paul was married to a woman from Goa who works in a care home and didn't know how to make a sandwich when they first met so she'd put the butter on the outside and she still cuts the slices as thick as your arm and he produced a vast slab of a sandwich to prove it and we all laughed. He said he has bought some land in Goa as a way of doing something with a bit of his money but he won't go there, he prefers Norfolk. His wife was in Goa now, seeing relatives and attending a church gathering. He was gutting the fish as he was talking and as they lost their vital organs their surprised look turned a bit less urgent.

The lugworms were all used up, the last bits of mackerel were thrown into the sea, along with the translucent pieces of squid. 'All done?' said Paul and he started the engine and we chugged back the same way we had come.

The four fishermen presented me with four fish as a sort of consolation prize and Paul wrapped them up in two plastic bags. When I got back that evening Herman and I discussed how we might cook the whiting, but as soon as we unwrapped them the look of betrayal on their pale faces got in the way and so the next morning I gave them to a friend who seemed pleased with the gift.

Hemsby

> The line of the coast here; the fragile image of
> land and houses and beaches, all clinging by the
> skin of their teeth to the edge of the immensity of
> the ocean. (FROM MY NOTEBOOK, JANUARY 2013)

In her written account of her life with John, Laura said that after a year they had to leave the quiet of Wiveton and go back to the demands of the family in Dereham. It was something to do with one of the brothers turning up and telling John he seemed better now and he was needed and must come back home to help. They returned to number 41 Norwich Road, the home of Laura's mother.

They worked as hard as they could in the Craske fish shop on Norwich Street. One day John was asked to paint the delivery van and no one, not even him, noticed that he was out working in the full sun. He collapsed and was put to bed. The doctor said he was suffering from sunstroke. *I need not say what this entailed*, wrote Laura.

The sunstroke triggered a relapse into all the layers of his mysterious and complicated medical condition. He was again helpless and stuporous, bedridden and speechless. And again the doctor said the only solution he could offer was the sea. This time they went to the village of Hemsby, just up the coast from Great Yarmouth and easy to reach by train. They went in 1926 and stayed for almost three years.

The only thing that Laura had to say about that entire time was, *How weak and ill he was. I remember how kind the dear Fuller family was, living in the Loke, and the Kings and Mr Gray. John spent much of*

his time going with Mr Gray, taking his goods out. Also he did boat building
when he was well enough and sold some.

I know from a fragment of an interview done in the 1990s that while
they were there he sometimes went with Mr King to Horsey Mere,
which is a stretch of water on the edge of the Broads. Mr King said,
He was tall, dark, always with a moustache. He wore a trilby hat and a
fisherman's blue slop. He was an ill man, but once he got hold of the oars
he had strength to use them.

So they would go out together, Mr King and Mr Craske in a little
boat, moving through the reeds; the clattering of ducks' wings as they
were startled into the sky, the call of marsh birds, the woven tops of eel
traps close to the muddy bank and water voles plopping into the water
because there were lots of them then, paddling about with only their
nostrils visible. And the windmill that is now in ruins, part of its rounded
wall gone and its roof fallen in; that would have been a working mill,
churning at the water, the sails creaking as they turned.

While they were at Hemsby, John made his paintings wherever there
was a space for them in the cottage and on bits of wood or paper as
well and he began to make much bigger boats, big enough for a small
child to sit in and to float safely on the still water of the mere.

And so now I was on my way to the village of Hemsby. It was a day of
pale sunshine, after many weeks of cold rain and mist and snow and
empty, colourless skies.

The place was nothing like I had expected it to be. I had imagined
it rather romantically perched on the edge of the coastline, but it was
a mile or so inland. I parked my unlockable and gently falling-apart car
behind an Alfa Romeo on a street of shoulder-to-shoulder terraced houses
and I went exploring. The church said it was open, but it was not. The
pub was also closed.

I entered a bakery shop and the woman busy with sweet buns and soft loaves was wearing such shiny yellow eye make-up that I wondered if it was covering a bruise. When I asked how to get to the sea she stared at me as though I was trying to catch her out with a trick question. She said she hadn't been to the sea for years and for a moment I thought she might tell me why not. She said I'd find the turning once I got to the public toilets, which were opposite the pharmacy and next to the bus stop.

I followed her instructions and three old people with learning difficulties were sitting in a row on the bus-stop bench, smoking cigarettes as if their lives depended on it and talking together in loud voices. Pinned on the board behind them was a handwritten notice reporting a Lost Dog who was brown and didn't come from round here and would be Scared to Death, so if anyone saw him please Get in Touch. The scared dog was not given a name to accompany his colour and his emotional state.

In the Spar supermarket I got talking to two blonde ladies behind the counter. I told them I was writing a book and I wanted to know what the village had been like in the old days. They hadn't heard of anyone called Craske, but when I mentioned Mr King, they brightened up and said, 'Oh, there are lots of Kings round here!'

They brought out the video rental book and began to look up all the Kings, but they couldn't find anyone among them who would be old enough to help and so we gave up. They suggested I visited the old people's home – not the big one where all the inmates were demented, but the one almost next door, just past the chemist.

I went through an unlocked metal gate and along a bleak path between an odd collection of spiky succulent plants; an empty fish pond was covered over with strong metal netting, presumably in case one of the aged occupants went wandering. I rang the front-door bell and when a woman in uniform opened it I was engulfed by a wave of warm and sickly-sweet air. From the main hallway I could see through into a room filled with elderly people who were all watching or not watching television. The lady in uniform said I would have to make an appointment with Matron if I wanted to speak to them. Matron was not here until Monday and by then I would be gone.

I returned to my car and took the turning signposted *Holiday Village*. Almost at once I felt as if I was entering the set from a 1970s *Carry On* movie. There was no one about and the road was lined with flimsy concrete constructions painted in bright shabby colours and emblazoned neon lights and names like Happy Hut, Treasure Trove and Pleasure Dome. There was an adventure park called Stonehenge, much smaller than the original, the imitation granite slabs painted a soupy brown.

All the attractions were closed apart from the Pleasure Dome Arcade

which was calling out to passing strangers in an American accent, like a mother bird that runs away with little cries of distress to draw the predator away from her nest. The recorded cries were accompanied by the recorded sound of money cascading down metal chutes.

If there had been any houses here for John and Laura to live in, they must have been swept away by the modern world a long time ago. I parked in a pub car park and walked between two walls of concrete which led to an expanse of sand, and beyond the sand lay the sea.

I had read that the dunes used to be inhabited only by fishermen, who lived in rough little houses made of wood. Things began to change at the start of the twentieth century, when young Londoners went for their holidays to Great Yarmouth and began drifting further up the coast. By 1906, local houses were taking in families for two to three weeks and the Hemsby Beach Estate Company was staking out plots of sandy land for people to buy, so they could build their own individual summer houses. Just before the outbreak of the First World War, a man called John Fletcher Dodd set up the first of his Socialist Summer Camps here, although he quickly moved the camp a few miles north to the village of Caister, which was more suitable although I am not sure why.

Lumps of concrete from anti-German barricades lay about on the sand like the remnants of a forgotten civilisation. A patch of marram grass on one of the few remaining sand dunes was surrounded by a fence made out of blue plastic barrels, with a *Keep Off* notice explaining how important it was to *Save Our Coastal Heritage*.

An old man wearing dark glasses was walking on the beach with two plump and faded terrier dogs, both of them strapped into dark blue dog anoraks, much patched up. I asked him if he came from the village and he said yes he did and took off his dark glasses and considered putting one of the dogs on a lead, until I said I didn't mind dogs. I told him I was writing a book about a fisherman who had been too ill to go

fishing and so he'd made paintings of the sea instead and he'd stayed here for a few years in the 1920s, which I knew was a long while ago, but I wanted to get a sense of how it all might have looked.

The man said he'd been in Hemsby since 1951 and everything had changed, but he wasn't sure he could say in what way it had changed, because there was nothing much then, just a few huts, a few people, and there was not much now either, apart from the visitors in the summer who mostly stayed in the caravan park. 'I've got friends you should talk to,' he said. 'They're in their eighties and have been here since childhood, but he's in hospital and she's gone on the bus to visit him.'

He looked at the smaller of the two dogs. 'I got her by default,' he said, using a word I only associate with computers. 'I had a friend went to hospital and he asked me to look after her while he was away, but he never came back because he died. His family took what they wanted all right, but they didn't want the dog . . . did they, Sheila?' When he spoke her name, Sheila gazed at him rather sheepishly as if she'd heard the default story before.

I told the man I wanted to visit the next village of Winterton and he suggested I follow the inland path: a sort of sunken way with the high sand cliffs of the land on one side and the lower undulations of the sand dunes close to the sea on the other. 'Much of the coast has gone,' said the man, and he made a gesture of loss with a sweep of his arm that reflected the changing sweep of the current.

He led me past a fish and chip shop and a concrete public lavatory with a curious warning about *no climbing on slippery surfaces* and then through a bleak car park that was closed for the winter. He pointed to the path. I thanked him and he said, 'You're welcome' and put his dark glasses back on.

There was a scattering of little houses, posted like sentries along the high ridge of the land, and another scattering of much more flimsy

houses like a squatters' settlement on the inside flank of the sand dunes, the fences and window frames painted in hopeful ice-cream colours and the rickety wooden steps giving them a territorial air. But none of them looked as if they could have existed as long ago as John Craske's time.

I stepped over the modern phenomena of dog poo tied up in little plastic bags and dropped casually and somehow virtuously on the ground, as if poo in plastic was not poo at all. There were signs of rabbits digging into the sand but never managing anything that could be called a burrow; there were a few seagulls but no songbirds; and some silver birch trees bent into crippled shapes by the force of the wind over the years. I wondered if some of them might have already been there, young and supple, in the 1920s, when Laura was manoeuvring her husband in his wheelchair along this same path.

The Norfolk Giant

OCTOBER 2012

I am in a B&B and the evening draws in. Just
back from a freezing walk as far as the windmill.
Skeins of geese moving across the sky towards
their night resting place. The sound of them made
me think of frogs.

(FROM MY NOTEBOOK) FEBRUARY 2013

After Hemsby I drove on to Somerton church because the name was
vaguely familiar, although I couldn't remember why. When I got there
I realised this was where Mr Robert Hales the Norfolk Giant was buried.

The church looks like an ark, adrift on the vast ocean of the landscape.
Inside it was damp and cold, but when I had got used to the dim lighting
I saw the faded remnants of medieval frescoes that had lived through
the Reformation and the long stretch of time and neglect that had followed
in its wake. I don't know how many colours they once had, but was what
left was faded images that had the colour of old blood, emerging like
mirages on the blotched plaster of the walls. I could see a couple of men
or perhaps they were angels who had lost their wings, and they were
blowing very long trumpets so that their cheeks puffed up like balloons
and beneath them was a jostling crowd of men and women, including a
bishop in a mitre and a grand lady with flowing sleeves out of which
emerged elegantly supplicating hands. It was clear that they had all been
judged and found guilty and they were being punished in the flames of
Hell, although most of the flames had faded and vanished, as if they had
now served their term and had been granted a sort of purgatorial remission.

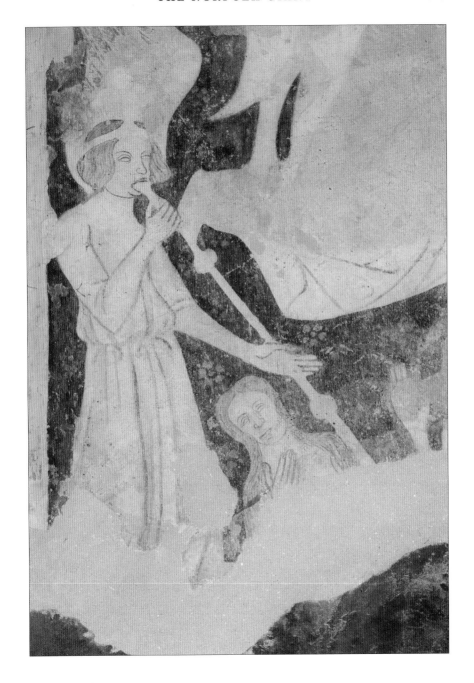

On another section of the wall, a pair of disembodied muscular legs were striding purposefully forward; I thought they probably belonged to St Christopher although there was no way of being sure, since the water which should have been swirling around his ankles had vanished along with his feet and he had no shoulders on which the Christ child could sit and no young and old head surmounted by haloes.

A little table in the half-dark displayed some information for visitors. There was not much said about the frescoes, but there was a whole sheet of blue paper devoted to Robert Hales.

He was born on May 2 1820, in the nearby village of West Somerton. He was one of nine children. His parents were both very tall, but in combining their genetic pool they produced giant children. Robert's sister Mary measured 7 feet 2 inches and his sister Anne was only a few inches shorter. He himself grew to be 7 foot 8. He weighed over 32 stone and measured 64 inches around the chest.

He became a sailor and joined the navy when he was thirteen, but by the time he was seventeen he was too big to fit into any bunk and so he was unemployable and had to leave. Just like the Elephant Man, he made the only living he could, by exhibiting himself at local fairs. He appeared at Great Yarmouth and at Lowestoft and then in 1848 he was invited to set sail for the United States of America, a guest of the Barnum Brothers Circus. In New York he was advertised as the Norfolk Giant and exhibited next to the smallest man who was just 24 inches high.

In 1849, as part of a publicity campaign, he was 'married' on stage in front of a large crowd, to the Quaker Giantess Eliza Simpson, who was 7 feet 2 inches high, although according to my Google search on a page devoted to giants, Eliza was really a man dressed up as a woman and anyway Robert Hales was already married to Maria Charlotte of Great Yarmouth and I don't know how tall she was.

He stayed with Barnum for two years and then he returned to England and ran a pub and was presented to Queen Victoria and was much praised for his genial manner. But things went wrong and he became destitute and sold pamphlets about his life story for a penny each.

He died in 1863 of what was described as *a rapid decline*, which seems a convincing enough cause of death, and his bulky body was transported back to the village of his birth. He was buried in Somerton churchyard in a big stone casket that had been commissioned for him by his grieving wife. It stands on four very odd stone feet, not quite lion and not quite griffon, and it looks like a strange beast without a head, a creature that might at any moment shuffle off, carrying the huge skeleton of Mr Hales in its belly.

There I was, busy with the Norfolk Giant and the Elephant Man who had nothing to do with John Craske, until I realised both of them had problems that originated in the pituitary gland, the same gland which I was beginning to think might lie at the root of Craske's stuporous states.

Uncatalogued Boxes

JULY 2013

We are back in Suffolk. Bright sunshine. Daffodils, primroses, tulips. Confident robins. Herman has inner ear dizziness-Labyrinthitis is the name of the condition-and the doctor seems to know how to deal with it. I keep thinking of Theseus following the red thread that leads him to the entrance of the labyrinth. (FROM MY NOTEBOOK, MAY 2013)

I had pretty well given up finding anything more about John Craske's life, but I did send one more enquiring email to The Red House, asking again if by any chance they had come across the 'Craske bag' which Peter Pears had mentioned in 1971, in his letter to Elizabeth Wade White.

There was a bit of a delay before I received an assurance that I had seen everything on my subject that was held by The Red House. Feeling as stubborn as someone pursuing an insurance claim, I persisted with my enquiries and listed every reference to the Craske papers that I had found, including Elizabeth Wade White's letter to Peter Pears in which she expresses disappointment at not finding *My Life and the Sea* when she went through the archive in 1973. It was *a longish piece of direct and simple writing, as I recall it, with a number of simple anecdotes about storms, rescues and so on, but not much about his actual painting.* There were also the remarks made by a local researcher called Barbara Brookes who had consulted the archives in the late 1990s and had made use of the letters from John Craske and had also searched to no avail for the text known as *My Life and the Sea*, but like me had only found the

invoice for the cost of typing it out, as evidence that it had once existed. This led to a brief confusion when the archivist twice addressed me as Dear Barbara when she made her reply, saying that unfortunately there was no trace of the material I was looking for. Everything went quiet for a few weeks and then I received an email in March 2013, which said,

> With the creation of a new library and study centre, we have come across two boxes of unsorted papers concerning John Craske and these include a number of photographs and correspondence between Elizabeth Wade White and the Craskes and between Wade White and Peter Pears.
>
> You are welcome to consult these papers in our new reading room when it opens in July. Would you like to reserve a seat?

I made my appointment and arrived at The Red House with notebooks and pencils and a sandwich and a bottle of water and a camera, since photocopies were forbidden but one was allowed to take photographs.

The new library, designed by Stanton Williams, is very beautiful. It has an introspective manner that seems to imply that the thoughts and revelations will take shape by themselves once you have entered the building and let it work its magic. It appears so much part of its surroundings it's easy to presume it had always been here, out of sight until its existence was revealed when some dense bushes were cut back.

I sat at the long table with a view towards the garden and the elegant house where Peter Pears and Benjamin Britten had made their nest. Two boxes were wheeled in on a trolley like patients being brought to the operating table. I signed the necessary forms and settled in.

There were many letters from Laura that I had never seen, all sent to Elizabeth Wade White and all confirming her nature: the combination of humility with determination and the steady devotion to her husband

that was unwavering, even after his death. There were enough letters on cheap and original lined sheets of writing paper to get a sense of her sitting at her table in the front room, pen in hand, pictures on the wall, budgerigar in its cage.

More importantly, there was also a collection of letters from John to Elizabeth, twelve of them in total, and mostly written between 1942 and '43. I took his letters one by one in my hand, trying to understand this shy and mostly silent man from the way he formed his words, the spaces between them, the punctuation, the workings of a mind as it was revealed by the things he said and did not say. His handwriting varied a great deal. The letters were very big and the words widely spaced when he was recovering from illness, and they became quite tight and precise when he had been in a period of relative good health. Laura wrote on his behalf when he was not well enough to sit up and hold a pen.

I found the original of Elizabeth Wade White's letter to Peter Pears in 1971 in which she says, *What I was very much disappointed not to find was a typed copy of the MS of Craske's reminiscences, called by him* My Life Story of the Sea. *I know I had one or more copies made of it and about 1950 I returned the MS to Mrs Craske and gave her a copy as well. I must also, I think, have given a copy to Valentine at that time and, if so, Sylvia still probably has it.* But still, there was no sign of the document itself.

I had booked two days of research at the table and rather abruptly on the morning of the second day, I realised I had made all the notes I needed and photographs of all the letters that I could work on at home later.

I asked if I could see the Craske file I had seen on my last visit, two years previously. I couldn't remember its name: but I thought it was under Townsend Warner or John Craske.

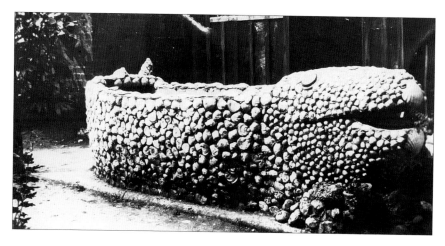

Two cardboard boxes were duly brought in for me, with files inside of them. As soon as I opened the first one, I realised I had never seen this material before. Some of it was quite straightforward, catalogues from exhibitions and that sort of thing, and there were also two very interesting letters from Dr Duigan's son John, in which he details his attempts to obtain a painting by John which is in the possession of one Doris Craske . . .

I found a typescript of Valentine Ackland's account of her first meeting with the Craskes in Hemsby and her subsequent visits to their house in Dereham. At first I thought it was the same text I had already seen from a copy with a page missing, held by the Dorset County Museum, but then I realised it was different to that other version. The overall story was the same, but details had changed, the emphasis had shifted, people appeared who had not appeared and others vanished entirely. Even the house in Hemsby and the house in East Dereham in which Laura and John were living changed shape, the rooms were not the same rooms, nor were the conversations that were held in them.

In the same file there was a small brown envelope, sent to Elizabeth Wade White by someone called Margaret M in New York and it contained

a whole set of original photographs relating to Craske, with Laura's captions written in biro with a wavering hand on the back of each one. Ten photographs in total, including one of the whale pond in the front garden at Norwich Road decorated with shells and stones and looking much odder than I could ever have imagined it. John and Laura on a little boat on the Blakeney estuary in 1926 and John and a nephew, much earlier. And John in a studio portrait that I had only seen in a faded photocopy, sitting very upright and formal. And he and Laura in the garden. Now I had reached a much bigger buff envelope. It was addressed to Mrs Ala Story at the Algonquin Hotel in New York and it contained a carbon copy of the single-spaced typescript of *My Life and the Sea*, all twenty-six pages of it.

There was also a text written by Laura and marked CONFIDENTIAL in which she repeats the familiar story of John's life, but with more blame allocated to those whose behaviour she felt hurt him. *What would my John think if he knew I was writing this?*

Another file had a lot more about the Dunkirk embroidery, including Sylvia's fury about how it had been neglected in the Norwich museum and eaten by moth and the story of Elizabeth finding it in a dark corner with its face to the wall and a letter from the curator of the museum in which she asks to not have her name associated with the embroidery because work such as this is bad for the reputation of Art.

My Life Story of The Sea
1930s & July 2013

A dream in which I lost my train ticket. The ticket
inspector said 'Don't worry, I'll give you a Naxos
Form' and in my dream I wondered about the
meaning of the word naxos and its derivation. He
took out a tiny piece of paper, no bigger than a
postage stamp, and started to write 'To whom it
may concern . . .' but then I woke up.

<div align="right">(FROM MY NOTEBOOK FEBRUARY 2014)</div>

When I got home I printed out the twenty-six typewritten pages I had
photographed and settled down to read and transcribe them. I was very
excited by the thought of being able to hear John Craske's voice and
perhaps understanding what the sea meant to him and why he missed
it so much.

But it wasn't anything like that. He had written a collection of
anecdotes from his childhood, without any introspection getting in the
way and certainly no mention of how the sea had saved him during the
various chapters of his illness, or why he needed to make images of it
over and over again. It is as if he had been told to write something and
obediently he had done so, like a schoolboy doing his homework.

He spoke of his father, his brothers, but he gave nothing away about
the different members of his family or the relationship he had with
them; even his fear of drowning in a storm or the coldness of the waves
breaking over a little boat were described from a distance, as if the
person who had these experiences no longer existed.

In order to get closer to his story, I typed it out in its entirety and then I began editing it, pruning the words back and back until all I was left with were just a few unadorned and curiously unemotional sentences bobbing about and doing their best to fend for themselves.

At the age of eleven I started going to Sea
With my Father and two Brothers
In a Grimsby smack named the Hunter
Crab catching on the Yorkshire Coast
Between Withernsea and Dimlington Cliff.

A Crab pot in which you catch Crabs
Is about two feet long
And eighteen inches wide
It consists of a wooden frame
Three inches wide by one inch thick.
Some of these have iron frames
Fit inside of the wood frame
Others have wooden spells
Nailed inside of the frame
Far enough apart so a Crab cannot get through.
Occasionally we have caught Whelks and Lobsters
In our Crab pots
Also small Cod Fish,
Weaver and Flat Fish.
Now Cod fishing
In the winter time
In a Crab boat
Is very cold work.
I have known times

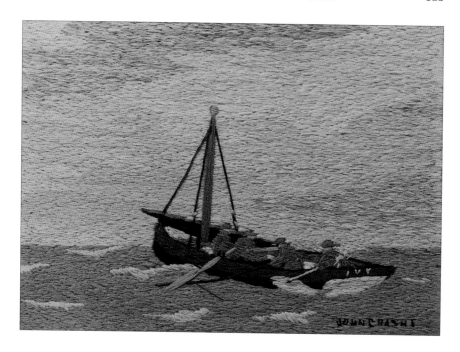

When it has been blowing
And snowing and freezing
And all the time my Father
Has been rowing the Boat
Up to the lines.
His very breathing has been icicles
On his beard
And the lines hauled
Out of the water
Would turn to ice.
And if your Boat was full of Fish
On a rough day
It would not lift over the Sea
But would go through a lot of water

The spray on your face and hands
Enough to flare the skin off.

For warmth
We would unroll our frozen lug Sail
And get underneath it
All our gear on –
Oil frocks Sou'wester mittens,
Woollen scarfs round our necks.
What warmth we got was from the Duck,
Also plenty of smoke with it.
Father sitting aft.
Rob with a part of the sail
Over his head and shoulders.
Robert Farrow and myself
Sitting in the bottom of the Boat
Between the mast & the middle seat
Covered over with the other part of the sail
And having the lighted Duck between us . . .

Between the Crab Fishing
And the long-shore Cod Fishing
There is a slack time.
During which time
We would go in the Smacks
Deep Sea Fishing.
My Uncle had a Cod Smack
Named the Englishman
Of which he was Owner and Skipper.
His two oldest sons James and John

Sailed with him.
I went to Sea for a few weeks as Cook with them.
There were also three more Men
To make the Crew up to six Men
And a Boy.
One was named George Farrow.
The Englishman was noted for the Rats
Aboard her
Of a night-time you would see several
Coming out of the Forecastle
And running up the rigging and main halyards.

Once, coming home
We were becalmed for four days.
We had some baking powder, flour
And a few sea biscuits
Hidden in my Uncle's bunk
And he gave them to me at intervals
As I was only a Boy
Although I was the Cook.
The crew lived on boiled Fish,
And flour and water Pancakes.

One day as they were rowing over the banks
The Boat was caught with a very heavy one
And nearly came over end on.
This was March 1894.
I was 14 years old.

Valentine

1927–28

I dreamt that Herman and I were clearing his
studio in Amsterdam. He caught two bright
orange, free-ranging chickens and said he would
put them temporarily in a cupboard. We discussed
what to do with a table and underneath it were
coiled ropes and cardboard boxes and piles of
papers; all things I had never seen before.

(FROM MY NOTEBOOK, MAY 2014)

One day in 1927, or it might have been in 1928, a very tall slim woman
wearing trousers and a waistcoat knocked on the door of the Craskes'
rented cottage in Hemsby. She had a soft voice and an upper-class accent
and her straight thick chestnut-brown hair was cut as short as a man's.
She said she had heard a fisherman lived here who made toy boats and
she would like to buy one please.

This was the poet who later took on the name of Valentine and set
up house with the writer Sylvia Townsend Warner. John came to open
the door and she explained that she was staying at Hill House in the
nearby village of Winterton, which her mother used as a holiday cottage.
She might have given herself more local roots by adding that her aunt
lived in the Old Lighthouse at Winterton and was a church warden.

In 1927 she was twenty-one years old and was still called Molly,
because she hadn't yet reinvented herself as the more romantically
provocative Valentine. Her maiden name was Ackland, but her surname
was currently Turpin, thanks to a brief marriage in 1925 with a bisexual

man called Richard Turpin. It was on the morning of the day of her
church wedding that she had her hair cut so very short, although its
absence was concealed by a white nun's coif done in the medieval style.
She said there was no sex between her and her husband, because
whenever he made a tentative advance on her virginity, it hurt too much.
She arranged to have her hymen broken at a hospital, but never returned
to her husband and embarked on a series of love affairs and casual
affairs with lots of women and some men. She became pregnant, but
had no idea who the father might be. At sixteen weeks she lost the baby
she presumed was a daughter and had planned to call Tamar and she
was devastated by the loss which she never quite recovered from. Eric
Gill made two chalk drawings of her long and somehow reptilian naked
body and her rather startling red public hair. She also sat for Augustus
John, but I haven't seen what he made of the encounter.

Valentine was a curious mixture of the brazen and the guilt-ridden, although her guilt was more focused on her drinking habits than anything else she did or didn't do. Valentine wrote the two accounts of her first meeting with John and Laura Craske in Hemsby, the four pages that I had in a photocopy with one page missing and the new one I had just found at The Red House which was six pages long. Both versions are typed and undated, but I get the sense that the longer version was written first; it's more awkward in its tone and doesn't seem to have been polished into shape quite so much. This is some of what it says:

> *I first heard of John Craske when, in 1927 or 28, I was at my mother's house in Norfolk. A guest who was with me there wanted to get a model boat to sail on the sea, and one of the servants told us of a man in the neighbouring village who was an invalid and who made model boats as his only means of livelihood.*
>
> *I went to Hemsby and found John Craske in the small scullery of his cottage. He looked fragile and sickly; he walked with difficulty and he talked with difficulty too. He went into the cottage to find me a model boat he was working on and I remained in the scullery which was his work-shop. There, among*

the pots of house-paint and the slivers of planed wood, I saw a picture, painted on the plywood lid of a tea-chest. It was a picture of a fishing boat in full sail and it was very murky but very fine.

When he came back, bringing a half-finished model of a lifeboat, I asked him about the picture and he took me through into the cottage. The small panels of the doors were painted with seascapes and boats; there were little oddments of china and woodwork and ornaments – all painted with seascapes and boats and on the wall hung one grand picture – framed in a cheap stained frame. I asked if I might buy that picture and he asked his wife if I might. It belonged to her. She came forward shyly, peering at me through her heavy glasses, and said I might buy it. But she seemed reluctant. I felt embarrassed and wished I hadn't suggested it, and then I looked at the picture and longed for it, and then I thought of my finances and felt embarrassed again. I was young and not well off . . . so I offered the limit of what I could afford which was 30/- and they accepted and I went off with the picture . . . but I felt uneasy about the price I'd paid. Perhaps because Mrs Craske had shown obvious reluctance, for 30/- seemed to me to be a decent sum of money . . . But I felt uneasy.

. . . I admired the picture very much and it went with me wherever I went. Most people laughed at it and the politer ones said it was a clever piece of work for an ignorant man to have done –

In the shorter version, it is Valentine's aunt, not a servant, who had heard of the Hemsby fisherman and there is no description of the painted room in the cottage, but *the grand picture* is the same one that is also

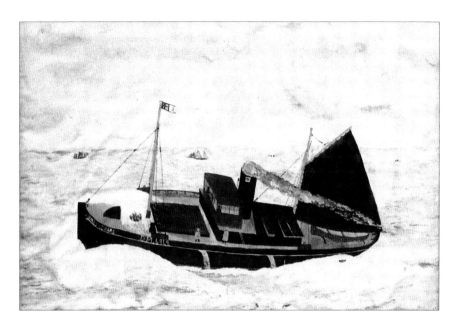

murky but fine and it is given the name *The James Edward*. It apparently doesn't belong to Laura, whose shyness and spectacles are not mentioned.

Valentine asked if she could buy it. *The utmost money I dared spend was thirty shillings; I was ashamed to offer so little, but they seemed to understand, and let me have the picture.* What is more odd and startling is that Valentine now says that she took the picture to her cottage in Dorset and *it was seen by many people who knew about pictures and much admired.*

But anyway, there I was, following the path between the sand dunes that connected the village of Hemsby to the village of Winterton, just as Valentine must have followed it some eighty-five years ago, when she set out to buy a toy boat.

I reached Winterton and climbed a steep bank up the dunes sign-posted to the *Hermanus Holiday Homes*. I asked two men carrying ladders and paint if they could tell me where I could find Hill House and they

found my question silly because they had lived here all their lives. 'The hotel reception is what's left of the old Hill House,' they said.

I entered a toy town of little bungalows and round thatched huts painted in Neapolitan ice-cream colours and came to the reception which was also the Highwayman Restaurant. I pushed the shiny brass handles on the double doors and entered what I suppose is called a lobby, with the reception desk on one side and dizzy carpets on the floor and displayed in panels on walls divided into patches by black-painted beams that looked as though they were made of fibreglass.

The lady behind the desk said she had never heard of the Acklands and she didn't know much about Winterton either because she didn't live here, but she produced a booklet on the history of the village and brightened up when I bought a copy because the money would go to the church. She paused to think and said she thought the bay windows at the front of the restaurant might be part of the original Hill House, but she wasn't sure.

I walked into the village and made a photograph of the pub sign for the Fisherman's Return which Valentine and Sylvia had written about. On one side it shows a Yarmouth steamboat approaching the shore in rough seas and on the other side a twinkly fisherman is embracing his wife, while the wife's lover watches nervously from the shadows. In 1750 a man's leg bone was found near the pub, and it weighed 57½ pounds, which makes it sound like the leg of a giant, and in 1901 some people found a Roman bath on the North Road but they broke it up to use as rubble. I wonder if there were carvings on the bath: nymphs and satyrs, gods and maidens. It must have been an odd sensation to destroy it, smashing the past into fragments so it could be made into a new road; but then I reminded myself that in nineteenth-century Rome many marble statues were ground into a fine powder that was perfect for making cement.

I went back across the dunes and down to the beach. I found a pebble which I liked and put in my pocket. I passed a couple and a dog and the woman, who was old and had no teeth, smiled at me and said, 'Excuse me, sir, is the beach nice?'

'That's not a man it's a lady,' said her companion, who might have been her son.

'Oh, I thought you was a man on account of you wearing a hat,' she said and grinned her gums at me.

I went to the pub for lunch. The screen above the bar had a slide show of guests all made up and dressed in Halloween costumes. The bartender was halfway between a boy and a girl. There was a Ladies' Night poster of a man's body naked from neck to knees, holding the details of the evening in front of his private parts. In the ladies' loo you could buy a mini battery-operated sex aid for three one-pound coins from a dispensing machine next to the Slimline Sanitary Packs which were only one pound. An enormously fat lady wearing a floral top and big earrings was saying, 'I told 'im I wanted to party,' while she dried her hands on a green paper towel.

The telly was on, as well as the jukebox and the quietly shifting slide show of the Halloween party. I watched an advert for Save the Children in which dark-skinned toddlers were crying because they had nothing to eat, and then a lady in a bubble bath was telling me about the Victoria Plum bathroom sale and then we were back into the middle of a film about soldiers doing their best in a foreign land with a lot of water and paddy fields, so it was probably Vietnam.

A tiny old woman was one of a group at the table next to mine. She kept smiling a curiously open smile, like a lonely child.

I said hello and she leant conspiratorially sideways on the arm of her chair and said, 'I was born in nineteen twenty. It were good times and bad times, but perhaps it were better then. Were if better then? It

were good times and bad times. My dad had a butcher shop, he took meat round on a cart. Ooo, we all had to work hard! I went on me bicycle to Lowestoft and came back in the dark but you weren't scared of them things then. It were good times and it were bad times. Nice talking to you.'

35

The Kind Doctor

NOVEMBER 2012

> . . . In all my books I have been drawn to people
> who are in some way trapped by their own
> circumstance. Napoleon on Saint Helena, Daisy
> Bates in the desert, Billie Holiday in racist America,
> Goya with his deafness and now here's John Craske
> hemmed in on all sides by poverty and illness,
> combined with the curious wordlessness of his
> nature. (FROM MY NOTEBOOK MARCH 2012)

John and Laura left Hemsby and returned to East Dereham early in 1929 because John's brother Robert who lived above the Craske fish shop had died of some sort of collapse. They attended the funeral and almost immediately they were drawn back into family complications. According to Laura's more emotional version of their life, John's youngest brother *had taken possession of the shop. We were not consulted in any way. Our money, what we had, was in the business. This again was a big hindrance to John. He felt he had been pushed out of everything he had worked for . . . In coming to this house, it had been sadly neglected. I had myself to paper and clean the six rooms. John was too ill to help me.*

In March 1929 they moved from 41 to 42 Norwich Road, the house where brother Robert had been living. And there they stayed for the rest of both their lives and never left the town, except when John had to go to the Norwich Hospital for treatment.

John was again seriously ill. The doctor said he had diabetes, that was the name of his trouble.

I wanted to know more about the kind doctor who was responsible for the care of John Craske for so many years and realised I had a phone number for his son, John, written by hand on a photocopy of a local newspaper article about the Craske family that someone had given me, but I have forgotten who.

The article appeared in the early 1990s and when I dialled the number the man who answered said he was not John, but Philip, the doctor's grandson. He sounded shy but friendly and said yes, he did have some paintings and embroideries by John Craske and also a poem his grandfather had written about him and maybe other papers, he'd have a look. We made an appointment for me to visit.

Philip appeared as soon as I knocked on the door. He wore a town councillor's plastic identity badge hanging from a long blue ribbon around his neck.

He ushered me into the hall and apologised for the untidiness. Heaps of papers, magazines, boxes, books and items of china had gathered close to the front door, as if they were planning a mass exit. A fat ancestor stared at me from one wall and a thin ancestor stared at me from the other wall. A steep flight of stairs led into the hallway and an electric stairlift was fixed on the inside rail, neither halfway up nor halfway down, just like the grand old Duke of York's 10,000 men.

'That was for Mother,' said Philip, when he saw me looking at it. 'She died two years ago.'

Having made her first entrance, Mother continued to appear in the conversation, as if she was not far away and was listening to everything being said, making sure she was not forgotten.

Philip led me into a large sitting room in which there were more gazing ancestors. Pastel-coloured teddy bears and soft toys from his childhood were heaped up on the sofa in the company of the more morose and stiffer-bodied teddy bears that had belonged to his father,

or perhaps to his grandfather the doctor. He told me which but I didn't make a note and now I have forgotten.

The paintings and embroideries by John Craske had been carefully laid out in a row along the seat of the sofa, underneath the watchful eyes of the teddy bears. There were seven of them and they were all in frames, apart from a little watercolour painting of a sailing skiff rounding a headland which was on a scrap of thin paper no bigger than a small postcard that had been placed under a loose piece of glass to keep it flat and to stop it from fluttering off. Philip explained that he had only just found it, when it fell from Grandmother's prayer book while he was looking for things to show me.

Philip said his grandmother, the doctor's wife, was known in the family as Granny Cats, because she was much more affectionate towards her cats than she ever was to human beings. 'It was understandable in a way,' said Philip, 'because Granny Cats's mother had died while giving birth to her and then her father died when she was just seven or eight years old; so cats were her best and most constant friends.

'Her father was killed by that,' said Philip, pointing towards a dark piece of Victorian furniture that stood in a corner of the room: a mahogany cabinet, surmounted by a mahogany and glass bookcase with the tight rows of books, listening as the story was told.

'He was getting a book down from a shelf when the top half fell on him. It's very heavy, but he wasn't killed at once. He died later, of septicaemia.'

Philip and I both looked at the bookcase with a mixture of awe and disquiet. I couldn't help expecting to see old bloodstains on the carpet, but if they were there they were lost in a patterned swirl of other colours.

I was left alone in the sitting room while Philip went upstairs to look for a family photo album and his grandfather's notebook and anything else that he thought might be of interest. I made photographs of the

Craske pictures, lined up all together on the sofa and then of them individually. I found it was best to lean each one at an angle by the armrest, so as to catch the most of the daylight from outside. With the smaller ones, I carried them over to a round sidetable that was closer to the window, balancing them on a scattered heap of steel knitting needles that I didn't want to disturb; I felt they had probably belonged to Mother and by now I was a little in awe of her.

There were some lovely paintings and embroideries. I especially liked the one of a ship in a storm done in all sorts of greys, but above all else I liked the tiny slip of an image that had dropped out of the prayer book. John Craske had written his name in black paint in careful but shaky capital letters in the bottom right-hand corner and he had written PEACE BE STILL over the top of the image.

Philip came back with the photograph album and there was Grandfather the good doctor, tall and pale-eyed with a big blond moustache and a look of benevolent abstraction on his face. And here was Granny Cats his wife, also abstracted, but less benevolently so, or was that my imagination? And here was their infant son who appeared so thin and wan and that you would never expect him to survive into adulthood, but he got through and became a solicitor and married and had a son called Philip so that was good.

I looked at the doctor's notebook. Poetry was clearly part of a family tradition. The doctor's brother, who was also a doctor, had written 'Ode to my Hot Water Bottle' in which he praised this kind friend which kept his feet warm at night while the doctor himself wrote a poem every year for his wife's birthday and his son's birthday and he wrote odes for his friends and patients and to commemorate all sorts of small events. There was one ode dedicated to *Miss Claye who knitted my socks*. Another, dated March 19 1933, was dedicated to *my friend John Craske*:

> *Painter of Pictures, Fisherman is he*
> *Whose memories of his early life at sea*
> *He now portrays . . .*
> *in paint or sometimes silk*
> *Most dexterously woven as he will.*

Dr Duigan had been a workhouse medical superintendent from 1906 to 1945 and he kept a separate notebook of his observations, with a section on Mental Deficients. *There are several grades from the idiot through to the imbeciles, the moral imbecile and the feeble-minded* and a section on *that very interesting and varied collection of humanity, the Tramps or Vagrants*, which included the story of an ex-naval stoker known as the Tattoo King, who had been tattooed from head to foot in Japan and afterwards joined Barnum & Bailey's circus at £7 a week. He left when

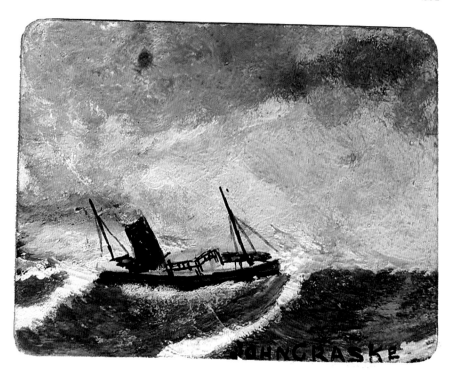

the show went to America and took to the road instead and things can't have gone so well because he entered the workhouse and that was how he came to meet Dr Duigan.

Philip disappeared again and I made notes from Granny Cats's recipe book from 1916, with instructions on how to make raw beef tea: *½ lb. lean neck of beef; 6 drops lemon juice; pinch of salt; a little water. Cut beef into strips, shred it, place in a jar with salt and lemon juice and enough water to cover the meat. Allow it to stand two or more hours. Pass through a coarse sieve, press well and get all the juices out. Serve in a coloured glass.*

I wondered about Laura giving such a drink to her husband, and whether she could afford lean neck of beef and whether she had a coloured glass to make the mixture look more appetising than it really was.

The good doctor clearly did everything he could think of to help John Craske and his wife, and because they had so little money, he must have suggested that they pay him in pictures and embroideries. There were more in the Duigan collection, but Philip's father gave several of them to Peter Pears in 1971 when there was an exhibition at the Snape Maltings.

As well as the ode and the exchange of medical help for works of art, the doctor also wrote an account of John's life which Laura mentioned in a letter, but Philip couldn't find a trace of it, not on the day of my visit, nor later when he had a more thorough search through the house. I suppose that just as the painting of a sailing skiff fluttered like a butterfly from the pages of a prayer book, so too a life of John Craske, fisherman and artist, might be hatching somewhere, ready to emerge from its hiding place in the fullness of time.†

† Just as this book was going to press Philip found four more postcard-size paintings which had been hiding among the pages of a book called *The Women of the Bible*.

Money

1928

> In the late afternoon I went walking with Emily down at Minsmere. The land so beautiful and poised and as the dusk settled, the huge moon that had been watching us vaguely through the blue sky got brighter and brighter. A murmuration of starlings and the shifting movement of deer in the gathering darkness. (FROM MY NOTEBOOK, JANUARY 2013)

Meanwhile, Valentine Ackland had taken *The James Edward* to her flat in London, or to her cottage in Dorset, where it was much laughed at or much admired by everyone who saw it, depending on which version of the story you chose. It was also much coveted by her friend Dorothy Warren, the niece of Lady Ottoline Morrell and the god-daughter of Henry James, who had a new gallery in Maddox Street that was doing rather well.

Dorothy Warren was representing the work of Henry Moore and Paul Nash among others and was the first person to exhibit D. H. Lawrence's strangely prim nudes, in a show that opened on September 18 1927. The writer himself was too ill to make the journey to London for the opening, but his wife said she would try to be there. In her diary Dorothy Warren didn't mention if Frieda managed to make an appearance, but Lawrence's planned American show had to be cancelled after the authorities confiscated a number of the paintings from the gallery.

Dorothy and Valentine were occasional lovers for a couple of years or more. The people who knew Dorothy described her as a dangerious

sadist and all her relationships with both men and women involved blood and bondage and laudanum and a lot of shouting and screaming and throwing things about. But she had a good eye for art and business and having admired *The James Edward*, she twice offered to buy it for £10. When Valentine refused, Dorothy gave her a blank cheque and told her to visit the Craskes as soon as possible and to obtain as much of John's work as she could, for whatever price he was asking, and then she would put on a show for him.

Valentine cashed the cheque for either £20 or £25 and off she went. She hoped it was the larger sum that she had ready in single notes in an envelope in her handbag, but in retrospect she had the sinking feeling it was the smaller.

She drove from London to Hemsby where she learnt that the Craskes had moved back to East Dereham. According to the shorter account, this was in 1928 and she was travelling alone, although Laura – whom I tend to trust more – remembers her arriving at the house with her mother in tow and the year was 1929. Perhaps Valentine felt that her mother's presence would make the visit seem less eagerly acquisitive to the Craskes, and then in describing it later, she wanted to appear more independent and so her mother became an unnecessary appendage in the adventure and her presence was removed.

Anyway, there she was or there they were, through the metal gate and walking up the little path and past the concrete whale pond, if it has been made by now, and knocking at the front door of 42 Norwich Road, which has since been demolished and replaced by the forecourt of a car repair shed that also does MOTs while you wait. Laura let them in.

According to Valentine's longer version, the meeting went like this.

I knocked on his door.

The door was opened by Mrs Craske, who looked ill and tired. She started when she saw me and said, 'Oh – you've come back! I've been feeling so bad ever since you came and bought John's picture—'

'So have I' – I said

She looked embarrassed and went on hastily: 'I know we charged you too much for that . . . it wasn't worth half of that – John and I have often worried about it. I am so glad to see you again.'

She went on to tell me, when I questioned her, that her husband had been very seriously ill: he had diabetes and it had flared up again and the doctor had told her there was little or no hope. John lay indoors, she said, unconscious and she feared dying.

I saw him. He looked desperately ill. I told her why I'd come. The whole house was covered with paintings. Doors, mantelpiece, ornaments – everything that had a surface that would take paint had been used. And framed pictures hung on the walls: in many cases he had made the frames by sticking shells and pebbles on the wood-work.

I gave her the £25 and took away sketches and unframed pictures of all kinds. It turned out that they had almost no money in the house at all and she told me my visit was a direct answer to prayer. Both she and John Craske, she said, were faithful believers in the goodness of God.

In the shorter version, Valentine told Laura,

I had been sent down from London by the owner of an art gallery who had admired The James Edward. *I explained she wanted to buy any pictures John would sell and that I had brought some of the money because she wanted me to take the pictures back with me so that they could be shown as quickly as possible.*

I wondered whether I ought to do this or whether I ought to wait until John got better, if he did get better, so that he could decide about his own work. Then I thought the chance might be lost, Dorothy might be booked up and perhaps Craske's work would never go out into the world.

I think I tried to explain some of this to Laura. I know she took me to see John, who was lying in deep unconsciousness on his bed. His face was stone white and his hair very heavy and dark. Laura stood beside me as I looked at him.

Then we went back into the front room and I said, 'May I look at some of the sketches?'

She . . . showed me a great many pieces of work. I chose what I thought best for showing and gave her the money I had brought – I wonder now whether it was not £20 after all?

From what Valentine wrote in this version, you get the impression that John was in another room in the cottage (*she took me to see him . . . then we went back into the front room*). But according to Laura's account, there only was the one room in which they both slept and ate and she and Valentine stood beside the bed where her husband was lying, his pictures displayed on the walls and on other surfaces all around him, and then they took a couple of paces back, in order to get on with a selection of the work.

Suddenly you can see him there, a silent witness, a man with black

hair and the pale skin of illness, lost to the world but nonetheless present and perhaps he can hear what is being said even though he cannot find the energy or the words needed for a response.

His wife and the other woman who looks like a man talk about him and about his work and its value, as they move from one picture to the next. He hears, or perhaps he just senses, as a picture in a frame is lifted from the wall; perhaps it's the frigate in a storm, which he decorated with little shells stuck on with glue. He hopes they are careful, that the fragile shells won't get broken.

His eyes are closed and his face is as shiny as candlewax. He hears, or perhaps he just senses, a rustling sound as one and then another painting on paper is picked up and placed on the table. They are putting them into two piles, the good and the bad, the sheep and the goats, the damned and the saved. He vaguely hopes they don't take any of the bad pictures, the ones where the rigging is wrong, where the tilt of the ship does not agree with the pull of the current, the push of the wind.

Inside the vague territory of his head he is aware of the soft deep music of Miss Ackland's voice and he almost remembers her from the last time, when she came to Hemsby and wanted a wooden boat and bought his first painting instead. He still misses that picture because it was the first he ever did, even though he welcomed the money and what it could buy.

Miss Ackland is saying how nice this one is and she will take it and then she pauses for a moment and says this one is not quite as nice and so she will not take it. And all the while poor Laura is apologising because it seems wrong to pay money for things done on nothing but a scrap of old cardboard or a sheet of paper better suited for wrapping up a piece of cheese.

The pile must be getting bigger and bigger and John Craske wonders from within his own silence what will be left for him to know himself

by when he returns to the surface of this strange sleep that keeps pulling him down, making him into a drowning man.

The pictures that connect him to his life are being carried away. The lady is even talking about the doors and the window sill and the mantelpiece, perhaps she wants to cut them loose with a saw, or prise them off with a chisel, so they can go to London as well. He wonders vaguely if she wants to take the little painting of the bunch of herring in which their faces turned out such an odd brown colour and their bodies look so thin and limp, there'd be no meat on them if they were eaten.

Valentine goes in and out of the house as she fills the back of her car with everything that has now become her property. She hands over the twenty or twenty-five pound notes and says goodbye to Laura and says *Goodbye John* to the man lying motionless in the bed, even though she knows he can't hear her. And then she vanishes into the night, back to London.

Dorothy Warren was very impressed by the sheer quantity and quality of the work that was presented to her. Valentine remembered *feeling bitterly angry with myself for not having more imagination, for not imagining myself in Dorothy's place when I cashed the cheque . . . for when I told her what I had paid out, for one moment I saw a look of incredulity on her face. . .*

Laura wrote: *I remember after Miss Ackland and her mother had gone, how I knelt by the chair bed in the corner of the living room where John laid and thanked God he had sent some help to me. I needed it. It takes a lot of money in sickness. How God undertook for us both. I remember telling Miss Ackland she had given me too much money. She said they were worth it. Those pictures looked very poor, to me.*

First Exhibition

1929–30

Suspended in the present moment. Blue and pink
flowers on the table. Dark night outside. John
Craske waiting patiently to be let in, his big hands
moving as he stitches the surface of the sea.

(FROM MY NOTEBOOK, JANUARY 2013)

The pictures that Valentine brought to London caused a buzz of
excitement among those they were shown to and Dorothy Warren wanted
even more of them for the planned exhibition. And so sometime in June
1929 she and Valentine set out together to East Dereham, to collect a
second batch.

They expected to find John Craske still lying on his bed in a stuporous
state, but he was much better.

Valentine, in the longer version of what happened, wrote:

*Mrs Craske told me that he had rallied a little after my
departure and she had been able to show him the twenty-five
notes and tell him how they'd come. And this, she said, put
heart into him and he had rallied more and now he was so
much better that she had found he fretted to work again and as
he couldn't see to paint, or sit up properly to his work, she had
bought him some canvas and some silk and he had embarked on
a new technique and was making silk works. I saw some and
they were very fine indeed.*

My friend bought some pictures, needlework and watercolour.

It was interesting to hear John Craske, sitting up in bed, discussing prices with her. Laura Craske showed shyness and fear that they might be cheating, but John meticulously measured each work by the time he had spent on it and the pains – and he held out sternly for fair prices. When my friend left she was carrying some of his finest work, but he had been fairly paid for it. I went back to reassure Laura Craske that her conscience could rest, and that John had behaved honestly. She took some time about believing this, but John had no misgivings.

In the shorter version, Valentine called her friend by her name and said:

Dorothy was enthralled by them both, by the house embellished from roof to floor by John's work, by the large fish he had made, from concrete stuck with smooth sea-pebbles, which was outside in the garden.

. . . Craske is undoubtedly a very great artist; that is so obvious from his work that there is no need to enlarge upon it. But as a person he is little known and as a person he is very exciting to the visitor.

He is middle-aged, tall, burly; he wears a blue sailor's pull-over and his eyes are blue and bright. He has a stern, intellectual face, with a beaky nose and fine bones. He is decisive and clear-thinking, but without any blanketing of theory or art-talk. He paints from what he calls 'memory' and when he was telling me about two pictures of coastline he said 'that one is Yorkshire and that one is Imagination'. He knows the exact history of every boat he paints, the story of how a boat looked, where she went, what the weather was like and who was aboard her. All these are practical concerns of his, but beyond them he had something else, betrayed in this, for instance:

*I liked a certain picture and thought it very fine indeed. He
disagreed, but gave no reason for disagreeing until he saw that I
really wanted to buy that one, then he definitely refused to let
me. 'It is not right yet,' he said, 'I think I need to alter this,' and
he took it away and looked at it carefully and then put it by.
Later it was altered and up for sale.*

The exhibition opened in August 1929. According to the biographical
information in the catalogue, John Craske was a *deep-sea fisherman who
was seriously injured in carrying out his duties as a volunteer mine-sweeper
in the last war*. I have no idea who decided that this was the best way
to describe his condition and his current state of health.

There was a drinks party on the first night and several reviews
appeared in the London papers.

The Times declared *the ship pictures by Mr John Craske are definitely
– if crudely – works of art. Mr Craske, until the effects of being blown up
as a volunteer mine-sweeper compelled him to abandon the sea, was a
deep-sea fisherman on the Norfolk Coast and it is very unlikely that he has
ever heard of translating nature into terms of the medium. Nevertheless,
that is exactly what he does, by sheer simplicity and directness of execution.*

The man from the *Daily Mail* wrote: *A popular artist, in the jargon
of the modern connoisseur, means not an artist who enjoys popularity, but
an untrained man of the people, who practises art from sheer enthusiasm.
Such a one was the Douanier Rousseau in France and such a one is
fisherman John Craske, whose work, though childishly naïve, has
extraordinary charm and decorative effectiveness. The hero of the hour
himself, a humble, God-fearing man, was not present as he is seriously ill.*

A number of pieces were sold both during the show and in the year
that followed: a small framed watercolour went for £2.10s, while an
embroidery made three times that much. Dorothy Warren kept a gallery

notebook and in it she recorded sales and comments by the public alongside the comings and goings of her artists:

> *Jan 11 1930: Mr Henry Moore called to collect all his drawings, framed and unframed, and six pieces of sculpture, leaving only two pieces of sculpture,* The Mask *and the* Japanese Dancing Girl's Head.
>
> *August 18 1930: Count Fery Erdovy called . . . He greatly admired the Craskes.*
>
> *September 8 1930: The sold pictures by Craske were taken down to be delivered to their owners and the residue of pictures rearranged.*
>
> *September 9 1930: Mr Roy Baker of the American Consulate called. He was impressed with Craske and hoped to be able to acquire one . . . He purchased the* Ladybird *by DHL and says he owes this gallery a debt of gratitude for having taught him to appreciate Lawrence.*

First Embroidery

1929

A muddle of little birds in the snow. Sudden
explosions of blackbirds, using all their energy in
fighting each other even though there are plenty of
apples and porridge oats for all of them. Herman
feeling very frail. I drift without focus. Thoughts
on Craske move like clouds through my head.

<div align="right">(FROM MY NOTEBOOK, FEBRUARY 2013)</div>

This is Laura's account of how John came to do his first embroidery. I
think the year was 1929, but I'm not sure, it could be later. I think they
must have just moved into their own little house at number 42 Norwich
Road, very close to Laura's mother, and maybe the mother is staying
with them for the time being because John is very unwell, restless and
unhappy with Laura struggling to look after him and to pull him back
from despair. Or she has come to help, as she does most days.

> One evening John was so distressed while there, he would not
> settle to do anything. I said, 'Shall we try to make a picture?'
>
> Mother found an old frame up and then I said, 'Mother, have
> you a piece of calico?'
>
> Mother replied, 'Only my new piece which I have bought for
> my Christmas pudding.'
>
> I looked at her and she looked at me and then said, 'Oh – let
> John have it!'
>
> We tacked it onto the frame. John drawed a boat on it.

We found some wools up and I showed John the way to fill it in.

He did it. Then when we came to the sky we had no wool suitable and no money to buy any with. I remember, I mixed some distemper in a saucer, gave him a brush and with Mother's blue bag he made the sky. Named the boat, I believe, Bob Roy.

That was the first picture after he got settled again in our home.

A nephew of John's, who was about nine years old at the time, remembered going to a shop in Dereham called Fancy Fair, to buy embroidery yarns. The boy set out from 42 Norwich Road with a couple of pennies to spend and came back triumphant, holding a paper bag filled with bright threads of colour.

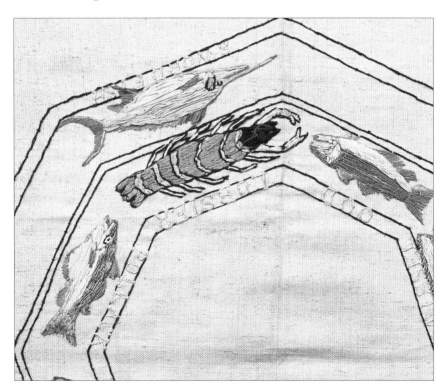

Craske had of course been ill many times before, but now he seems to move towards a more serious state, tumbling into a deep stupor that could last for months on end. Laura felt she could not leave her husband's side for a moment. She had to rely on her mother for practical help and the goodwill of neighbours for shopping. The rest of the Craske family provided a supply of fish and a financial allowance from the business.

The doctor was called in, but he felt at a loss, unable to see what could be done to help. He advised Laura to let her husband go, but she was not willing to do that and she persevered, dogged and determined, moving through the days and the nights, from one to the next. It seems that as mysteriously as it had begun and taken root, the coma – if that is what it was – diminished, and then it had gone and life returned to its quiet and uncertain pattern.

And he just picked up his work where he had left off and would say, 'Have I been away again?'

I would just say, 'You was tired and wanted extra sleep.'

He would say, 'Oh yes.'

When much stronger, and able to step again, I spoke of his work, but he had forgotten.

He started drawing again and we got back to stitches again after this long rest.

He started doing wonderful pictures. But I want to put it on record that John made every picture. I never did any sewing of the pictures and often I have been amazed at the wonderful colours he has chosen; indeed his work was his delight.

From this time he did painting and Needlework during which time he was subject to Mental Stupor.

In the early summer of 1934, a man from the *East Dereham Times* came to visit John and Laura at home.

LY 7 1931.

JOHN CRASKE, ARTIST.

Dereham Ex-Fisherman's Fine Work.

John Craske never went far beyond the slate and pencil stage at school in art education, and by the time he was eleven years of age, he was sailing the high seas with his father, a Grimsby fisherman. Not much of a start on the road of art.

Yet John Craske is an artist with distinction. So much so that last year he had pictures accepted by the Warren Gallery in London. He had never been inside a picture gallery, but that mattered not. John Craske, a Norfolk invalid ex-fisherman, the National Press described him. Few knew he was a Dereham man and that the efforts the Warren Gallery was prizing had matured in a little cottage in Norwich Road, dabbed to completion with bed as the easel and bedroom as the studio. For days he would be too ill to do anything.

I found him one afternoon perched in a chair overlooking his garden. It is not long since he ceased to be

Mr. John Craske.

John Craske never went far beyond the slate and pencil stage at school in art education and by the time he was eleven years of age, he was sailing the high seas with his father, a Grimsby fisherman. Not much of a start on the road to art.

Yet John Craske is an artist with distinction. So much so that last year he had pictures accepted by the Warren Gallery in London. He had never been inside a picture gallery, but that mattered not. John Craske, a Norfolk invalid ex-fisherman, the National Press described him. Few knew he was a Dereham man and that the efforts the Warren Gallery was prizing, had matured in a little cottage in Norwich Road, dabbed to completion with bed as the easel and bedroom as the studio. For days he would be too ill to do anything.

bedridden. Some thought he would scarcely walk again. Not so, Mrs. Craske. With unswerving devotion, she nursed him year in and year out. He went into hospitals in different parts of the country and spent some time by the sea, but it was left to Dereham to see him conquer the adversary to any extent.

It was in pre-war days that Mr. Craske first came to Dereham to open a fish business, of which he is still a partner. He brought with him wide practical experience as a fisherman, having lived a breezy North Sea life for years before. The war came, and he joined the Bedfordshire Regiment. He saw little of the conflict however, because it soon robbed him of his health with a complaint which has held him a victim on and off ever since. It was because time hung on him so wearily that he first began to look for an outlet for his artistic mind. To begin with, a few stitches of silk on something were all that was attempted. The stitches grew, and, bedridden though he was, it was not long before pictures in woven silk began to make their appearance.

MAGNIFICENT PICTURES.

You have only to walk through Mr. Craske's house as I did to see the development that has taken place in a man with no education in the craft. There could be no fairer example in the utilisation of a gift of God. There are water-colours (scores of them), oil-paintings and several magnificent pictures woven in silk. The subject of all is, broadly speaking, the sea.

Mr. Craske, in the technical terms of an old mariner, reeled off the names of all the boats and ships tossing about on the tempestuous seas he has created, and the more you looked at them the more the detail was apparent. If there was a shore scene, the population on view were all doing something with a common object. Mr. Craske's fishermen weren't idlers. One would be painting a boat, another setting out, equipped to the teeth, to look for worms and bait. One of his best efforts is in silk depicting the interior of a boathouse. As a work of art it is worthy of all admiration, and as a mastery of detail it is perfect. Nothing has been overlooked, not even the pans with which to bale water from the boats.

Mr. Craske has lost the vitality which characterised his early days as a fisherman, but his memory is alive with the past. You can see it in his pictures. There is scarcely a picture which hasn't a sea which is surging and rolling. They are alive and you can almost feel thatoonj feel that you can almost hear the roaring.—W.J.H.

I found him one afternoon, perched in a chair overlooking his garden. It is not long since he ceased to be bed-ridden. Some thought he would scarcely walk again. Not so, Mrs Craske. With unswerving devotion she nursed him, year in year out.

Embroidering Men

Herman and I have entered a new and unfamiliar
territory. Stroke-country he calls it and we don't
know its ways and are uncertain about what
damage it has already done and what strange
attacks it can make in the future.

(From my notebook, Amsterdam, February 2013)

The process of stitching a picture is very different to putting paint on
paper or canvas; it is much slower and more passive: a quiet and quiet-
ening activity in which the stitches have their own rhythm of repetition.
It cannot be hurried and once you have fixed on the design, you can
work on it in patches as you might with a jigsaw puzzle, filling in the
areas of colour with the thread that you have on your needle and then
threading it with a different colour and moving on to other patches that
demand your attention. The stitches are words on a page that cannot
be read, the notations of a silent song.

For me the idea of embroidery has always been synonymous with
stifled emotion: a silent woman sitting poised on a chair in a closed
room, working an intricate pattern into a tiny piece of cloth, while waiting
for her child to be born, her true love to appear, her husband to return,
or the pain of life itself to move on and be replaced by gentle death.

But it is an art which has often transformed itself from one generation
to another and after the chaos of the First World War, when so many
men were traumatised by what they had experienced and crippled by
the wounds they had suffered, it was taken on as something that could

help to keep a person connected with the world, to steer a person's mind away from other troubles.

I went to see an expert on embroidery, who told me fascinating stories about the art. She told me that Desdemona's handkerchief was Egyptian silk embroidered with strawberries and Mary Queen of Scots made stitches that went in all sorts of directions but still they were exquisitely beautiful and I should go to Oxburgh Hall in Norfolk to see them for myself. One of the reasons Mary Queen of Scots was beheaded was because her last embroidery showed her half-sister Elizabeth's vine as a mass of twining leaves and tendrils but no evidence of the ripening fruit of children, while her own vine, ennobled with the Norfolk arms, was heavy with bunches of grapes. It was a statement of defiance: a treasonous embroidery. In prison Mary sat in the Tower alongside Bess of Hardwick who had married their jailor, the two of them stitching day after day as death moved closer.

It would have been, she said, very uncomfortable for John Craske to stitch while lying in bed. Firstly, you need natural daylight and in a small cottage it was unlikely that the bed was close enough to a good window. But more importantly, you stitch towards yourself if you are right-handed and always down from the top because you use much more thread if going up from the bottom and sitting propped up in bed would make it very difficult to get your hands behind the canvas. She was quite certain that my Mr Craske could not have worked as I had imagined him working, lying flat on his bed with the frame made from an old deckchair suspended above him; you need to place the needle from the other side and on a taut cloth it would not be possible from a supine position. Even with pillows behind his back it must have been very difficult. It was only after this meeting that I learnt John Craske was left-handed, but I never got round to finding out if that made it easier for him to make stitches while lying in bed.

Apparently, before the last war, the wool for embroidery was composed of much finer threads because the sheep were on fields that were not artificially fertilised and so the grass was less rich and their wool was less thick. And before the last war the wools and silks were dyed with natural vegetable dyes and so the colours were not so harsh and bright as they are now. Silk threads can be wonderfully vivid, she said, but their colours are quicker to fade than wool, especially the greens, which often turn into a rather lovely shade of blue. Chemical dyes were developed in Germany just after the last war and the first colour they produced was a sharp and almost iridescent purple.

She said embroidery was a tribal activity and very soothing to do, like monkeys grooming each other. It was a source of immense sorrow that her hands were now too damaged by arthritis for her to do any more needlework. 'I used to sit and do one leaf and that would be three hours of uninterrupted stitching for an area of maybe three by three inches,' she said.

For many years she had taught embroidery to prisoners. Most of her students came from the vulnerable prisoners wing, the people who couldn't work in the kitchens or other departments because there was always the danger they might attack or be attacked. They'd begin with something small like a spectacle case in simple cross-stitch and then they moved on to standard cushions and more complicated stitches.

She told me that when I had a chance to examine the back of a Craske embroidery I would be able to see if he used wool or silk or a combination of the two and of course I could tell at once how much the colours had faded and even how many threads he had in his needle and whether he used knots because a good embroiderer doesn't use knots, but works from what is called a loop start.

I knew he worked with a simple sailor's long stitch and developed

his own sort of stuffed stitch for doing the breaking of waves and he
learnt to make wonderful twirling embroideries in which the clouds seem
to boil in the sky and the sea seems to be rising and falling upon itself.
There is one image in particular in which a little lifeboat is setting out
to rescue the crew from a big liner and as well as the boiling sky and
the heaving sea there is a snowstorm which flecks the air, the water and
the boats with a Morse code of little white dashes. Just looking at the
picture, you get the sense of his determination.

She said that if I wanted to know more about men doing embroidery I should visit an organisation called Fine Cell Work. Founded by Lady Anne Tree in 1997, it introduced embroidery to men in prison and it had become a successful business enterprise. Later I arranged to meet a man called Martin who worked there and had agreed to talk to me. He was shy and formal in equal measure, telling me his story as if he had learnt it by heart, but that was OK, it was good to listen to him. I had been told not to ask any personal questions and to not try to enquire about the nature of his crime. He was only in prison for eighteen months.

'When you're sent down you're in that prison, you've got to work, get yourself a job or an education; if you don't you're just banged up. It's very lonely, you can't open a window and stick your head out, and anyway there's not much of a view. So your mind starts to wander, you have regrets, thoughts about where your life is going. I went to the workshop and there were only three others there and I didn't know how to sew by hand or how to use a sewing machine, but it went well and by the time I left there were twenty or thirty men, making purses, cushions, aprons, scarves, making stuff for Barnardo's.

'For those of us lucky enough to have their embroidery, time just flies and you just don't want to stop doing the work. It's not the money, it's about creating something, making the time worthwhile.

'Now I do cross-stitching at home, I make my own design. When I did art at school, they said *draw yourself* and that put me off. For my first work at home I did a square and then a square in each of the four corners of that square and then a square in each of those four corners as well and it looked nice. I got a picture of a puppy dog from a pound shop and I ended up with a twelve-by-twelve dog. I've been doing roses, that's fourteen by fourteen, a full-blown rose and a bud and one starting to break out. Somehow I didn't want to do the dead rose. It can be

stressful because you don't want to stop until you have finished and so you go on and on and don't notice the hours.

'Everyone in prison wanted to know how to get involved in embroidery. You'd expect it to be the women, but in a man's prison when they see it being done, they see there's no stigma, no teasing. One guy has been there a few years and during the summer, the biggest trouble is the gnats coming through the windows and so he got some net and made a fabric frame and took it to the governors to see if he could use it as a screen and make the same for the other men. The governors were keen, but the security guards stopped it because it would be one more thing needing to be checked for drugs, razors, that sort of thing.

There's a biker with a long goatee beard who works here, he does fantastic stitches. It calms you down. Fine Cell Work has saved my life, to be honest, if it wasn't for them I'm not sure if I could have coped. They got me put on a course for making curtains. I live in Clacton and my ambition is to make cushions and curtains for people in the caravan park close by. That would be nice.'

I was introduced to Joseph who teaches at an art school and specialises in embroidery. We spoke on the phone and he said his grandmother left him her sewing machine, much to the horror of his parents. He is interested in the issue of femininity and masculinity in the process of stitching. Really it's for anyone who is trapped, just as women were trapped. Sailors, soldiers, prisoners, hospital inmates, they all needed to find a way to survive isolation, incapacity, boredom.

Joseph told me how Ernest Thesiger was wounded in 1915 and both his hands were damaged, and he started embroidery and set up the Disabled Soldiers Workshops in Ebury Street, London. The Imperial War Museum has a collection of samplers done by soldiers and there's something called the Thesiger kit, for crippled men. They all did their own designs, little embroidered handbags, things like that. Joseph said

he would try to find a photo of soldiers with crippled hands, showing off their work, but he never got round to sending it to me and very soon I became too distracted by what was happening in my own life to ask him again.

Valentine and Sylvia

1930

> I thought of the image of a candle burning in a
> window and that seems to be all I can give him, all
> that I can do for him; although maybe a night-
> light is better, flickering and not strong, but
> lasting until the morning. I am walking beside the
> man I love but I am not able to save him from the
> many frailties of his body, I am just able to keep
> him company. (FROM MY NOTEBOOK, FEBRUARY 2013)

In 1930, Valentine and Sylvia Townsend Warner became lovers. Sylvia was thirty-nine and feeling increasingly dowdy and insecure in spite of being an established and successful writer, while Valentine was twenty-three and as yet unpublished and often feeling very tipsy, with the growing fear that being happy would surely get in the way of ever being a good poet.

They stayed together until Valentine's death from breast cancer in 1969. Sylvia was always faithful and devoted, worshipping her beloved's melancholy beauty, her fox's smile, her arched instep, her willowy body, her languorous walk, her skill at catching trout, and her early appreciation of the works of John Craske which quickly became one of their several shared passions. Valentine answered this devotion with feelings of unworthiness and doubt and ambivalence and regular infidelity which Sylvia knew about and did her best to tolerate.

In 1931 Dorothy Warren was keen to do another Craske show, but there is the sense that her enthusiasm was fired more out of her

resentment of Sylvia and a wish to recapture Valentine, rather than any grander hopes for John Craske's reputation. She must have discussed the idea of a show with Valentine who had also been thinking about the idea of doing another exhibition and was rather angry that Dorothy was stepping on what she considered her patch, *I wrote to the woman who had first shown it but she refused to allow it to be shown at another place, saying that she had been intending to have another show of his work at that exact time and had been working hard to establish interest in it.*

In May 1931, Valentine took Sylvia to visit the Craskes in East Dereham. Sylvia was delighted with the encounter.

> *J. Craske lives at 42 Norwich Road. A red brick cottage in a row, with a front garden. He was lying in bed by the window, a crumpled-faced man with darting eyes and large pale face. Mrs C was short, upstanding, pale sallow. Her knobbed hair and folded hands gave her the air of something by Craske – a model of a woman . . . The room was filled with Craske's work, pictures in wool, silk, paint – even the ornaments painted with ships and lighthouses.*

Valentine took the opportunity of consulting Craske about another show and he insisted his work must go to Dorothy Warren. And so that was settled. Sylvia bought several pictures and the two ladies went away happy.

In her diary from a few weeks later, Sylvia wrote:

> *June 14. London. Sunday. We spent the morning rollicking in bed while the parrot squawked and whistled opposite.*
> *June 18. Teague had dinner with me. He had met Einstein at*

a lunch . . . He was, said Teague, an extremely simple man.
Perhaps that sort of simplicity which goes with genius is not only
a concomitant, but an integral part. For the ordinary mind is
teased into complexity by leaving off its thoughts to worry over
this and that.

. . . at about 2 a.m. Valentine rang up and asked me to go
round. I went. Letting me in she said, 'I have had a frightful
scene with Dorothy, the worst I have ever had.' It looked like it.
The room was all upheaved, rugs scratched up, scars on the
wooden floor, ink split, furniture awry . . . Dorothy had gone
back there to see the Craskes. Suddenly, while Valentine was
leaning on the mantelpiece, Dorothy launched herself at her and
knocked her down. The dog Rudi immediately sprang on her
chest growling, while Dorothy, seizing the kettle, threatened to
knock her face in.

Dorothy also tried to strangle Valentine with a tie, hit her on the face
with her fist and banged her head against the floor. When Valentine
went limp as a way of saving herself, Dorothy tried to throw her out of
the window. All this was followed by tears and threats of suicide and
even an attempt to tear up Valentine's poems. At one point Dorothy
stormed out, and returned a little later with a conciliatory smile to say,
You see, when I am angry I am always violent.

The Craske exhibition was finally mounted in 1933 and Dorothy Warren
decided to place a rather random selection of Craske's work alongside
that of Paul Hamanu, who had developed a technique of making very
quick life-masks. For these he painted his subject's face with a preparation
that *looked like tomato soup and smelt very faintly of vanilla. Gradually*

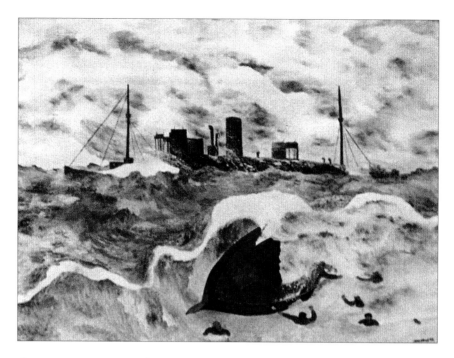

this mass . . . is spread over the features and in the last few seconds even the nose is covered. You reappear perpetuated, ennobled, with a spiritual as well as a posthumous look, after forty minutes in a chair.

This second show did not go well; there were no reviews and almost no sales. But that made little difference to John Craske who had by now suffered another serious relapse and lay in his bed in the front room while Laura fussed around him, attending to his needs as best she could and ignoring the doctor's advice that she should *let him go.* He remained in and out of this stuporous state for three years, during which time Laura said, *I never set a step outside my front gate.*

Valentine sent Laura a copy of *Bleak House* in 1933, along with *David Copperfield, Oliver Twist* and Dickens's Christmas books and she was grateful for that, because *although there is much sadness in them yet one sees another side of life.*

Sylvia was more practical, encouraging all her friends to go and see him and perhaps buy something from him. She wrote to David Garnett in June 1932.

> *How far are you from East Dereham, where Cowper died? I am concerned about a man there, called Craske, whose pictures you may have seen at the Warren Galleries . . . Craske has fallen on very bad times and is ill and miserable. I can't afford to go there myself, and I have been trying to think of someone intelligent in his neighbourhood, who would go and look at his work, and revive him. It is attention he needs, more than L.S.D.*
>
> *His address, just in case you or Ray should feel inclined to go there, is 42 Norwich Road, East Dereham. He has a nice wife called Laura. His tariff, I may mention, is moderate. One guinea for water colours, thirty shillings for the larger needlework pictures. They are both so respectable and speechless it is worth knowing this. The pictures are really magnificent.*

Trellick Tower

I said we hadn't heard a thrush since coming back
to Suffolk which was true, but just as I had
finished speaking it began a loud burbling song
from somewhere close by.

(FROM MY NOTEBOOK, MAY 2013)

Tanya, who had taken me to meet Jacynth, had just finished her book
about Michael Cardew the potter. She is the daughter-in-law of Billa
Harrod who acquired several Craskes that have now been scattered
among her descendants. Billa was a friend of the poet John Betjeman
and he had some Craskes, including a big embroidery, but I have failed
to find out where they are now. Billa was a friend of Sylvia and Valentine
and of Richard Hughes who wrote *A High Wind in Jamaica* and his
daughter remembers being told by her parents how they went to buy a
little Craske painting that is now in her possession. Desmond MacCarthy
also had some, but I haven't tried to get in touch with his descendants
and I don't know now if I will.

Quite by chance, Tanya is the stepmother of the man called Huck
who has the tiny boat which took Herman and me out across the Blakeney
estuary until we tipped over the side and had to walk the last bit of the
way with soft mud between the toes and salty water almost up to the
waist, but I only found out that connection much later.

I got into email contact with Tanya and we realised we had many
such overlaps in our lives, so that it felt as if we had just missed meeting
each other on numerous occasions in a long past. And when we met

she felt like an old friend whom I hadn't seen for some time, even her quiet and thoughtful face was familiar to me. We were at the same university but two years apart; we have spent a lot of time in the same mountainous valley in North Wales. Even Michael Cardew is a connection, because I knew his son, Cornelius, the one who became a very modern and political musician and died in suspicious circumstances when he was knocked off his bicycle many years ago.

Apart from taking me to see Jacynth, Tanya kept discovering new people I could or should meet who might help me in one way or another in my vague pursuit of John Craske and sometimes she heard of the whereabouts of paintings and embroideries scattered among her friends and relations. Having finished her book on Cardew, she was talking about what she might do next and she took me to see Trellick Tower, which is quite close to where she lives in London; she said she was thinking of writing about it.

The Tower looks as though it is part of a power station, or the headquarters of a Soviet intelligence agency. It was designed by the architect Ernö Goldfinger, whose name and a bit of his character was adopted by Ian Fleming as one of James Bond's malevolent enemies. Each flat has a slightly different floorplan, with internal stairs to give a sense of space and 1930s tiles in the bathroom and on the floors. Originally the tenants were provided with washing and drying machines at the end of a narrow corridor on each level, but Tanya said they were cul-de-sacs and very dangerous for a women who was doing the washing on her own and might suddenly find herself being attacked with no way of doubling back and escaping. There were other problems with the overall vision, but still there is something wonderful about such an awkward and unlikely structure growing among the streets, a big heavy beast with an odd long side structure that seems to have developed independently on a separate slow march of evolution.

We lurked around the building and went through a passageway and emerged on a patch of grass with walls around it and no one to be seen until a woman appeared on the balcony of her first-floor flat and began to hang out her washing. Is it your own washing machine? I wanted to ask, but I didn't.

We did ask her how long she had lived there and if it was nice and she was very jolly and said the flats were lovely and she was Moroccan but most of the tenants were Portuguese and she had been there for ten years but many people had been there for much longer.

We went to the library just across the road and the Head Librarian was Portuguese and lived in one of the flats, but her mother was the one to talk to because she had been there right from the beginning: unfortunately her mother was not at all well. Very ill in fact. We said we were sorry about that and hoped she would get better soon.

We went to a Portuguese shop where you could buy plastic images of the Virgin with flowers in her hair and the baby Jesus in her arms, or curious plastic figures of a fat baby girl or a fat baby boy, which were traditional christening gifts. The Portuguese teashop next door was very loud and bright, like stepping into another country.

I had a brief fantasy of working with Tanya, just as soon as Craske was all in one piece. We would go knocking on each one of the 130 doors and be welcomed inside with offers of tea and cake and then we'd talk about life and make notes and the book would automatically tell its own complex story about London from the 1930s up to the 2010s and the tenants would happily pose for a photograph with a canary or a washing machine or two children or a picture of the Blessed Lady of Fatima. But that was then and this is now.

Turin

August 2013

A storm swept up the valley and the hail fell for
almost an hour, clattering down, and I couldn't
leave my workroom for fear of being hit by lumps
of ice, big enough to hurt . . . This morning I see
how it has shattered the leaves on the trees and
bushes and has torn all the flowers into shreds;
except the sweet peas, which don't seem to have
noticed anything.

(From my notebook, Italy, August 2013)

I am not sure if I have said enough about my husband Herman and the
story of our life together. It didn't seem relevant, but now it does and
so I'll do my best, but only very briefly. Little steps towards understanding
things that otherwise might not be understood.

We had first been together in 1966 and then we parted in 1971 and
then we met up again and got married in 1999. We always had an easy
intimacy that made us presume on being understood in whatever it was
that we wanted to communicate. We laughed a lot. We seemed to breathe
with the same breath, sometimes we even had the same dreams or
aspects of the same dreams.

In 2004, Herman was diagnosed with throat cancer and during the
treatment I nursed him and watched over him by day and by night as
if he was a newborn baby. When it became clear that he had survived
the illness, the two of us entered a somehow altered world in which the
fact of being alive was in itself a bonus.

So now, this was the summer of 2013 and we were in our house in the mountains of northern Italy. It was about to be my sixty-fifth birthday and to celebrate we decided to go for a short holiday, first to Turin and then on to a village called Viozene in the Piedmonte mountains, which are much higher and wilder than the ones close to us.

In Turin we stayed in a little apartment right in the centre of the city. We had a bedroom leading into a tiny kitchen/dining room and wherever you looked there were hearts: red felt hearts in frames, clusters of dancing red hearts on the tea towels and a big solitary red heart on the bath mat; heart-shaped plates and hearts on mugs and hearts woven from twigs and festooned with red ribbons. I suppose it was a way of welcoming strangers.

On our first morning we visited the Egyptian Museum. It has the biggest collection of Egyptian artefacts outside of Cairo, including a lot of so-called *secondary items* that were rejected by other nineteenth-century Egyptologists as they rummaged full tilt through the paraphernalia of death in the opened tombs of the Pyramids. So here you can see round loaves of bread, as hard and dark as pumice stone, combs for the hair, pots to hold water, stools to sit on, faded mirrors to gaze into. And here is a simple bed on which a man once slept, more than three thousand years ago, the wooden headrest on which he placed his head, the woven web of rope which held the weight of his reclining body. Another bed close by was for his wife; I couldn't help wondering where or how they made love, since there was clearly no room for the two of them to lie side by side.

On the lower shelf of a glass cabinet there was a Soul House, made of pale ochre-coloured clay and vivid with life from the sweeping movement of the thumbs and fingers that had brought it into shape. The Soul House was not much bigger than a dinner plate and it looked as though it had been pulled apart to reveal its contents, like some fruit

can be pulled apart. A soft courtyard was in front of the House itself, with tiny sacks of grain and pots of water standing together along one wall, and in one corner of the courtyard soft steps led onto the flat roof that seemed to be in danger of sinking in upon itself. If I have understood it correctly, then these houses were made to remind the soul of the life they had once lived, in case it should ever be forgotten.

Herman had been a sculptor until his illness and he had worked a lot in clay. In the 1980s he was commissioned to make a collapsed house out of brick which was erected in a park in Holland. Children played on it, they climbed through the crooked windows and shouted with triumph when they stood on the tilted roof. He had made a little maquette of the building out of clay and that was cast in bronze and now it stands on a window ledge in our house in East Anglia, next to a Neolithic axe head that I found on the beach at Walberswick, not far from where the Little Auk was washed so unceremoniously ashore. But neither he nor I had ever seen an Egyptian Soul House before, or if we had seen one, we had not paused to notice it. Now this little model of a building seemed more powerful, more filled with thought and story than all the gold and finery and the grand statues of dead kings and queens in the museum. That is what we talked about as we wandered from room to room.

On the next day we decided to visit Doctor Cesare Lombroso's Museum of Criminal Anthropology. I had read about him and thought that his collection might be relevant in some way to my book on John Craske. The doctor was of a Jewish family, born in Verona in 1835. He was one of those new rationalists who believed that Reason and Science was bound to make the world a better place and the process of colonization would bring the gift of happiness to savage peoples everywhere.

Lombroso was very busy with the wide-reaching scope of his studies.

At the age of twenty-one he wrote an essay on the influence of Civilization on Madness and Madness on Civilization and by the age of twenty-three he had graduated from university with a study of Cretinism. At forty-one he became a professor of Forensic Medicine at Turin University and he published a study entitled *The Criminal Man*, which was eventually followed in 1893 by a companion volume, *The Criminal Woman, the Prostitute and the Normal Woman*. The Museum of Psychiatry and Criminology, which represented the embodiment of his life's work and belief, was opened in 1898.

Lombroso was the first of a narrow line of thinkers to develop the idea of analysing the intelligence, cultural development and moral character of men and women from the shape of their skulls. As his studies evolved, he became increasingly messianic in his desire to uncover every single degenerate among the criminal classes and those classified as mad, so that in an ideal world they could all be wiped out, thus enabling Civilization to move forward in easy and contented steps. Lombroso died in 1909, so he missed seeing how his theories were welcomed by the newly evolving Fascists as they set out to create a pure race of human beings.

The museum which is the home of Lombroso's obsession is to be found on the top floor of an eighteenth-century palazzo. The collection is displayed in specially designed glass cabinets and in its entirety it contains six hundred and eighty-four human skulls, eighty-eight wax and plaster death-masks, twenty-seven human skeletons, eighty-three human brains, five hundred and two examples of material evidence of crimes committed and forty-two shackles.

It also houses eighty water pitchers made and decorated by prisoners, four hundred and thirty-seven of their drawings, and a visual record of the tattooed bodies of one hundred and thirty-four soldiers visited by the doctor in 1863, when he realized that tattooing was an outward sign

of inner degeneracy. Beneath the tattooed images of roses, skulls and crossbones, men with moustaches, a ballet dancer and a bird carrying a garland in its beak, the words, *The past torments me. The present . . . The future dismays me (le passe me tourmente. Le present me . . . l'avenir me pouvante)* are written into the skin across the abdomen of one of these soldiers, while *pas de change – nothing changes*, appears in bold letters across his forehead.

In the rooms dedicated to the insane there are one hundred and seventy-five objects produced by asylum inmates, including thousands of tiny paper birds made from folded squares of newspaper and a lace sleeping cap worked by Elisabetta del Panno, a *furious maniac* from Colomo. The cap was designed to be pulled down over her face, as far as her shoulders. It has a tassel on the top and two mother-of-pearl buttons have been fixed over the place where her eyes would have been hidden beneath the dense stitch of the lace.

In this same section of the museum a large glass cabinet displays a costume made by a mad man called Versino who had the job of cleaning the asylum floors. He unravelled the rough cotton floor cloths into lengths of thread and knitted them into trousers. a sort of tunic done in layers and a long scarf and a jacket which has pink details around the neck, the sleeves and the hem. Versino also made himself a pair of boots with tie-up laces. In its totality the outfit weighs forty-three kilos and apparently Versino wore it every day, summer and winter alike.

After Turin we drove up into the Piedmonte mountains, to stay in a guest house we had visited two years before, when Herman was stronger, before he had a stroke which affected both sides of his brain equally. The stroke caused no obvious damage, but it had shocked him and left him physically more frail.

In that earlier time we went on a walk that took thirteen hours, not because we had planned it to be so long, but because we kept losing sight of the faded painted arrows and the little heaps of stones that indicated the direction we must take. The final stage of the walk followed what was called the Salt Road, used since Roman times to carry the sea salt prepared on the coast inland as far as Germany. The road was no longer a road, it was a slight smudge of a path, worn thin and unprotected as it traversed the steepest of edges and inclines. Herman was becoming very tired during this last stretch and he wavered with tiredness, so that I felt like a sheep-dog racing around him, exhorting him to be careful and steering him forward. When we reached a point where a track joined the path I left him to rest against the trunk of a tree while I raced down to the car, to drive it closer to where he was lying. It all ended well, but I resolved never again to do such a long walk, either by accident or by design.

But now, there we were, back in that same magical region and in spite of his frailty, Herman was determined to see the view of eternity that is offered by high mountain landscapes. We agreed that we would not go so far, but we would go far enough. And so we set off, following the same route we had followed before, but walking more slowly. After a couple of hours, we reached the lip of the bowl of the mountain, from

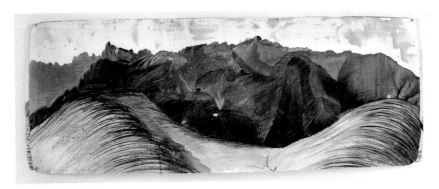

where we could look into a whole ocean of them, heaved up in great disappearing waves of distance. We heard the whistle of a marmot but didn't see its hunched form. We sat with our backs to a white boulder and ate a picnic, wind on our faces, flowers scattered among the tufty Alpine grasses, the flickering song of grasshoppers. Herman seemed happy to be there, to be taking it all in, the beauty of it.

I wandered off for a while, just far enough to get a glimpse of the tin mountain hut which provided basic shelter for anyone in need, the door unlocked and camp beds and rough blankets inside and a jam jar containing a worn piece of soap, carefully placed next to a tiny trickle of spring water. I turned to look at Herman sitting beside the boulder and because he seemed so far away I hurried back to be close to him again.

The next day we walked up through a forest of old spruce trees, pale green lichen hanging around the shoulders of their trunks like lace shawls. There were lots of fritillary flowers and other flowers whose names I did not know or cannot now remember and termite hills constructed from fallen spruce needles, urgent with angry life if we disturbed them.

We met a man who told us that we could make a circular journey by following a path going down between the two high trees we had just passed on our left. He said that as long as we continued to go straight, we would not get lost. We trusted his instructions and sometimes the path appeared clear and strong and then it faded away again and sometimes it was so steep we had to grasp the branches of little bushes to stop us from tumbling forward and down. But we got back safely.

It must have been either on that day or on the day before that I lost the diamond from the ring Herman had given to me for my birthday just a year before and I kept thinking of it, lying somewhere among the tufts of grass or among the pale stones, glinting abstractedly in the

sunlight; or perhaps the ants had carried it into their city of pine needles, or it was lost among the loose earth of a marmot's burrow.

And then, a week or so later, we packed out bags and came to England, because I had a book to finish and some more haphazard research to complete if I could.

Einstein on the Heath

1933

Man tries to make for himself in the fashion
that suits him best, a simplified and intelligible
picture of the world: he then tries to some extent
to substitute this cosmos of his for the world of
experience and thus to overcome it.

(ALBERT EINSTEIN)

Einstein has been keeping me vague company ever since I first
encountered the painting of him with a mug of tea in his hand on the
sea wall at Sheringham. The painting is there to commemorate the fact
that for a few weeks in the autumn of 1933, he was to be found living
quite close by, in a group of ramshackle wooden huts on an area of
scrub and sand dune known as Roughton Heath, a couple of miles
inland from Cromer.

 The circumstances that brought him to the Heath were quite random.
He was on good terms with the King and Queen of Belgium, especially
the Queen who enjoyed cooking omelettes for him, and in February
1933, when it was no longer safe to remain in Germany, the King and
Queen gave him the use of a house at Coq Sur Mer on the Belgian
coast. There were armed guards around the house and visitors were
searched for weapons in case they might want to assassinate him. Einstein
planned to stay there until he was ready to leave for America in October.

 In the summer of 1933 he was in England to give a series of lectures
at Oxford University and I was told that someone kept the blackboard
on which he had made his mathematical calculations and it was put in

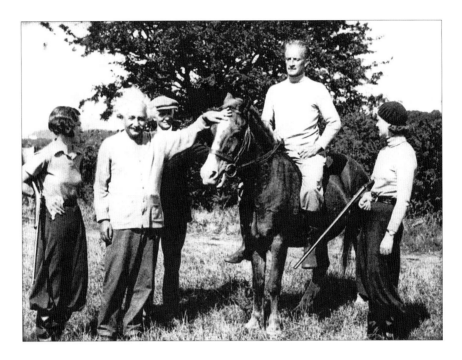

the basement of the old science museum on Broad Street, but I suppose it's been moved by now. When he returned to Belgium, the coast was becoming deserted, his bodyguards were getting nervous and it was clear that he would have to leave.

During his visit to Oxford, he had been introduced to Commander Oliver Stillingfleet Locker-Lampson, a tall, thin, pale-haired English barrister and MP who claimed to have been asked to assassinate Rasputin while he was in Russia before the Revolution. Locker-Lampson had a house in Mayfair and a grand family property in Cromer, famous for its indoor tennis court. He also had a recently deceased wealthy American wife who in the photos looks rather like Bianca Jagger. He collected custom-built cars and bred Great Danes. He used his country house as a sort of private hotel for important friends.

For a while Locker-Lampson had been the leader of a fascist organ-

isation called the Blue Shirts and they produced a pamphlet called *England Awake!* with the image of a man shouting on the cover and lots of talk inside about resisting the spread of Communism. But then there was a disagreement between the Blue Shirts and Mosley's Blackshirts and Locker-Lampson didn't like what he was hearing about Hitler's ambitions and he gave up fascism and became involved in helping Jewish intellectuals to escape from Germany.

When he spoke to Einstein he told him that if he ever needed a secret hiding place, he could provide one and get him there safely. And that explains why, on September 8 1933, Einstein crossed the Channel from Ostend to Dover in Locker-Lampson's private yacht. His only companion on the voyage was a journalist from the *Sunday Express*.

These two men went incognito by train to Victoria Station, although it was a rare event for Einstein not to be recognised wherever he was and so perhaps this part of the story is particularly unreliable. For some reason they spent the night not in Locker-Lampson's Mayfair house, but in his housekeeper's basement flat in Earls Court.

The following morning Einstein was collected in a car by two pretty young women wearing the knitted twin-sets and pearls of their class. They both carried rifles and explained they were good shots and not afraid of using their weapons. They drove to the north-east coast of Norfolk, stopping for lunch at Newmarket, and then for a drink at Locker-Lampson's hotel home in Cromer, where I suppose the Commander was waiting to welcome his guest, dressed as was his custom when in the country in riding britches and leather riding boots and a pale roll-necked sweater which he wore as tight as a fisherman's knitted gansey. He was carrying a pistol, because he didn't like being anywhere without one.

Einstein gave a short interview to a journalist who seemed to have been expecting him and he was then transported a couple of miles

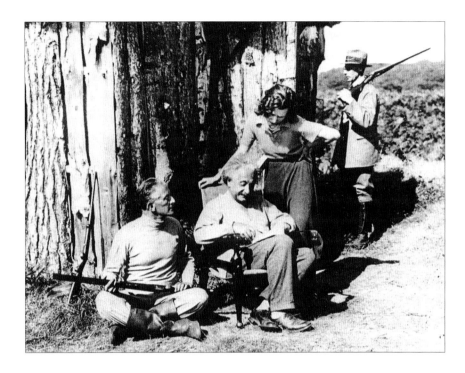

inland, first along a road and then along a rough track, until they arrived
at Roughton Heath.

Depending on who you chose to listen to, there were three, four or
even six little wooden huts scattered close together on the Heath. A
couple of them had been rethatched in honour of Einstein's arrival,
although the work was still not quite finished. One of the huts was
designated as his bedroom, another was a kitchen and in a third there
was a baby grand piano which had already gone out of tune because of
the sea air; and it occupied most of the hut's interior. A violin brought
up from London for the occasion had been placed on the piano, but it
was also not responding well to the damp.

Locker-Lampson explained that even though the Heath did not
belong to him personally, Einstein was going to be very safe there, care-

fully guarded by the two lady secretaries and their rifles during the hours of daylight and by the local gamekeeper, Albert Edo, during the hours of darkness. The gamekeeper had a shotgun and he would be helped by his son-in-law Lal Thurston – a poacher by trade and often drunk, who had agreed to be paid for his services in bottles of beer.

Einstein sat himself down in a deckchair and was given a cup of tea. According to Locker-Lampson, the Professor felt at home immediately . . . *He says he is happier on a heath because he can see so much sky.* According to Einstein, in a letter to his wife, *Locker Lampson is a very good man with a fatherly instinct and the happy-go-lucky nature of a young boy. It is a blessing that I got to know him.*

On the first morning of his stay another journalist along with a photographer by the name of Mr Tensley arrived unannounced at the secret location and on September 11 1933 their illustrated article appeared in the *Eastern Daily Press* and the *Daily Sketch*.

> *It was in a tiny, wooden hut with the sun shining through a window facing the North Sea that a reporter found Professor Einstein yesterday . . . He seemed to have not a care in the world. He asked for a penknife to clean his pipe. 'All I want is peace,' he said, 'and could I have found a more peaceful retreat than here, in England . . . No one will know where I am until October, when I go to America to lecture. I can live quietly working out my mathematical problems.'*

There were four accompanying photographs taken in the autumn sunshine. One shows the huts, one shows a wind-ruffled and benevolent Einstein with his papers on his lap, the lady guards standing close by, the gamekeeper in the distance and Locker-Lampson sitting cross-legged on the ground and offering his angular profile to the camera. Then the Commander and the Professor stand in front of one of the huts and

smile at each other and then Locker-Lampson sits on a pony which was used to deliver milk in the area and here are the ladies again, but now the gamekeeper has been replaced by the poacher who is patting the pony's head while Einstein has a hand on its saddle.

The weather was nice and warm during those weeks of his stay and thanks to Locker-Lampson, Einstein was relatively undisturbed by people wanting to talk to him and ask him questions. *He keeps them all at a distance from me in a friendly sort of way, while I wander about in the heather.*

He quickly developed a routine. He rose early and would sit in a deckchair in the morning sunshine writing letters and working on his Unified Field Theory according to which, if I have understood it correctly, the space-time continuum of eternity and the universe is already laid out and so there is no unfolding line of history to be followed step by irrevocable step. *I live here like a hermit, the only difference being that I don't have to eat roots and herbs. This quiet life makes me very happy and I notice with satisfaction that I find myself a pleasant companion. During the last few days and part of the nights, I have done a lot of work . . .*

In 1990, an old woman called Pamela Pycroft remembered how she was asked to come to the Heath to wind up the gramophone and put on records for Einstein, one after another. *He wanted someone to play quiet music while he was writing. I was sent there and I played records outside another hut, while he just sat about, writing away. I did not know what a renowned professor he was, I was too young. I was only a young girl of about ten or twelve in those days.*

In between the work, he was free to relax. He played the piano, he liked to chat with his guards and to potter about and he watched insects and the gamekeeper's goats. In an interview much later with the poacher's son, he said his father and mother got on well with the

'Jarman' Professor. They'd take him down to the post office at Roughton Heath village – *it weren't that far to walk* – and they waited outside while he went inside. He always bought boiled sweets: humbugs, barley sugar, that sort of thing, although he *fussed and worried about which ones to choose. 'Mr Einstein liked sweets, perhaps he never had a chance to taste sweets where he come from.' And then they'd all walk back together, my dad carrying his twelve-bore shotgun just in case. 'One day my granny baked a cake and came out with it for him and when Mr Einstein saw it he cried, which might be because he'd never seen a cake before.'*

Locker-Lampson wanted to have his famous guest immortalised and so he invited the sculptor Jacob Epstein to come up from London to make a portrait bust during a week of sittings. Epstein wrote about this visit in his *Autobiography*:

> *I travelled to Cromer and the following morning was driven out to the camp situated in a secluded and wild spot very near the sea.*
>
> *The two-hour sittings were held in the hut with the piano and because there was so little space, I asked the two rifle-carrying 'angels' if they would mind removing the door, which they did with a lot of fuss and jokes about having to take the roof off next . . .*
>
> *At the first sitting the Professor was so surrounded with the tobacco smoke from his pipe that I saw nothing. At the second sitting I asked him to smoke in the interval. His manner was full of charm and bonhomie . . . At the end of the sittings he would sit down at the piano and play and once he took a violin*

and went outside and scraped away. He looked altogether like a
wandering gipsy.

Einstein watched my work with a sort of naïve wonder, and
seemed to sense that I was doing something good of him.

Meanwhile, the threat of war in Europe was taking shape and Locker-Lampson was in contact with Winston Churchill who was eager to hear whether Einstein's views were changing as a result of what was happening. Samuel Hoare, the Secretary for India, dropped by as if by chance to discuss the situation, and Einstein told him that in an ideal world he would have liked to be a lighthouse keeper, because on a lighthouse there would be no distractions from intellectual thought. The physicist Dr Walther Mayer arranged to stay nearby and came to the Heath and spoke of the dangers faced by Jewish scholars, while Einstein's step son-in-law arrived to express his concern for the other members of the family still in Germany. He asked Einstein if he would give him a simplified version of the Theory of Relativity, but the Professor did not oblige.

When he first arrived Einstein was still committed to the principles of Pacifism, but then he learnt of the assassination of a fellow academic in Marienbad and there was news of the death of a close friend, who had taken his own life after witnessing the growing persecution of the Jews. After that, he and Locker-Lampson sat up all through one night talking about war and peace, humanism and religion and anything else that crossed their path and Einstein agreed that he would attend a meeting that was to be held at the Albert Hall in London on October 3. His last days on the Heath were spent preparing his speech on Science and Civilisation.

There was no more time for portrait sittings and Epstein was dismissed in a rush with the still unfinished clay bust to take home with

him, after only three sessions instead of the five he had been promised. *I could have gone on with the work. It seemed to me a good start . . . but it had to be stopped before I had carried it to completion.*

Locker-Lampson, who knew all about the power of publicity, let it be known that the fascists were planning to assassinate Einstein as soon as he arrived in London. The newspapers took up the story and as a result the Albert Hall was packed with over ten thousand ticket holders, all eager to see the famous Professor and to hear his pronouncements on the world situation.

Before leaving England, Einstein thanked Locker-Lampson for his hospitality and promised he would try to come back to the North Norfolk coast in the following year; perhaps the two of them could go out sailing on the Broads and wouldn't that be nice.

On October 5 1933, he set off for America, never to return to Europe.

Looking for Einstein
MARCH 2013

I rarely think in words at all. A thought comes
and I may try to explain it in words later.

(ALBERT EINSTEIN)

I went to see the area where Einstein stayed. I stopped at the first garage
I came across in the village of Roughton and asked a fat woman buying
crisps and chocolate if she could direct me to the Heath. Someone just
ahead of her in the queue said it was on both sides of the road and
what was I looking for. 'Einstein,' I said and he said in that case I'd
better go and see Sid in the next garage off to the left, because he'd
been here for more than fifty years and he would know if anyone did.

Sid was on the phone in a shabby office and he waved at me through
the window and went on talking. In the showroom next to his office he
had a white open-top Jaguar sports car from 1964, the upholstery in red
leather and the gearstick as delicate as an old lady's umbrella handle. I
meant to ask more about it, but got caught up with other questions instead.

Sid knew Einstein had been on the Heath and he explained how to
find the place: follow a side road and then after passing a farm take a
sharp right up a track marked *no entry/private*. 'You need to speak to David,'
he said.

The track was pitted with deep puddles and glistening mud and my
little car kept slipping and sliding like a nervous horse. I stopped where
there was enough room for turning around later and stepped out into
the mud, carrying my camera, with a notebook and a pair of reading
spectacles stuffed in a pocket.

I reached a gate which was open, but it had a *strictly no entry* sign attached to it. I followed a footpath separated from the farmyard by a thick hedge, blackbirds startling out of the bushes as I passed. The fields were pale and exhausted from the recent snow and from the cold rain that had followed the snow. I told myself there was something familiar about the lie of the land, something I recognised from the photos I had seen, but I wasn't convinced.

The footpath ran beside a drive leading to a little house. A couple of sheep were grazing behind the electric fence which encircled the front lawn. A restless gaggle of ducks and chickens were being noisy beyond the house. I could smell the ripe stink of pigs and then there was a sudden ululation as dozens of dogs in a row of metal pens noticed my presence.

A youngish woman dressed in layers of clothes against the cold came over from the pens to speak to me. I asked if David was around and she said he was out walking the guard dogs and they could be a bit temperamental, so if I saw him I had better keep my distance. I thanked her and was going back the way I had come, when through the hedge I saw a man approaching the house from the farmyard, surrounded by a boisterous pack of dogs. I turned again and walked parallel with him, but neither he nor the dogs noticed me, I was in another world as it were. Once I was back to where I had been a moment before, I called out and a flurry of little dogs charged at me, teeth bared, but they stopped at the invisible barrier where the farmyard joined the public footpath.

The man came towards me. I can't now remember what he looked like, but there was something warm and steady about him and he took off his gloves to shake my hand, which was an unexpected gesture. He said yes, he was David and he knew about Einstein being here and he could show me exactly where he was because he had worked it out from the photos in that newspaper article.

I followed him until we were standing in the glistening farmyard mud, with a shed filled with white-faced heifers and a broken bale of hay on one side and a big metal silo silhouetted against the sky just ahead.

'There were three huts,' said David. 'The main one with the wooden veranda was here,' and he pointed to a spot between the hay and the shed, 'so the picture of him sitting in a deckchair with the two young ladies carrying rifles beside him and Old Locker cross-legged on the grass, that was taken where we are standing now. And if you know the other picture of Old Locker on the milk pony with Einstein beside it, next to Lal the poacher, that was taken where the big puddle is, over there.

'I worked it out from the line of Norfolk pine beyond the field,' he said. 'They are the same even though the shape of the land has changed. It was very hilly then – high sand dunes covered in grass – but after Einstein went, the Army moved in. They did target practice and bomb disposal practice here and they had an old tank and God knows what else and when they left bulldozers were used to clear the ground and flatten it. I was told they hid the tank under a mound of earth.'

I asked if I could take a photograph of the site and he laughed and said of course and if I wrote anything about Einstein, maybe I'd send it to him, because he'd like that and so I put his address and postcode in my notebook.

David said Bob, the poacher's son, was living quite close by and I should go and visit him; he would know lots more. He gave me the name of the village and the name of the street, but he didn't know the house number.

When I got there I could see Bob Thurston and his wife watching football on the telly in their front room. I knocked on the door and he said this was not a good moment and could I come back and we agreed on Monday at three.

On my second visit Bob and his wife Olive welcomed me as if I was an old friend and I sat on the sofa in the front room and they gave me tea and custard creams. Bob told me about his father the poacher who had married the gamekeeper's daughter, *I married her so I could get close to the birds* was what he said. His father had other professions before he took to poaching and for several years he was something called a silver-service waiter in London. He was light on his feet and you'd never hear him come up close and that was good both for hotel work and for the laying of traps and snares.

Lal walked across the Heath quite regular and one day he met his father-in-law the gamekeeper who told him, 'We got an old Jarman, he's running away from Hitler who put a price on his head. He needs a bodyguard.'

So he went up there to meet Mr Einstein and got to know who he was and that was how it started. He and his father-in-law were responsible for keeping watch during the night and he often dropped by during the day as well, because Mr Einstein was such a nice man to talk to, even though he was famous. There was a piece of rope slung across the track to keep strangers away, but people did turn up unannounced, the journalists and the photographers and others.

His dad was sure that Mr Einstein stayed on the Heath for several months; he was certainly still there in the spring of 1934 and he knew it for a fact because he attended Bob's christening and he remembered the occasion as if it was yesterday and how the yellow broom was in flower and how Mr Einstein kissed the baby on the top of its head and said he would do well in life, which he did.

I asked Bob about Locker-Lampson, but he said Old Locker didn't come from this village, he came from Cromer, but he hung around a lot when Mr Einstein was on the Heath because he liked to talk to him whenever he could and he liked to go out riding with Herbert, the

gamekeeper. He had a big house in Cromer, but it burnt down and who knows where Old Locker went then.

I asked if Bob had any photographs from that time and he said he did have quite a few, all made by a gentleman called Mr Tensley of Cromer and probably worth quite a bit now, but when the newspaper did that article a few years back a nice chap came and spent the whole day asking questions and looking at things and he took the pictures when he went and they never came back. There was another picture that he had in a frame, but it disappeared after a builder came to do the roof and they only noticed it had gone much later and by then the builder had gone as well.

Bob said the huts were all removed when the Army came, but I could see one of them which as far as he knew was still standing in a field on the side of the Norwich Road, just opposite the old isolation hospital.

I went to look for it later in the day, but I couldn't find it. It was getting dark and maybe I didn't try hard enough.

I had brought my file on Einstein with me and that evening in the hotel I looked at the article from 1999, with Bob's father's photos in it. There was the hut and the little groups of people and there was also a portrait of *celebrated sculptor Jacob Epstein seen during one of the Einstein sittings*. The artist was standing close to one of the huts and wearing an artist's smock and a woolly hat, but he had a paintbrush in his hand and he appeared to be painting a landscape. I kept staring at the photograph and wondering why Epstein looked so different to how I thought he should look and wondering why he was painting a landscape in oils when he was supposed to be working on a bust in clay, but still I managed to dismiss the confusion and to believe in what I was told. It was only much later that I discovered the gentleman in the artist's smock was a German painter called Karl Ott who often came to stay

with Old Locker during the years leading up to the war and he liked to spend time on the Heath, painting the sand dunes and the pine trees in the clear seaboard light.

Karl Ott was probably the curly-headed Professor whom Mary had told me about, riding a bicycle along the coast path and stopping to talk to the fishermen in his thick German accent. That not only explained the photo caption, it also explained why Einstein, as if in living proof of his unified field theory, was often sighted on this stretch of the coast, both before he had arrived in England and long after he had packed his bags and set off for America.

45

An Afterthought

2013

The strange thing about growing old is that the
intimate identification with the here and now is
slowly lost; one feels transported into infinity, more
or less alone, no longer in hope or fear, only
observing.

(Albert Einstein in a letter to
the queen Mother of Belgium, 1953)

I suppose I have held onto the vague companionship of Einstein because
I am reassured by his idea of eternity and the way it surrounds us on
all sides and the unimportance of human beings within the vast mystery
of the universe. And I like what he said about drifting thoughts without
the words to hold them down and the way he sat for hours in a little
boat on a calm lake. I felt he would have understood why John Craske
missed the sea so much and understood his need to make paintings and
embroideries, so he could at least go to sea in his mind.

And because I believed in the absurd journey across the English
Channel in a yacht, and in the grand piano in a wooden hut on a heath
and the little girl winding up the gramophone so Mr Einstein had music
to listen to while he worked on the mathematics of his theories and in
the visits to the post office to buy mint humbugs and barley sugar twists,
it was easy to see him perched on a bike with Lal the poacher riding
beside him until the two of them reached the sandy coastal path.

And then once they were there, close to the sea, they could watch
the fishermen busy with their nets, and Einstein could ask them what

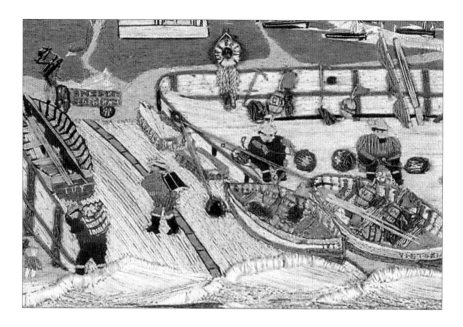

it was like going out in difficult weather, laughing as he told them that his idea of sailing was sitting quietly on his own in a tiny boat on an unruffled lake. They could even buy some fish to take back later, to the newly thatched hut on the Heath that served as a kitchen.

Almost imperceptibly I began to bring John Craske into the picture. Without concentrating on the facts, I jumped a decade and forgot that Craske was staying nearby in Blakeney and then at Wiveton in the early 1920s, and I had him there in my mind in 1933.

So there was Einstein bicycling along the coasal path, his mind filled with the miracle of the ants he was watching that morning and the rolling continuum of the universe that goes on regardless of whether we are here or not, when suddenly he and his friend Lal the poacher have to pause and dismount because a woman pushing a man in a wheelchair is approaching them from the other direction. She appears very determined, but distracted as well, and the man in the wheelchair

is all wrapped up in blankets and staring at the sea with a hungry look.

In the intersecting moment of them going their different ways, there could be just enough time for Einstein to say, 'Good afternoon!' in his thick German English and for Laura to nod a shy greeting to this oddly dressed man with so much curly hair. And John could look up and get a glimpse of the stranger, without recognising the famous face.

The more I thought about this encounter, the more clearly it took shape in my mind and so when I found out that the Einstein Archive at the Hebrew University in Jerusalem was in possession of what are called the Cromer Letters I wrote to them in a casual and friendly manner, mentioning that I had met people who knew people who could remember seeing Einstein on his bicycle and how he had often stopped to talk to the fishermen because he was such a friendly sort of man. I asked if I could obtain copies of the letters he had written while he was on the heath and I received a very curt and almost angry reply in which I was informed that Einstein had stayed on Roughton Heath for a total of not more than three weeks and would I please bear in mind that there were armed guards keeping careful watch over him at all times and given his importance on the world's stage and the danger he was in, he clearly was not permitted to leave the area for a moment. As a final shot, they said that nobody could have seen him riding a bicycle because he had not yet learnt to ride one.

Only once I had understood the mistake was I able to remind myself that in September 1933 John Craske was lying in a stupor on his bed in Dereham and he was still in the same stupor three weeks later, when Einstein was whisked off towards the next stage of his life.

I am not sure exactly what happened to Locker-Lampson in the end, but I heard he became sad and left Cromer and moved into the ground-floor flat in Earls Court, where he became reclusive and eccentric. Someone remembered visiting him without an appointment and when

he opened the door he was wearing old slippers and full military uniform under his dressing gown and he was either very drunk or very distracted. He died just a few days later. This was in 1954, when I was a young child and living in Earls Court, so perhaps I caught a glimpse of him shuffling along the streets, but without knowing who he was.

The Pituitary Gland
OCTOBER 2013

Clear bright morning. Autumn stillness. Chickens
waiting in a shuffling row outside the French
windows. I hold out crumbs and seeds for them in
the flat of my hand and it's as if I am watching my
own timid self, moving closer. I must not make
any sudden movements or I will be gone again,
back into the bushes.

(FROM MY NOTEBOOK, DECEMBER 2013)

I've just had a meeting with Bari Logan, the former Prosector from the
Royal College of Surgeons. He was the one who showed me the head
and shoulders of a dead man, with part of the skull removed to reveal
the location of the pituitary gland when I last saw him in 1984.

After leaving the Royal College of Surgeons, he worked at Cambridge
University and collaborated on a series of textbooks about human anatomy.
I found his phone number in a very old address book and he answered at
once.

We arranged to meet at Snape Maltings, where they have the
collection of John Craske's work given to Peter Pears in 1971 by Sylvia
Townsend Warner and her friends, the paintings and embroideries my
daughter-in-law did her best to photograph on her mobile phone and
never mind the dazzle of the flashbulb on the glass.

There was something immediately familiar about the Prosector when
I saw him walking towards me across the car park, even though I had
no clear recollection of what he looked like; there was a sort of boyishness

which I remembered from before because it was so unexpected in a man whose job it was to work with corpses.

We went to the tea shop for a sandwich. He showed me a copy of his book, *The Colour Atlas of Head and Neck Anatomy* and he turned the pages until he came to the photograph of a man's head, with a section of the skull cut away. 'That's probably him, the one you saw,' he said and it was true, I recognised the solemn face that had impressed me so long ago: the beauty of it and the sense of absence which gave it an inward-looking quality as if this man was deep in the contemplation of other worlds and times. It was like meeting another familiar but forgotten acquaintance.

I asked him about the long and narrow china sink I had seen in his room. I could not remember where it had stood and so he made a little drawing, the sink on the left as I came in, then a table and working bench. The window at the far end of the room looked out onto Lincoln's Inn Fields.

'They broke the sink into rubble while they were modernising and moving things around at the College,' he said. 'I found it a pity when I heard what had happened, it was only a simple object, but it held a story. It had been used for more than three hundred years, and you could feel the shape of the bodies that had lain there, made by the pressure of heels and hip bones, shoulders and skulls.'

I remembered how he had told me to run my hand over those indentations and it was like touching the mystery of the inert but still powerful bodies of a whole succession of ghosts who had lain there.

The Prosector explained that under the Anatomy Act of 1832 – amended in the 1960s – people could decide to leave their mortal remains to science, and their bodies could be retained for two years. 'We preserved them in a mixture of glycerine, spirit, phenol and low-level formaldehyde, but only a bit, so there wasn't that sharp smell. After two years I would

put all the parts back, next to the corpse and then it would be buried or cremated depending on the wish of the family. Since the Alder Hey scandal it's all become much more complicated. But when I was working we only ever had the bodies that had been bequeathed to us by their owners.'

I explained what I knew about John Craske's condition and how his doctor at the time thought it was diabetes and how members of his family had suffered from headaches and eye problems that might have been caused by a benign brain tumour situated close to the pituitary gland.

He said that I must *lay down all the symptoms* and then move them back through time to try to find the cause of John Craske's troubles. He said that if indeed he'd had a benign brain tumour which made him fall into a stuporous state every so often, then it must have been a very small one contained within the pituitary, because otherwise it would have also affected the optic nerves and that clearly was not the case, if he was still able to thread a needle and make embroidered stitches and paint the image of a boat in a carefully defined rough sea.

The Prosector could not tell me much more, but he gave me some printed papers that he hoped would help me to understand the pituitary and he told me I should talk to a neuropathologist or an endocrinologist if I could find one. I thanked him and we said goodbye and wondered how many years might pass before we met again, if we did.

Since then I have studied the papers and I have learnt that the pituitary gland weighs around five grams in humans. It is surrounded by something called the Circle of Willis and it consists of two lobes held within a bony cavity that is known as the Turkish Saddle because of its double egg-cup shape.

The posterior lobe is an extension of the hypothalamus, which controls the release of hormones. The frontal lobe lies in a fleshy

fold called Rathke's Pouch, in honour of Mr Rathke who first discovered it.

The frontal lobe 'arises from an invagination of the oral ectoderm', which means it begins its life at the back of the throat, in the pharynx of the developing embryo and then at a certain moment it migrates upwards into the brain and settles on the Turkish Saddle. I imagine it swimming like an eel through a dark and difficult terrain, but I am sure this is not a correct visualisation of the event. I realise how little understanding I have of such things and I very much doubt if I will now ever get round to increasing my understanding. But in spite of my ignorance, I find the pituitary gland fascinating, much as I find fossils fascinating, because of the vast stretch of time that they hold, fixed in the stones they have become.

The Retired Endocrinologist

October 2013

Yesterday was the Iron Age fort, a sort of high
table of hand-worked land and a steep path to
reach it and then a flat top and earth banks known
as 'rabbit pillows', used for breeding rabbits in.
High ramparts looking out across the valley and
black cattle staring. Today was Chesil Beach, the
sea with a soft but dangerous breath because of the
steepness of the pebble bank tipping into it.

<div align="right">(From my notebook, November 16 2013)</div>

On the following day and quite by chance, I was given an introduction
to an eighty-four-year-old retired endocrinologist living in Oxford. I
telephoned him immediately. His precise and focused way of speaking
gave no clue to his age.

With the Prosector's textbook on head and neck anatomy opened
on the page showing the pituitary gland belonging to the dead man I
had first encountered some twenty-five years ago, alongside a couple of
diagrams of the position of the pituitary from the internet and a
description of the possible effects a tumour might have upon it and
having written a list of all the symptoms I could think of that Craske
had suffered from, I presented my diagnostic problem to the
endocrinologist.

He sparkled with curiosity. 'Ah!' he said. 'It could have been maleic
diabetes, brought on by a disruption in the pituitary, but that's a very
rare condition. Did your man have big hands?'

I said yes, he did, but then Trevor Craske had told me that all the members of the family had big hands and he had held his hands out towards me, palms outwards, so I could see the truth of his words and I also saw in my mind the photo of John Craske's mother, wearing an apron and a white cap and standing in the doorway of a cottage, her hands hanging so big and loose at her sides that it looked as if she was wearing gloves.

By now the endocrinologist was busy with other signs. 'What about a pudgy nose? A heavy jaw? I wonder if anyone mentioned his skin, whether it was rubbery and pale. That's a very common sign of the condition we might be looking for.'

'Pale, yes,' I replied, as if I was going to win points with the correct answers. 'But then he was pale because he was so often unwell and no one said anything about rubbery, nor does it show in the photographs. His skin looks quite normal.'

'Nose and the jaw?' asked the endocrinologist. 'You say you've seen photographs, so anything odd about them? Even if the nose was not pudgy, was it unusually big and wide, the jaw somewhat pronounced and square?'

I had to say that John Craske had a rather nice nose and a strong jaw, with nothing abnormal or exaggerated about it. He was a good-looking man.

The endocrinologist sounded disappointed. He sighed down the telephone from Oxford.

'Have you considered psychotic disturbance?' he asked after a pause. I began to feel as if I was a fellow professional discussing a patient.

'Well, that was close to Trevor's Aunt Doreen's diagnosis and she was the only person I have spoken to who actually met him. She said she knew nothing about brain trouble or diabetes, he was just depressed, that was all.' And then I suddenly thought of Charles Darwin's sister,

who spent years in bed, for fear that she might otherwise become ill. She designed her own germ excluder made out of a tea strainer, filled with cotton wool soaked in something strong. But she never dipped into a coma, she just reclined on a chaise longue in the drawing room and made conversation.

I didn't mention Darwin's sister to the endocrinologist. He was pausing again to think and then he said it was very possible, particularly in those days without our current psychological insights, to fall into a stupor as a result of mental trouble. And indeed, such a stupor could last for weeks, even for months. Clearly my man had enough consciousness to eat and to drink in order to stay alive. I hadn't thought about that before.

'Were there any possible triggers that might have caused the various collapses?' he asked now.

I turned the idea over and it quickly took root. The first recorded collapse was when Craske was in the Army, being prepared for the war in France. He had been twice rejected on medical grounds, but on his third application in 1917, he was accepted.

'They were taking every man they could get by nineteen seventeen,' said the endocrinologist, as if he was referring to his own experience.

'He had a bout of influenza and then according to his wife he fell into a stuporous state, but she did say it was a relapse, so he must have had something similar before,' I said. 'He was put into a lunatic asylum and they diagnosed him as an imbecile.'

'Quite usual, especially among the poorer members of society. A lot of shell-shock victims were given the same diagnosis,' said the endocrinologist.

'He was clearly never what you might call well, but it was the death of his father that seemed to trigger the next serious collapse and then there was the sunstroke, but Laura implied that there was a lot of family trouble at the time.'

'Any mention of how he was treated?'

I explained that the local doctor did his best to help but was very perplexed by the condition. He recommended the sea as the only possible cure he could think of and it seemed to work, at least for a while.

'Wise man,' said the endocrinologist and it was as if I could see him smiling with the knowledge that his hypothesis might be the right one. 'It is a well-known fact that the movement of the sea acts as a very good calmative for mental instability.'

I thought of John Craske in a little sailing boat on the Blakeney estuary, three hours out and three hours back to the place he had started from; Laura watching over him, so pleased when he began to notice his surroundings and became more calm.

I explained how he started making paintings of the sea after going out on the estuary, and the endocrinologist liked that idea as well because it also fitted into his diagnosis.

'And then,' I said, as the logic of the story began to take shape, 'he had to return inland, to the town of East Dereham where the rest of the family was based, and the attacks got worse again, even though the painting and later the embroidery clearly helped to quieten him down. There was some sort of crisis around 1930, coinciding with the time when he had his first exhibition in London. According to the newspapers he wasn't able to attend the opening because he was in a stupor and he remained in the stupor on and off for the next three years. He came out of it when his wife told him that he had just sold a number of pictures and so they were out of financial trouble for a while.'

'Well then,' said the endocrinologist and I could feel that our conversation was drawing to a close, 'I would suggest mental instability as the main cause of the condition, but it would help if you could get hold of the hospital death certificate.'

*

Much to my surprise, the death certificate was easy to obtain, I hadn't realised that such an intimate fact of the ending of someone's life could be ordered over the phone. I just had to pay £10 with my debit card and a few days later the document arrived in an official-looking envelope.

John Craske had died in hospital and there had been a post-mortem which showed that he died of septicaemia, a lymph condition and diabetes. I again telephoned the endocrinologist. He said the lymph condition and the septicaemia were both common side-effects of diabetes and in the days before penicillin that could be fatal. Antibiotics were being used in 1943, but only among the soldiers, and I must remember there was still no penicillin.

He thought the diabetes must have been quite mild, Type 2 was his guess. He said, 'Of course, that swings it further away from the tumour, especially since a post-mortem would most probably have found it, even if it was within the pituitary. The fact that you say some members of the family might have suffered from benign tumours does not in itself prove a link. You need to go down several blind alleys before coming to any sort of conclusion. I am increasingly persuaded of the likelihood of this man's condition having a psychic/neurotic basis.' I could almost see him sitting opposite me at a table in his consulting room, enjoying his profession and the professionalism of his knowledge.

I was rather disappointed. I had liked the idea of the tumour and its mysterious effects. I suppose it could still have been there, but it's more likely that it was not. It had never occurred to me that John Craske's troubles were all in the mind, although now I can see that this explanation makes more sense than any other.

Sugar Sickness
OCTOBER 2013

I keep scattering into different notebooks.
Sometimes wonder if I have lost the thread, if there
is a thread to be lost. But every morning with the
first shifting light, a thrush has been singing a
wild song of almost spring and this morning a
tree creeper was darting up and down the trunk of
the oak tree outside the window and it made me
laugh to see such erratic energy, such unconcerned
upside-down-ness. (FROM MY NOTEBOOK, FEBRUARY 2012)

According to his green death certificate, which I now have before me,
John Craske did suffer from diabetes. Sugar sickness it used to be called,
and it was Pliny the Elder who noticed how ants gathered around the
honey-like crystals from the urine of one who suffered from otherwise
mysterious symptoms. Tasting the sweetness of the urine was a simple
way of finding out the level of sugar that had accumulated, but for
almost two thousand years there was no clear idea of the cause of the
condition or how to cure it.

The endocrine system in the pancreas consists of clusters of cells
which carry the romantic name of the Islets of Langerhans, because of
Paul Langerhans who discovered them in 1869, scattered throughout the
organ like islands in the sea. They produce the hormone insulin, which
determines whether glucose is burnt immediately or stored in the live
muscle.

In the nineteenth century it was believed that grief, chills and an

excess of sexual indulgence were contributing factors. Starvation diets helped to reduce the sugar levels while also damaging the health of the sufferer. By 1901 it was still considered *a general disease which has no local seat* and eleven years later doctors could state with confidence that *the majority of patients have only themselves to blame because they have ignorantly or carelessly abused their systems . . . Thinking deeply, reading or worrying while eating all tend to produce that disarrangement of metabolism which exhibits itself as diabetes.*

Insulin had been discovered in 1909 and first used on a human in 1922, but it was too expensive for all but the very wealthy and it was difficult to maintain blood sugar levels with any degree of accuracy until clinical tests were introduced in 1944.

According to a paper published in the *Journal of Metabolic Research* in 1922, the initial symptoms of diabetes *were nervousness, tremulousness and excessive hunger, along with a feeling of weakness and a sense of gone-ness . . . As the blood sugar falls further, the feeling of nervousness may become definite anxiety, excitement or even emotional upset . . . More severe manifestations . . . include marked excitement, emotional instability, sensory and motor aphasia, dysarthria, delirium, disorientation and confusion have all been seen. Most diabetics were irritable and many were unduly suspicious . . . Some became melancholic, in which case they were treated for what was called toxic insanity. In addition to an appropriate diet, strychnine was given internally and electric shock treatment was also considered as an option.*

For people like John Craske, the first real help might have come from a book called *The Diabetic Life*, which was first published in 1925 and reprinted over and over again. The author, R. D. Lawrence, was a young doctor who developed diabetes and went to Italy to wait for his death

with the companionship of good weather and beautiful surroundings, but then he came home in a hurry when he learnt that insulin might save him. He recovered and was able to continue with his work as a doctor and with the help of his patient and fellow sufferer H. G. Wells he campaigned to make insulin available for people without much money and his book gave a very clear account of the nature of the condition and how to keep it stable with a strict diet as well as insulin use when appropriate.

Lawrence described the case study of a man he calls Herbert who was diagnosed in 1931 and kept alive mostly by the determination of Elsie, his wife. She tested his urine before and after each meal, which was given rigorously on time, and she always weighed his food. Once or twice a year he'd become unconscious from low blood sugar during the night and Elsie would revive him. 'I wouldn't have managed without her,' said Herbert and I can't help thinking this must be a variation of what happened with John Craske. First Laura struggling on her own and then Laura and the good doctor working together to keep him going as well as they could.

October 20

2013

I got lost on a walk here, but it was a very simple
sort of lost-ness: I walked the four sides of a big
field, to come back to the place where I began.

(FROM MY NOTEBOOK, SUFFOLK, OCTOBER 2013)

It was a gentle autumn, the days mild and soft, the low sun casting long
shadows on the ground. Quinces. Small apples. I felt my book about
John Craske was moving steadily forward and there was not long to go
before it reached its conclusion.

I kept seeing it in terms of an embroidered tapestry and that made
it possible for me to jump to different sections and fill them in, before
returning to the central line of my story. I had written the three chapters
on Einstein quite early on; they stood together as a little group and I
moved them from place to place, looking for where they might best fit.
I had started a piece on the Cornish fisherman painter Alfred Wallis
whose life paralleled John Craske's life in many ways, but before
continuing with that I wanted to go with Herman to St Ives, to visit the
Tate and to see what Wallis had seen of the ocean and the horizon that
defined its edge, so as to understand better how he had turned it into
pictures.

I still needed to find out more about diabetes and maybe to talk to
someone who suffered from it, to get a clearer understanding of the
feeling of gone-ness that creeps in when the blood sugar level drops too
low. I had a big file on the Evacuation of Dunkirk, filled with transcripts
of the recorded voices of the men who were there on the beaches or in

the boats. When I read through their stumbling words, I seemed to be listening to what was happening at that moment in history, just as John Craske had listened to the wireless next to his bed in May 1941, but I still hadn't worked out how I wanted to use the information.

Herman was very excited by the oddness of the book's shape; he said he liked the way that time shifted through the chapters, the past and the present jostling together as if there was nothing to separate them. He had just received confirmation of three new exhibitions of his recent drawings and his whole being was somehow shining with energy and enthusiasm.

So there we were, busy and happy to be busy and rumbling around in close proximity to each other with the occasional absences when he went to Holland for a medical check-up or to talk about new work plans, or I went on one of my haphazard research trips, while he stayed at home and waited to be told of my adventures.

Recently, apart from the stroke that hadn't seemed like a stroke, he'd had a very uneven heartbeat and a tendency to get sudden palpitations if something made him nervous. It happened at Gatwick Airport when we had to go through a surreal corridor of glittering shops: the clash of perfumes in the air, the noise and confusion of it all and then it came again when he was filling out a tax form. His doctors put him on warfarin, that strange drug which was first developed to kill rats. He took it willingly. He did not want another stroke and the incapacity that a stroke can cause. I did sometimes wonder vaguely about my choice of John Craske as a subject, at this moment in my life. There I was writing about a man who was not well; a man who was being cared for by his wife; a man finding strength in making images while having to negotiate the delicacy of his physical body.

But then again, every book I have written has been deeply subjective and I have grown accustomed to the overlap between my own life and

the imagined life of a stranger. I learn from the process of writing. I learn about the people I am focused on and about the predicament of their particular situation. I sometimes feel that I can only access my own thoughts, my own nature, through the process of putting the words down. I don't reread my own books once they have been published, but when I look at their covers I am vividly reminded of where and how I was at the time of writing.

So now, back to the month of October 2013. I have been to meet the Prosector and he has sent me his book on human anatomy. Herman was intrigued by it. We sat side by side and examined the intricacy of the head and neck. We saw where his cancer was located, close to the area within the pharynx up which the little thing called Rathke's Pouch must swim in order to reach the Turkish Saddle. We looked at the ligaments connecting the neck to the shoulder, which in his case had been removed on the left side after the discovery of a malignant lymph gland and we looked at the location of the saliva glands in the lower jaw which the radiation had eradicated. It was not a ghoulish fascination, but a respect for the intricacy of the human body and the strange miracle of its functions.

The days moved on. I made quince jam and pottered along with Craske. Herman was writing an application for a Dutch artist's grant and his first sentence opened with the words *in four years I shall have reached the age of* 80. This made him laugh because when he was young he never thought he would grow old, but now the accumulation of eighty years seemed as close as tomorrow.

It was October 19 and the moon was one day short of being full. That evening we decided to go down to the sea at Walberswick, where the murmurations of starlings had been coming to roost in the marshes behind the shingle bank, and where we had found the Little Auk, washed up on the sand almost two years before.

The air was completely still. The moon was suspended above us and the weight of it seemed to have pulled it out of shape, making it swell at the base like a drop of water about to fall. Thin clouds shifted and shuddered in front of its luminosity but it was strong enough to shine through with a ghostly determination.

We walked across the dividing line of the sand dunes held together by marram grasses and made the small jump down onto the sand and there was the sea further away than I had ever known it before, pulled back to reveal an expanse of sand, molten silver in the moonlight. The black stumps of the wooden groynes that once defined the river's banks where it joins the sea looked for all the world like the broken stumps of a petrified forest.

We walked hand in hand close to the water's edge, and the moon

at our back cast ghostly shadows of our bodies on the sand. I realised again how happy I was, how content with my life, the way it had taken shape, loving the man I had married and knowing that I was loved by him.

At a certain moment we turned back the way we had come.

We got home. The Vikings with their horned heads and their sombre faces observed us as we prepared supper, drank a glass of red wine. And then we watched a DVD on the laptop on the kitchen table: it was *Whisky Galore!* and we were both sure we had seen it before, but if we had, we remembered nothing. The film made us laugh. We went to bed. We slept.

In the morning, just after breakfast, Herman turned to me. He was standing close to the sink. He did a little *Whisky Galore!* Highland jig with his arms above his head and I was startled again by the elegance of his movements and by the way he sparkled with a sort of inner energy that seemed to grow brighter every day. 'I never knew I could be so happy', he said then, 'so happy with you, with the life we have together.

'I am doing my best,' he said then, 'but I am not sure how long I can hang on.'

My heart lurched, even though he had said this sort of thing before. He knew, we both knew, how many small defects his body had accumulated and each one of them could carry him away if it chose to. Nothing to be done about that, except to live for as long as life continued.

'What would I do without you?' I asked, because although I meant to be calm in the face of such knowledge, my heart was still lurching with fear.

'You must work,' he said, serious in answering the seriousness of my question. 'Only work will get you through.'

Later on that same day, he was in his studio and I was in my writing room and at five o'clock I walked down the steep wooden steps that

separate the upper part of the garden from the lower part and I saw him lying close to the steps, lying on the wallflowers I had planted under the oak tree, lying very relaxed, his knees bent. At first I thought he was simply resting, although it was an odd place to choose. I ran down the steps and crouched beside him. His eyes were open, but I realised at once that he was not recognising the world he was seeing. He did not answer when I called his name. He did not respond when I held his hand.

I had saved this sweet and gentle man many times in the past; willing him to stay alive, warming his body with my own, calming his racing heart, keeping close as he struggled with one physical trouble or another, but this time I could not bring him back to me, like a fish on a line. I could not will the life to stay in him. The person who he was had already gone.

I phoned the ambulance. I phoned a friend who was working nearby and he came to help in any way that help could be given. It had started to rain. The nature of the world I inhabited had changed irrevocably.

February 17

2014

Craske and the sea and the quiet that comes from
having thoughts wiped out by the noise of the
wind and the waves. Shuddering window frames.
Ululating birds. (FROM MY NOTEBOOK, SEPTEMBER 2012)

That was then, this is now. Time passing. I have started a new notebook, to give myself the companionship of the written word, especially when I cannot sleep at night.

I write when I surface into wakefulness during the night and I write at odd moments during the day. I write on trains and in the houses of friends. A few words or many words, but when I look back at them and their accompanying date, then I see the evidence of my own existence, the thread of who I have been and who I still am. A compass to steer by.

The days come thick and fast and the nights are long. There is never a moment when the thought of him, the knowledge of him, the present absence of him is not with me. I cry and I stop crying and then I cry some more. I can feel how my mind and my body are working to try to process the enormity of loss and that must be why, even if I seem to have slept for many hours, I wake exhausted. I also wake with the immediate knowledge of what has happened because I am endlessly busy with it, even in sleep.

I have strange dreams, but none of them are frightening, just as nothing of the memory of his departure is frightening. In one dream he helped me to mend the brakes on my bicycle and he stood very close,

smiling as he so often did, and he said, 'Surely you didn't think that just because I am dead, I wouldn't help you?'

I keep going back to what he had said about working. *Only work will get you through.*

The first time I came up to my work room and opened the Craske file on my laptop, I was so nervous I felt I might faint. It was something to do with connecting the past with the altered present. As if to reflect my state, the printer made a hiccupping noise and refused to print anything and flashed a red warning light at me. Then the wood-burning stove wouldn't get going and the little room was soon filled with clouds of sweet-smelling smoke. I gave up and went back down the steep steps, pausing to look, as I always do, at the patch of wallflowers where Herman was lying when I found him.

By now it was four o'clock in the afternoon, an hour before the hour when it all happened and I couldn't do anything and so I climbed into bed and closed my eyes because I had no strength left.

The next day, I started again and it went better. I felt there were two ropes, or maybe two stretchy bands is more accurate, and they were coming from two different sides of the world: east and west, north and south, and I was holding one end in each hand and pulling them with all my strength towards each other, because it was crucial that they were brought into contact. And when they did touch, I knew I would have to hold them steady while they sealed over the division that separated them like a wound. The past with the present. I realise that only when I have got back to John Craske can I get back to the shore of who I am.

Since January I've been teaching eight students one evening a week in London and that has helped because I need to step away from my own preoccupations as soon as I see them, eager and tremulous in equal measure. I talk and listen and we discuss things and in the process I forget my daily being and discover the things that I have learnt about the business of writing, things I can try to share with them.

I've also been doing a long recorded interview for the British Library. A nice young woman asks me questions about my life and my work and so far we have completed twenty-one hours with maybe ten more to go. It was something I agreed to do before Herman died and now it acts as another sort of lifeline because I see myself in terms of the books I have written, trying to make sense of the world that surrounds me.

Now it's February 17 2014 and my notebook is almost full. I think of me and Laura, both of us watching over our fragile husbands, but mine died four months ago, while John Craske is still alive, his death in 1943 has not yet come.

I had hoped to meet Trevor Craske again, to talk to him some more, and I'd like to return to the house of the doctor's grandson, but so far all I can do is stay where I am, work with what I have already got, hold still at my own centre.

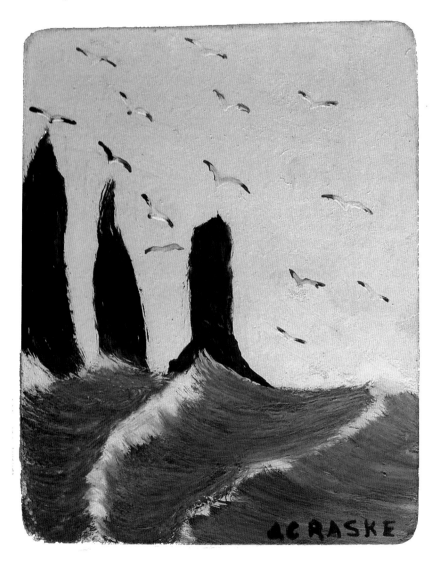

Valentine, Sylvia and Now Elizabeth

1937

It's 3 a.m. and the rain has kicked in again. A cup
of warm milk. A new hot water bottle. The warm
nest of this bed. I think of Craske, of the chapters
I must write to make the transition between then
and now. (FROM MY NOTEBOOK, JANUARY 4 2014)

So now the year is 1937 and Sylvia Townsend Warner and Valentine
Ackland are still living in relative harmony, although they never got back
to the rapture they found when they were first together at Winterton.

Those early days of happiness had become encapsulated not
only in the memory of their love for each other, but also in their
continued love for the work of John Craske. What Sylvia called *his visual
acoustics* had become part of their vision of a lost time. His passion to
keep on working in spite of illness became their passion to work in
spite of endless emotional upheavals. They felt he understood the true
nature of art in its most fundamental form and they clung to him
in order to keep close to their own belief in each other and in their
work.

It was an unlikely connection, but the two literary ladies remained
true – in their fashion – to the invalid fisherman and his wife. While
they wept and shouted and made amends and wrote poems and stories
and letters of love and despair, the pictures on the wall were part of the
family and never mind that direct sunlight was cracking the thin surface
of the poster-paint colours and bleaching the embroidered stitches, or

that clouds of cigarette smoke were slowly imbuing the fragile surfaces with a pervasive yellow stain.

Sylvia clearly enjoyed her *queer and ghostly encounter* with John and Laura in 1931, but, as far as I can tell, although she kept planning to return, it remained her only visit. She carried vivid recollections: *It is a most extraordinary experience to walk into Craske's stuffy little parlour and find oneself surrounded by these unaffected works of genius. It has rather the same quality of walking into an engine room and finding all the engines functioning . . . and nobody there to give them a word of advice.* She considered the meeting to be *nourishing*, but said it was important to keep sentiment out of it and she must have seen the Craskes with the curiosity and enthusiasm of a novelist, an outsider looking in and gathering material that might be used later.

The last time Valentine visited the house on Norwich Road was in 1938. By then she and Sylvia were pretty much ensconced in Dorset, with occasional trips to London and very occasional trips to Norfolk, to see friends or Valentine's mother. They went on writing letters to John and to Laura but they didn't keep many of the replies they received. Sometimes they sent friends to drop in with the idea that they might buy a picture or two.

Valentine continued to have frequent brief affairs with whoever took her fancy and Sylvia tolerated the infidelities and made a note of them in her notebook. Valentine was also drinking more heavily, but Sylvia apparently didn't notice the bottles, the breath, the wavering steps, or the gathering alcoholic gloom. As a friend remarked later, Sylvia *was not so much solitary as entirely self-sufficient . . . perhaps because of the necessary and concentrated aloofness of the creative mind.*

In 1929, Sylvia was invited to America to promote her two most recent novels, *Lolly Willowes* and *Mr Fortune's Maggot*. In New York, where *the skyscrapers crop up everywhere and as randomly as though*

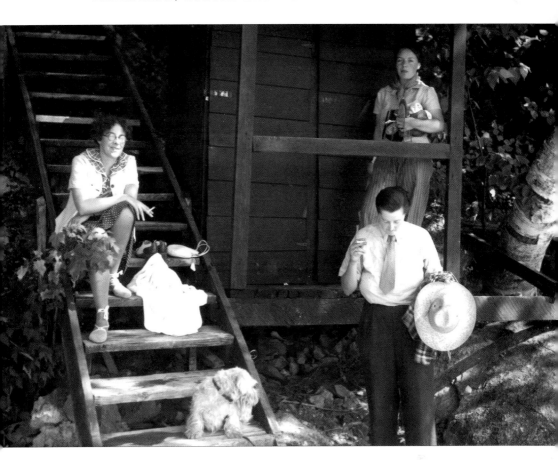

someone had scattered a packet of skyscraper seeds, she gave a talk at a literary luncheon in the Hotel Biltmore and had a brief encounter with a young and enthusiastic American called Elizabeth Wade White.

Elizabeth came from a wealthy Connecticut family who would have been good material for a Tennessee Williams play. It was old wealth and lots of it and there was a fine country house and uniformed servants and an eight-car garage as well as a property in the city for the winter months and a shooting camp called Strawberry Hill in the coastal wetlands of South Carolina – much favoured by Elizabeth's father who

had no need to earn his keep and loved nothing better than being looked after by the descendants of the family's slaves and shooting quantities of wild fowl from flat-bottomed boats.

The mother was a busy society hostess, *tall, sour-faced, white-skinned, with pale blue eyes . . .* was Sylvia's impression when they met and didn't get on. The brother, Wade, was devoted to his mother and they always had the last dance together at every family party. He was pretty and girlish in his manner, but nobody was allowed to mention his sexuality, regardless of the fact that he lived for ten years with one partner who was known as Johnny Twinkle Toes and then with another called Ernie.

Elizabeth was plain, heavy-bodied and awkward and not at all the kind of daughter her mother wanted. She had the deep insecurity which unloved children can carry throughout their adult lives. As a young woman she tried to please her parents by falling in love with a suitable man and getting married, but her plans always came to nothing. She wrote poems for each season and kept a journal filled with self-doubt and self-loathing for her sins and failings as a human being. She arranged dried flowers and was preparing a herbal. She felt trapped by the constraints of her family and was eager to break out in any way she could, but then Mother and the demands of Connecticut society kept pulling her back into the tight ancestral mould. When Sylvia first met her she saw reflections of her own young and struggling self and was solicitous and benignly maternal towards her new protégée. Later, she was less enthusiastic and said that Elizabeth was *turgid*, with a dangerous belligerence that lay under a layer of melancholy.

When they met again in England in 1935 Elizabeth was invited to come and stay at their cottage in the Dorset village of Chaldon Herring. The visit went well. The three ladies talked about literature, landscape, pets and herbs, politics and the looming threat of fascism. Sylvia and Valentine were determined to help Elizabeth find her authentic voice,

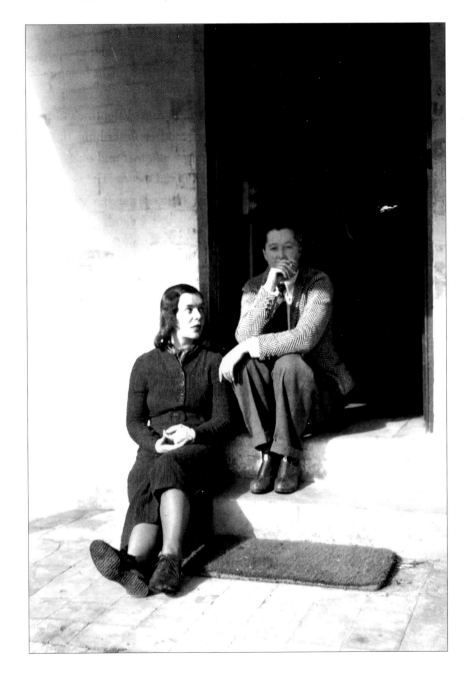

her creativity. They showed her John Craske's *stuggy, exact, passionate work*, and their collection of his paintings and embroideries quickly became part of this other world in which she felt she might belong and flourish.

Elizabeth was back in 1936. They took her to meet Valentine's mother in Winterton, and she wrote to her own mother describing the *fine fortress-like place with miles of gardens and greenhouses and only a great wave-like swathe of silver-green dune between it and the sea.* The landscape of the Broads reminded her of the happiest times she spent with her father, when they went bird-shooting in the swamplands of Carolina. Valentine's skill with a rifle also impressed her very much.

Back in America, Elizabeth kept in regular contact with Sylvia and Valentine, and they were eager responders; if one wrote first, the other usually wrote later on the same day. By June 1938, Elizabeth was trying to arrange an exhibition for Craske at the East River Gallery and she wrote to the ladies: *I suggest that when I am next in England, I carry home with me, to be exhibited in New York or elsewhere if possible, and if not returned at my expense, about thirty watercolours and a half-dozen or so needlework pictures of Craske's . . . In the meantime I have grown very fond of the big wolf snow seascape through all these months of wrapping and unwrapping it and should very much like to own it . . . so am sending you a money order for ten pounds which I hope Craske will think is enough, also perhaps it will please him to think that one of his pictures has found an affectionate home in America.*

She was again in England in 1939 and on this occasion she and Valentine went, as she explained in another letter to her mother, on a three-day *sort of camping trip*, to a converted farm building just outside Chaldon Herring known as Rat's Barn. It rained continuously and it was here that Valentine launched Elizabeth into a passionate affair, an experience she had never encountered before. *I know now and finally*

what love is and must be, that without it is only death and I am hopelessly, *helplessly inarticulately and everlastingly in love,* as she explained to her private journal.

It now all gets very muddled and the situation makes me uneasy because I have a long history of uneasiness with triangular relationships and just reading about the three ladies and their confusion and heartbreak, their manipulation and connivance, leaves me feeling dizzy. Sylvia is the rejected wallflower who stands back and suffers and observes the developing romance and sends jolly letters to Elizabeth's mother, saying what fun they are all having. On one occasion she moves into a hotel, so that the two lovers can be undisturbed by her presence.

Elizabeth was determined to live together with Valentine in America. Early in 1939, as part of that process, she persuaded Sylvia and Valentine to come to stay with her and her parents at the wonderfully named Breakneck House in Connecticut. Wade, the brother, got on well with the three ladies whom he always referred to as *Les Girls*, but for everyone else the visit was not easy. As Sylvia described it, the mother was furious to be confronted by her daughter's obvious infatuation with a lesbian who smoked and drank too much and dressed as a man and she quickly recognised Sylvia as the procuress.

Elizabeth, not wanting to lose either her friend or her lover, rented a house where the three of them could spend the entire summer quarrelling and weeping. Valentine made passes at the maids and smoked cigars and, as she wrote in her memoir with her usual combination of pride and contrition, *I was lecherous and greedy and drunken there and yet I had two very serious loves in my heart, even then, and poems too, in my head.*

On April 4 1940, Valentine wrote to Elizabeth: *I want and intend that we shall be together as belonging to each other . . . we shall <u>be each</u>* *<u>other's</u> property and possession . . . I will give you all you ask of me so far*

as I can always, asking only that, in major decisions or any conflict of opinion between us . . . you will follow me.

The affair came to a rather abrupt end shortly after. Elizabeth set up house with a much more steady companion called Evelyn, and the two lived more or less happily ever after. In 1949, Elizabeth was cut out of her mother's will (apart from trust funds), perhaps because of her communist sympathies, but almost certainly because of her lesbianism. She rushed to see Valentine in England and there was a brief rekindling of what Sylvia described as *the disease of Elizabeth*, but it ended in a quarrel.

Even though Elizabeth's love affair with Valentine did not last, she remained faithful to Craske and for her his work was bound up with recollections of lost love. She regularly bought paintings and embroideries and after his death she kept in touch with Laura and sent her regular food parcels as well as cheques. And because she was a natural hoarder, she kept six hundred pages of letters from Valentine and even the briefest of communications from John and Laura.

Dear Madam, wrote John to Elizabeth in December 1940,

> *Thank you for your kind letter. I have today sent the needlework of The Window. I made enquiries and found it best to send it by North Atlantic Air Services. I made the weight as little as possible. It weighed one pound six ounces. I registered it. The postage was two pounds fifteen shillings. The postage I will pay the half of one pound seven shillings and six pence. We thank you for your great interest in my work. We trust the exhibition will be a success. It was a big interest to hear of Leonard Craske we do not know him.*

In March 2013, Herman and I had gone to Dorchester to visit the Dorset County Museum which has a collection of Sylvia Townsend

Warner's papers. Herman looked at farmers' smocks and a collection
of clocks and pots and fossils and I had an appointment to visit the
archive and was shown an envelope containing five letters from Laura
to Valentine and Sylvia and several photographs I had never seen
before and two drawings of Valentine in the nude, done in chalk by
Eric Gill. A few days after we got back, the archivist got in touch and
said she had found reference to Elizabeth and Valentine in the recently
released MI5 papers for 1941.

A telegram, dated May 4 1941, had been intercepted by MI5, for
reasons of state security. On June 5 1941 it was sent to a Mr Foyer in
the Plain Code Section, at 58/62 High Holborn in London WCI, along
with an accompanying note saying, *I should be grateful if you would test
the following cable for code:*

> ADVISE CAREFUL LIST CRASKE PICTURES HAVE
> PREVIOUS EXPERIENCE PERSON IS SHE
> PRODUCES PICTURE DARK STORM IS MY
> PROPERTY LETTER EXPLAINS STOP ALL WELL
> SOLOMON SEVEN VERSES SEVEN EIGHT

Mr Foyer did his research and advised Mr Lothian at MI5 that he had
ascertained the cable was sent by Valentine ACKLAND, to Elizabeth
WHITE:

> *The last four words translation from Bible as follows: 'this thy
> stature is like to a palm tree and thy breasts to clusters of grapes.
> I said I will go up to the palm tree I will take hold of the
> boughs thereof know also thy breasts shall be as clusters of the
> vine and the smell of thy nose like apples'.*
>
> *. . . Miss Valentine ACKLAND is a member of the
> Communist Party of Great Britain and Elizabeth WHITE is also*

a Communist; there is little more information I can give you. I
do not know what personal relationship exists between the
parties.

Is there some error in the copy telegram at the point 'Person is
she produces . . . should it be IF.

There is a firm Alfred Craske Ltd Photo Engravers of 5 E.
Harding St. EC4. I also wondered if there is a firm dealing with
Cinema pictures of that name but I am unable to trace them.

The telegram appears to be in the nature of a warning that
some person White is dealing with is unscrupulous and if she
produces among others, a picture called 'Dark Storm' that really
belongs to Ackland.

The biblical quotation is of an unusual character – and
possibly rather unpleasant. I do not think it is meant for a code.

Telegram harmless I should think.

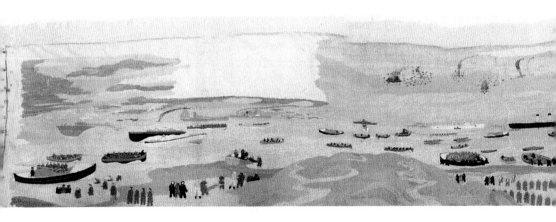

52

Into the Sky

1940–1943

It's four days later, maybe five. 4.30 in the
morning. The night still. Through the dark of the
window I know the place where he was lying,
knees bent, eyes staring up at the branches of the
trees but not seeing them, or at least not being
aware of seeing them. No fear in him.

(FROM MY NOTEBOOK, OCTOBER 25 2013)

John Craske lies in his bed in Norwich Road and listens to the wireless.
The Second World War is going on – if that is what wars do. The news
on the wireless tracks its development, men fighting in distant lands
across the sea, bombs falling; there was even one the other day that
landed close to the post office in Sheringham. I imagine it makes him
think of the other war, the one he had tried to fight in, the one that
marked his first serious collapse into the illness that has dogged him

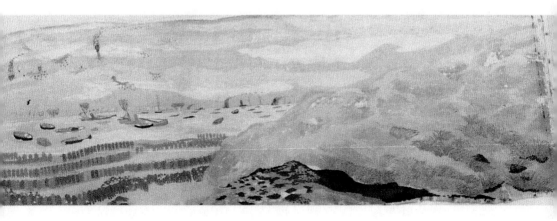

ever since. Or did he have the illness before then? Laura had referred
to it as a relapse, but he could not now remember.

His life has drifted by, much of it in a dream of oblivion. He used
to be upset about all that he had lost, the children he did not have, the
money he did not make, the fishing expeditions he did not go on: heaving
in the crab pots and the lobster pots, emptying out the rattling harvest
of whelk and clam; dab and plaice flapping on the deck like squares of
wet cloth; the big-lipped, disappointed mouths of haddock and cod. He
and his father and his two brothers out at night on the quiet ocean, the
backs of herring glinting like pale flames. But now he no longer feels
that grief of failure. He has done the best he can and he has been loved
by his wife and he has loved her, in his way. Above all else, he has
created pictures and they have made him almost famous, almost
successful, and maybe that is enough or even more than enough. There
is certainly enough money in the bank for Laura after he has gone,
mostly thanks to the American woman whose name he always forgets.
She buys his work quite regularly and shows it to other Americans who
also buy it and then she sends Laura a cheque. He has looked at pictures
of America in a magazine. Wide landscapes of grass, moving in the wind
like water. Tall shining buildings, higher than any lighthouse. The big
glittering liners that cross the Atlantic Ocean. Smiling men and women.

It's the last week of May 1940 and according to the wireless the
English soldiers have been driven down to the Normandy coast. They
are being pursued by the Germans and the English Channel is blocking
their escape. Maybe the Lord can pull the sea back and create a corridor
as He did for the Israelites; failing that, He must ensure that the sea is
calm and quiet while they make the crossing over to the other side.
While John Craske was thinking about what was happening, he made
a painting on a scrap of thin paper no bigger than a postcard: a little
skiff rounding the headland close to the Beeston Bump in a gale-force

wind and in the sky he wrote the words PEACE BE STILL in capital
letters, so the skiff would come to no harm in the storm.

He has heard that all sorts of ships are being got ready to set out
for the Normandy coast, hundreds of them: trawlers and liners, crabbing
boats and lifeboats, all coming to the rescue. They set out on the evening
of May 26. He decided that if the soldiers were saved by the sea then
he would make a picture of their story.

On May 28, the wireless reports that the sea is as calm as a mill
pond and thousands of men have been rescued. Time moves on while
the sea holds its breath. The final day is June 4. Later he learns that a
total of 338,226 Allied soldiers were brought to safety across the Channel,
carried by 222 Royal Navy and Allied ships and over 800 civilian vessels
– somebody said there was even a two-man canoe. Nine Allied destroyers,
nine ferries, and twenty-three trawlers were sunk, along with one hospital

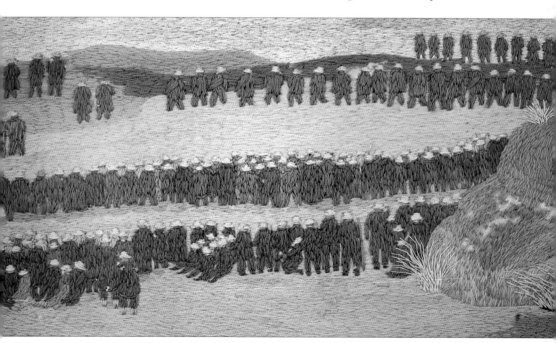

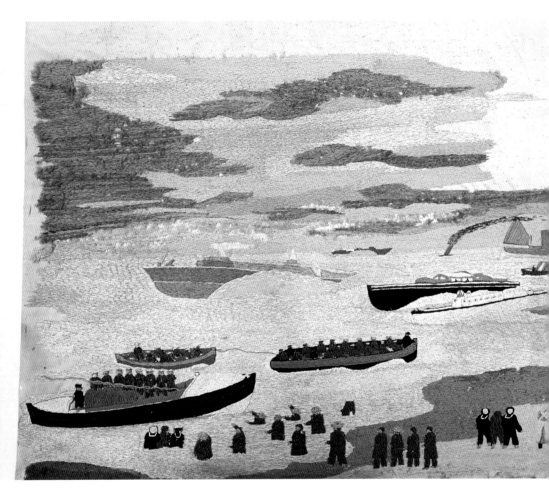

ship, but that was because of the bombing and shelling; the sea kept
its promise.

 More and more stories were told and he began to put together his
idea for a picture. An old friend from Sheringham came to visit and said
that towards the early morning of the first day of the Evacuation great
queues of soldiers formed at the water's edge, wonderful, orderly queues
so you had the impression that they were waiting for a bus in peace time.

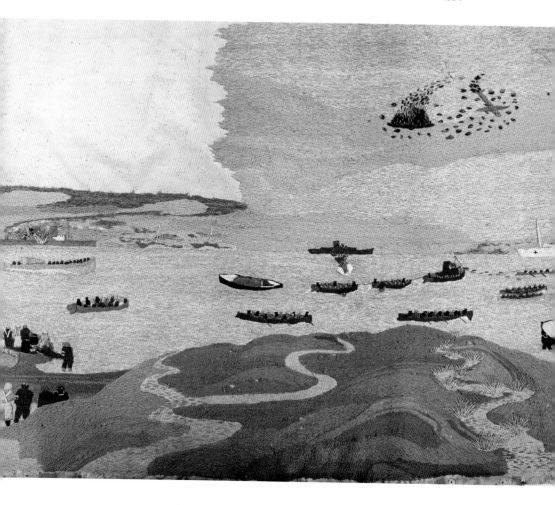

Mr Farrow wrote to tell him that a trawler from Grimsby made it across and a couple of sailors reached the coast in a rowing boat, which meant they could get close to the beaches and nose into all sorts of quiet corners. They took perhaps a dozen or so at a time, couldn't take more for fear of being overloaded, and that was hard with so many soldiers up to their waists in the water, trying to climb in. The beaches were black with men, said Mr Farrow, and there were the bodies of the

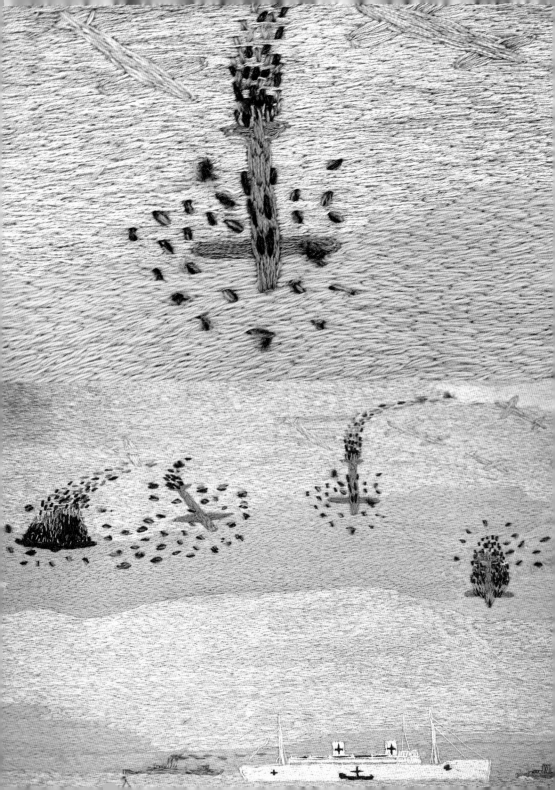

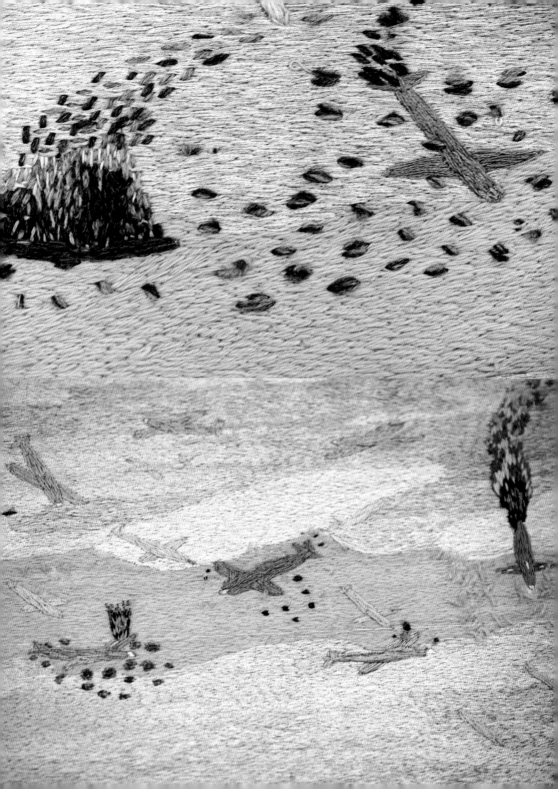

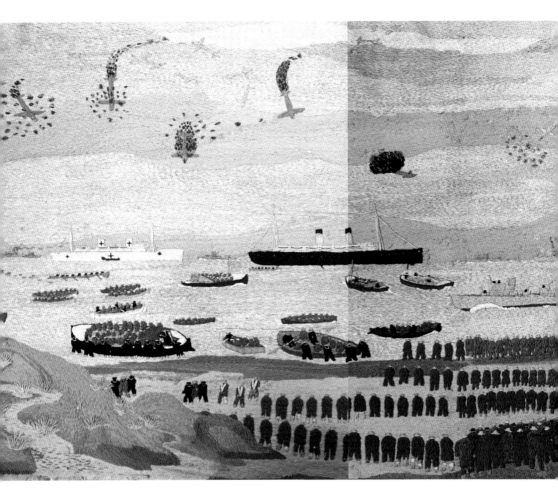

dead as well, lying about on the sand. There were men running into the
water screaming from fear, while others were unnaturally quiet and he
was told of men who couldn't move, not even when the guns started, it
was as if they were made of stone.

John told Laura he needed a long piece of cloth, as much as five
yards, because he wanted to show everything that was happening there
on the beach and out at sea. He needed wool and silk thread; khaki

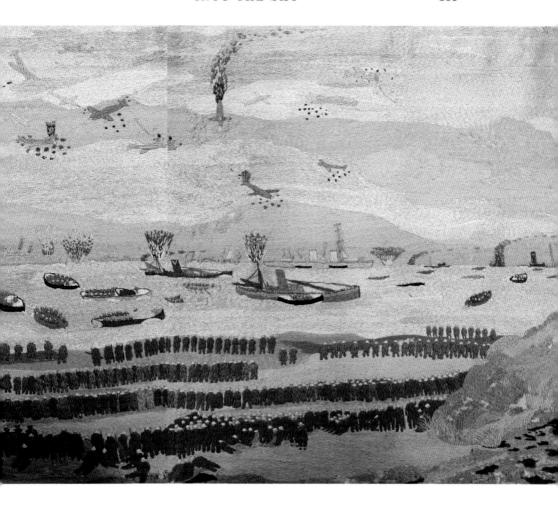

wool for the soldiers, blue for the sailors, white for the nurses, red and
yellow silk for the red and yellow heart of the exploding bombs.

He wondered about the coastline in France: he had almost seen it
once, but then he hadn't. Still he thought it must be more or less the
same as the Norfolk coast, silent waves of sand dunes, and he would
need soft green and cream and pale blue silk for the sharp blades of
the marram grass that holds the sand in place with the web of its roots.

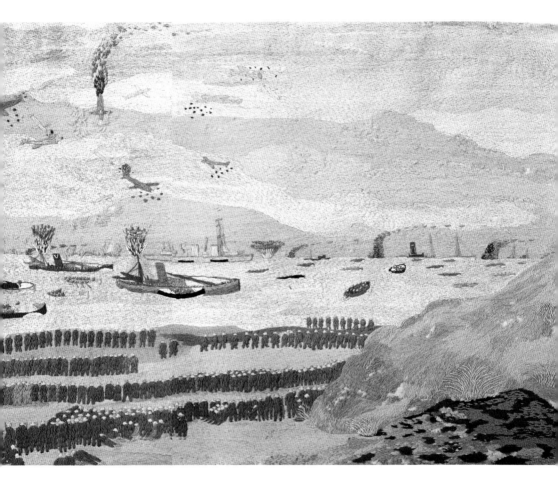

He had understood there were no buildings on these beaches, or at least none close to the shoreline where the men were gathering, so it must look very like Winterton or maybe more like Hemsby where the dunes were lower. He imagined some of the soldiers taking shelter from the wind among the sand dunes, just as he and Laura used to take shelter when they stopped to eat their picnic.

Laura fixes the first stretch of cloth onto the frame. She uses the metal skewers from the butcher's for pegs because they are stronger

than tacks. She asks if he wants to make a drawing with a pencil, since the picture is going to be so big. He says he doesn't need a drawing, he'll just allow the scene to take shape before his eyes: the calm sea, the early dawn light in the sky, the sand and then all the different boats and the fighter planes and then the men. But he does mark out the measurements in inches along the top unworked edge of the cloth, so in that way he can watch his own progress, step by step.

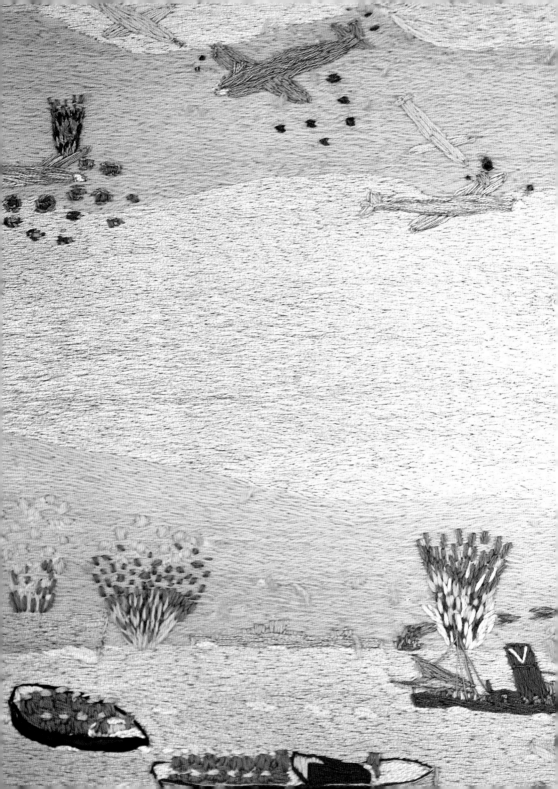

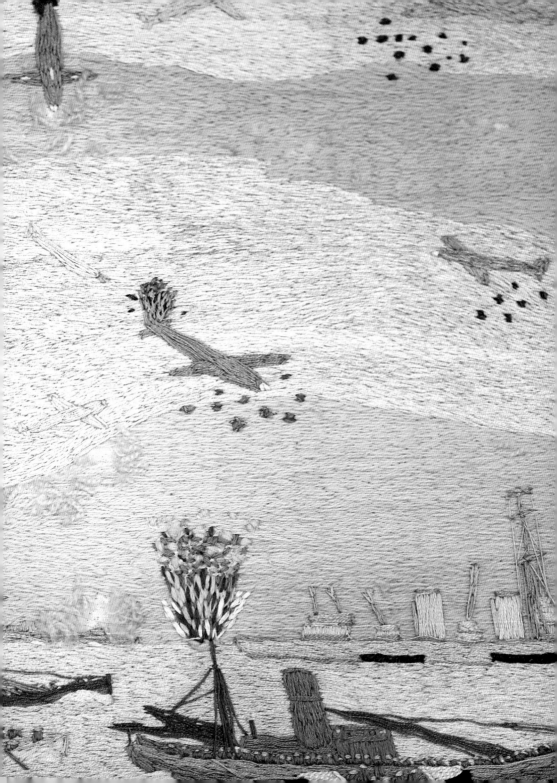

It's a big task, especially because he keeps feeling dizzy, the old trouble creeping up like a tide coming in and Laura watching over him, her eyes magnified by the lenses of her spectacles. He is left-handed and that is why he starts on the lower left-hand corner: sand, grass and light and then he moves into the calm sea. It's such a long time since he has seen the sea, but it is always there, sitting in his mind, and it comes to life as soon as he allows it to, his own breath is the sound of it.

Work is the thing. Work gets him through. When he is not working then a sort of low mist of sadness creeps across his mind and surrounds him, with nothing to steer by, no Two Skates Nose, no Beeston Bump, no lighthouse flashing reassurance across the space between land and water.

But now he is working and his mind is clear as he pulls the stitches up through the stiff layer of the cloth. He is hardly aware of being John Craske, fisherman and invalid, he is just the energy of making, the quiet pleasure of seeing this adventure take shape. His fingers are tight on the needle. Laura helps him with the threading, even though his eyes are still good. His back aches from the effort, but pain has always kept him company.

The days roll into each other. When he becomes too tired to go on, he puts his work to one side and lies there on his narrow bed, empty and silent. Sometimes he feels himself sinking into the old trouble and then Laura and the doctor arrange for him to be taken to hospital for a while. Laura packs his needles and threads and some small pieces of cloth into a bag so he can perhaps make a picture as a present for the kind sister on the ward. He'd like to take Dunkirk with him, but it's not possible, so he thinks about it instead, the boats, the sea, the bright sky.

When he is back home again, he begins to stitch the first of the soldiers who are gathered in orderly lines along the beach, and he also

includes some who are lying down because they are wounded. The wire-less said they kept very quiet and that showed they were not afraid. Dunkirk is silent in his mind; even when he is embroidering the exploding bombs, he feels the silence. The men do not speak to each other. Birds must be here somewhere, redshank and dunlin, oystercatchers and herring gulls, but he cannot see them and they do not reveal themselves with their mournful cries.

The weeks move on and John Craske keeps pulling himself through the sense of gone-ness that can invade his head. Sometimes the work seems to have more life in it than he does. 'I cannot die,' he thinks, 'because I have to finish what I have started.'

He writes to the American woman. He forgets her name. He calls her Madam. He tells her:

It will be a large piece of work the width is 22 inches, at the
present I have done 2 yards there are at present 800 figures in
navy and khaki in the boats and on the beaches and I hope to
put many more on . . . I saw a wonderful sunset in March 1941
of Bronze and Grey . . .

On this day his handwriting is widely spaced with big loops on the
letters, which is how it goes if he is not feeling very well. When he is
stronger his handwriting is smaller and more precise and when he is too
weak to sit up and hold a pen Laura writes for him.

The American lady is the only one who keeps in touch now. Laura
says that the other two, the one who came first, blown in like a kite
from the beach, wearing trousers, her hair as short as a man's, is not at
all well, but she hasn't come visiting for many years, not since 1928,

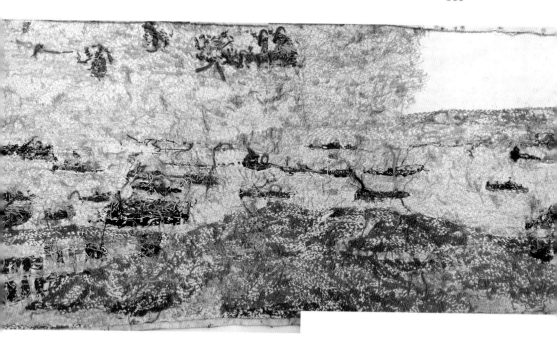

according to Laura. And it's even longer ago since he saw the other one, the one with the spectacles and the short black hair. When she came to Norwich Road she watched him from a corner of the room, smoking a cigarette and grinning a rather foxy grin if she caught his eye, as if they were sharing a joke, even though nothing had been said.

A while ago it was January and now already it's December. He is still busy with the unfolding story of the men saved by the sea. He writes another letter to the American woman. He uses a biro, which is a new sort of pen.

December 26 1942
I am still working on Dunkirk. When I wrote you last I had
done two yards. I have just completed another half yard I wish
so much you could see this in the making.

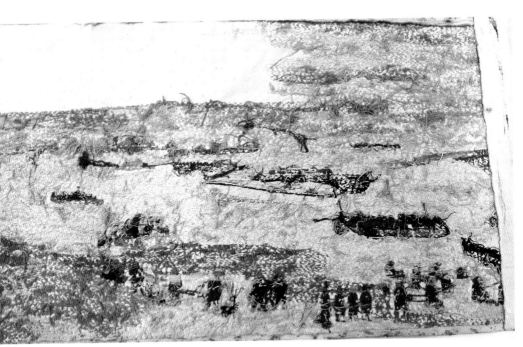

In August 1943, John Craske has to go back to hospital: the old trouble is getting bad again. The embroidery is close to being finished, there is just one raggedy patch of sky still needing to be done. He thinks it looks as if a hole that has been torn in the picture. Soon it will contain more aeroplanes, more explosions, along with the continuation of the soft blue and pink light of the early morning.

Laura comes with him to the hospital. They talk to the sister on the ward who knows him quite well. She has several of his embroideries and she says she has put them on the wall in her house and she likes to look at them. He comes in without any of his work, but Laura promises she will bring Dunkirk in on the following Wednesday. He is restless with the thought of the sky that has not been filled in.

That was on the Sunday. On the Monday Laura is told she must come as soon as she can, but when she arrives he is already unconscious. There is nothing to be done. John Craske dies on Thursday August 26 1943.

I remember that when I first started this book, I had carried in my mind the image of this shy but determined man, swooping in a great arc of energy through the unstitched area of his embroidery and out into whatever it was that lay beyond. And then, when Herman died so suddenly and quietly just six months ago and I found him looking up at the branches of the oak tree above his head, it was as if he too had made a similar leap.

Laura on Her Own 1943–1957
October 2013 to May 2014

> Three days ago, my daughter gave birth to her
> first child, my first grandchild: an exquisite, dark-
> haired, peaceful little girl and with her arrival I
> have the sense of a new and brightly-coloured
> thread, intertwining with my own life.
>
> (From my notebook, May 3 2014)

In January 1978 I was halfway through my first book when I discovered I was pregnant with my first child, the book and the baby due in the same month. The doctor laughed when I told him and said, 'That's not a problem, but you will probably write a different book than the one you had planned.'

And now John Craske and my search for him and his delicate story has been superseded by my own loss and the need to come to terms with it as best as I can. My mind is not functioning in the way that it was before, it is filled with silent areas that I don't dare to approach, memories cry out like seabirds, grief is prowling close.

Early this morning when I was just waking from sleep, I suddenly realised that the joke at the beginning of this book in which a soldier explains how there in the sunlight was his rifle – gone – is reoccurring in an altered form at the end of the book, because here in this house, laughing and talking and vivid in the immediacy of his being, is my husband – gone.

In a very simple yoga exercise, when you want to balance on one foot you must concentrate your gaze on a point on the floor and hold

your eyes fixed and then you will not fall over. And now I feel that I must concentrate my gaze, in order to not fall into too much sadness.

The tears are right up to the edge of my surface, but the red anemones on the table are beautiful in their yellow terracotta pot and a blackbird is singing in the first dark of the evening and I must hold onto what matters and let go of what does not matter.

Somewhere, in another time far from this one but close in its way, Laura Craske is also on her own. She looks at the paintings and embroideries that cover the walls of the front room with its two single beds and she walks into the little parlour next door where there are more pictures. She looks at the white cotton mantel over the fireplace with its embroidery of lobster, crab, whelk and cod, each with their name carefully stitched beneath them. She looks at the painted table, the painted chair, the painted window ledge. *I do miss my dear Husband*, she writes on January 20 1944, in a letter to the American woman . . . *my house is very empty without him but there are some Beautiful Works both rooms are full.*

And here am I in this house and I look at my husband's sculptures: a bronze head in the garden close to the place where I found him lying, a row of three naked dancing Christs that were used by Stanley Kubrick in the film *A Clockwork Orange*, the little Soul House on the window ledge. I look through his drawings stacked up in the wide drawers of a plan chest and I see the years they contain and read the stories they tell. I look through the framed drawings and hang a different one on the wall as part of a conversation with the silence. I move things around. I make plans for exhibitions. I suppose I want to try to ensure the life of the work after the death of its maker.

Laura is in correspondence with Valentine and Sylvia, but their letters have disappeared and only a few of hers have survived. Elizabeth Wade White keeps in regular contact and because she is such a method-

ical person, she puts Laura's letters in a big envelope and there they
stay. Laura addresses Sylvia and Valentine as *My dear friends* and sends
them *love as always*, but Elizabeth is always *Dear Madam* and the letters
never lose their formality.

November 22 1944
Dear Madam,
I do not know how to express my thanks to you. How pleased my
dear husband would be could he but know your kindness to me.

I am sorry I cannot send the Evacuation of Dunkirk *as after it*
had been exhibited at the Annual exhibition I offered it to the
Museum Commission to keep as an example of a Norfolk artist
wool work and they gratefully accepted the offer. It was my husband's
hope to get a picture accepted by the museum.

I have all the other pictures you asked for.
Dunkirk *was unfinished.*
I trust you are well.
I am feeling much better these past weeks thank you.
God Bless you and keep you Safe
Always yours gratefully
Laura a Craske

January 1 1946
Dear Madam,
I have not been very well this past year.
I am told it is due to the strain I had with my dear husband.
I have enclosed a small painting.
I had a lot of postcard size I found amongst my husband's things.

January 19 1946
I thank you very much for the great interest you have taken in my
husband's works. I hope someday I will see you.
PS Dear Madam I ought to say Panorama of the Norfolk Coast
was exhibited at Norwich also went to Windsor.

June 4 1946
I enclose a snap of John and Doctor has written re John's life
anything further I will be pleased to answer.

December 6 1949
Thank you for the cheque for £15.0.0 enclosed . . . I much
enjoyed seeing the two dear friends from Dorset I think it was
1938 when I last saw them I think you were with them when
they called.

May 3 1950
Please do not worry about me. I am not in need. *I have been*
very careful with what has been kindly sent to me from time to
time. I have promised my dear friends in Dorset if ever I am in
need I will let them know.

December 17 1950
As I look from the window the birds are sitting on the apple
tree. I have given them all the bread I can spare. The thought
comes some will perish with hunger.

June 22 1951
Somehow I have been a bit nervous I heard from my dear friend
Miss Ackland that she has been so very ill . . . I hope you will
be pleased to know that the long picture and Moonlight
Reflection *were in the Exhibition for the Festival of Britain*

which was held in the Church House here in Dereham . . . Mrs Puddy has spoken of me going to Norwich to see Dunkirk *as I cannot do the stairs at the Museum perhaps they can get it on the ground floor for me to see . . . Miss Ackland said in her letter that Miss Warner had been nursing her . . .*

The surviving letters written to Sylvia and Valentine are much more intimate and relaxed in their tone. This is from one of them:

October 14 1956

My dear friends,

Thank you for your kindness in sending me 'Daily Strength for Daily Needs'. I think it is a wonderful book. As you have gained daily strength from it, so shall I. The postman put it through the letter box and I found it at the back of the door curtain late on the Monday.

I had a man come on the Tuesday to Wednesday. I had that iron stone taken out of my living room. It was so burnt away and I could not lift the canopy out to sweep the chimney and was always getting burning soot down during the evening . . . and my dear John said if ever we had the money us would have another one in . . . On Friday the man came to gather the apples these are laying on the front room floor . . . and then yesterday Mrs Harrod called, Mr Betjeman had asked her to call . . . I showed them all the works including the long needlework. They thought them all very fine. Mrs Harrod took some small early works which had been to America . . . I ought to tell you I have got a budgerigar for a pet it is only a baby bird . . . I like little dogs but could not take them for walks. Much love to you both as always.

Looking at What Is Left

1959–2014

Little Saskia is getting fatter and more noisy.
She looks like both her parents, but she also looks
unmistakably like herself. She makes the first
weeks after my own daughter's birth as vivid as
yesterday. (FROM MY NOTEBOOK, MAY 2014)

The three ladies remained preoccupied with Craske. Elizabeth kept in regular correspondence with Laura during the 1940s and had plans for exhibitions, but I can't help wondering if it was part of her desire to keep close to Valentine. There was an exhibition in New York in 1940 which went quite well and she tried to organise something else in 1943 but it fell through and then there was another scheme towards the end of 1944 when she wanted to include the Dunkirk embroidery, but Laura said that wasn't possible, because she had just given it to the Norwich Museum.

In January 1946 Sylvia wrote to Elizabeth to tell her that *Mrs Craske in her Christmas letter asked after you . . . I mean to see her when I go to Norfolk next month . . . at any rate I mean to find time to see Craske's Dunkirk – his last picture which is in the Norwich Art Collection.* This communication seems to have inspired a new spirit of determination and in 1947 Elizabeth was again hoping to put *Dunkirk* on show in America. This time she wrote directly to the curator at the Castle Museum in Norwich, to make preliminary enquiries. She received the following reply:

> *Regarding a large needlework picture of the retreat of Dunkirk,*
> *although I am quite willing to arrange for the dispatch to New*
> *York, I do not wish to have my name associated with such an*
> *exhibition because, quite frankly, I do not think work of this*
> *type comes under the heading of art.*

So that also came to nothing, but in 1949, coinciding with the brief flurry of a second affair with Valentine, Elizabeth was in England for several months and a scheme evolved for an exhibition at the British and American Gallery in New York. She didn't manage to see Laura, but she did pay a visit to the embroidery.

> *I had a regular set-to with Miss Barnard, a prune-coloured*
> *sourpuss . . . She said I couldn't see it because she had no idea*
> *where it was and I practically made a scene and she finally took*
> *me into the main exhibition hall and asked one of the guards*
> *who immediately produced the picture from out of a dark corner*
> *where it was standing with its face to the wall.*

Again, the work was considered too big and too difficult to transport, but Elizabeth obtained a number of other embroideries and paintings from Laura and Valentine wrote the catalogue entry, including a description of *Dunkirk*:

> *a tremendous dramatic tour-de-force and a difficult work to fit*
> *into any general exhibition for it obliterates everything else . . .*
> *It is a single, massive statement and a huddled confusion of*
> *incidents, violent, tragic and grotesque. I doubt if there is any*
> *other work in the world like it.*

On December 5 1949, Elizabeth wrote to Laura from New York, to let her know how things had gone:

I cannot describe how beautiful the big needleworks and the small watercolours looked, hanging in the handsome gallery. Mrs Story now has 3,000 copies of the catalogue with the John Craske photograph and Valentine's account of his life. About 100 people attended the opening.

The show was not much of a success, six watercolours were lost, presumed stolen, with no insurance to cover them, and Elizabeth managed to insult Laura, probably with the tone of her letters and the way she approached their financial dealings. When she sent a cheque – and she sent quite a few – it was seen as charity and when she tried to be more businesslike and offset her framing and transport costs with a few paintings, it was interpreted as greed.

Elizabeth, however, was not easily daunted and she went on asking for more art and more background information on John's life. He had told her in a letter that he had written an account called 'The Story of The Sea' and she persuaded Laura to send the text to her so it could be professionally typed out. Once this had been done she sent Laura a carbon copy and kept the original, *for fear it might get lost in the post.* She also asked Laura to write some more memories of her life with John, and this she obediently did, putting together some brief but much more emotional additions to what she had previously given to Valentine.

May 1 1950
Thank you indeed for the 'Story of the Sea' and what you kindly packed in with it. Yes I will try to write some little things I remember of John in the coming days.
November 22 1950
Yes, I am writing little things as I remember them about our lives. Somehow I creep in with it, but that is I think because our lives were one. <u>But you can drop me out</u>.

After 1951, there seem to be no more letters from Laura to Elizabeth and I presume the connection between them was broken. Elizabeth had become the owner of several paintings and a beautiful long embroidery of the Norfolk coast and two rather strange and stuffy embroideries that were apparently especially commissioned and copied from an image that John was given. One of these shows a vaulted medieval window with the sea beyond it and a ball of wool on the window ledge and the other is of a little table on which stands a goldfish bowl holding two goldfish, a framed picture of two boats out at sea hanging on the wall behind it.

Sylvia had also gone in search of *Dunkirk*, maybe as a result of Elizabeth's experience, and she was horrified by the way it was being treated. She did her best to have it preserved and also to get her friends to see it.

> *His widow presented his last work (a needlework panel of the evacuation of Dunkirk) to the Norwich Art Gallery. It is an amazing composition, and should be permanently on show. When I was last in Norwich I forced them to resurrect it from one of their lumber-rooms, where it had been forgotten and damaged by moth. By being extremely unpleasant to the authorities I did manage to get it de-mothed; but I don't think they show it. If you should be in Norwich, please make a point of going there and insisting on seeing it. In relation to his other pictures, it is on a par with the Beethoven 'posthumous' quartets.*

After what she referred to as *the disease of Elizabeth* had passed, Sylvia was writing well and earning enough to think of moving to a bigger house, buying another car, taking holidays abroad. In a letter to a friend she describes herself *grey as [a] badger, wrinkled as a walnut, and never a beauty at my best; but here I sit, and yonder sits the other one, who had*

all the cards in her hand – except one. That I was better at loving and being loved.

Valentine, less good at loving and being loved, was not at all happy. She clearly felt sidelined, seeing herself, as she wrote in her diary, *as others see me: as the younger and duller of a pair: as one who is part-friend, part-secretary . . . as the person no one can understand what Sylvia sees in her.*

For a while they were both keen to move, to start a new chapter in their life together. They found a bleakly romantic former coastguard station to rent for the winter on the North Norfolk coast and it seemed just right. Great Eye Folly stood on the edge of a noisy pebble beach near Salthouse. It was more a tower than a house, with no electricity, no drinking water, and a small petrol engine for pumping hot sea water into the bath tub. The windows were dimmed by encrustations of salt from the sea spray and, as Sylvia put it, *the east wind sobs and whimpers like a Brontë in the kitchen.* They stayed there for five months, but after a particularly wild storm, Great Eye Folly was badly damaged and they decamped and returned to Dorset.

Valentine's sense of worthlessness was compounded by arthritic aches and pains and a swelling and ache in the breast, which the doctor diagnosed as mastitis. She started buying and selling little antiques and much to Sylvia's dismay, she re-converted to the Catholicism of her childhood. In 1953 she announced that she was *giving up talking about Elizabeth* for Lent.

When Sylvia had reached the age of sixty she felt physically and mentally as strong as ever, while Valentine, who was ten years her junior, was becoming increasingly frail. They were united by a recollection of the joy and sensuality they had once shared and Craske's paintings and embroideries still spoke to them about what they had known and lost.

In 1968, Valentine was treated for breast cancer, but the treatment

did not remove the problem and nothing could be done to save her. Sylvia nursed her and watched over her and wrote in her diary that early in the morning on November 9 1969, *when the first light sifted into the room, I knew she was beginning to die.*

After Valentine's death, Sylvia became increasingly concerned for the welfare of their Craske collection and that of other works of his, the ones in England and the ones that, via Elizabeth, had *escaped to New England.*

Sylvia felt that Craske had never been properly appreciated and now he was in danger of disappearing without trace. She realised that even her friends who owned paintings or embroideries seemed to love them for sentimental reasons, but not because they took him seriously as an artist. John Betjeman was typical. As Sylvia said despairingly in a letter to a friend, *He bought a large and fine embroidery but couldn't for some reason, fit it into his car and left it behind at the Old Rectory. [He] feels sure it is safely somewhere and will look for it next week (they are just off to one of their stately pleasure dome visits).*

Then she had an idea and on February 19 1970 she wrote to Peter Pears at The Red House in Aldeburgh where he lived with an ailing Benjamin Britten. She didn't know him personally, but she had long admired his singing. She invited him to come and see her collection of Craskes. *You will see that he is an artist whose work should be on view in East Anglia and I would like to leave my collection to the Maltings . . . They will be immensely enhanced in the sharpened light of a seaboard sky. I don't know if there is a word for visual acoustics, but I know the condition exists.*

Peter Pears came and the meeting was a success. As Sylvia described it, he looked at the work *and in five minutes SAW them; and in fifteen had conceived a Craske exhibition for 1971. I liked him a great deal: he has the ardour of his singing.*

After he had gone, she wrote in her diary: *When I came home this afternoon I looked at the Craske pictures with an unclouded pleasure as I have not been able to see them for many months. There you are, I thought, with your future assured; you will have a good home in your native climate, and be honoured in your own county.*

With the plan for an exhibition taking shape in her mind, Sylvia set to work. *I have been reckoning up the other Craske owners who will loan their pictures . . . and, if my persuasions can do anything, will bequeath them to your gallery.* She kept in regular contact with Peter Pears and met up with him whenever possible. She asked him to ask Elizabeth if she would lend works from her collection, saying, *There are some good ones in American ownership. I think the best chance for these would be if*

you enquired about them. The owner is (A) a snob and (B) doesn't like me.

She also put him in touch with Dr Duigan's son who was happy to lend all of his Craskes and later bequeathed some of them as well and managed to hunt down other works in East Dereham, including a painting belonging to a Mrs A. Craske.

I told her you were interested in purchasing her oil painting and that I thought she might be willing to sell as it was only kept in the attic. She said she was quite willing to sell and I asked her what she wanted for it. She said she did not know as it was only an old piece of ply wood and asked me what I thought she should say.

A total of forty-seven pictures were gathered together, although in spite of her righteous indignation, Sylvia was not able to organise the loan of the Dunkirk Evacuation. *Where is Dunkirk? Which Norwich told me is at the Shell Museum. I can believe almost anything of the Norwich gallery's total indifference to Craske, but the work had several shells exploding in the firmament, corpses too if I remember rightly and a great deal of warlike scurry . . . Dunkirk is MAGNIFICENT . . . I think we ought to have it if we can wrench it out of them.*

By March 1971, Sylvia had completed a foreword for the catalogue and she wrote to Peter Pears, *I long to be at hanging . . . it was a great pleasure to write the piece about Craske. I am glad you like it – and that I was able to get in a word about Laura Craske. She was a Gluck character. If it hadn't been for her we should not be writing to each other about a Craske exhibition.* And in May, as she told her diary, *the Craskes have gone, taken away by Peter after a comfortable not very well established lunch. O my Love, these are piecemeal partings.*

The exhibition opened on July 28 1971 as part of the Aldeburgh Festival for that year. It had some good notices, even though it did not succeed in transforming Craske's reputation as an artist; he remained

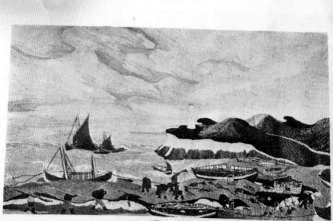

"Waves" by John Craske. Needlework, cotton and tempera.

Craske's needlework pageants

The work of a seafarer and gifted
marine painter who made a daring combination
of needle and thread with other media.

Worsted seascape. Photos, American British Art Gallery.

an oddity, a fisherman who made childlike paintings of the sea and boats on the sea; a bedridden invalid who passed the time of his helplessness by stitching embroideries.

Once the exhibition was over, Peter Pears came in person to return the work to Sylvia, *dressed for 80 degrees in a beeyoutiful silk shirt, orange shot with purple and a brilliant turquoise-blue tie and went away clasping a Robert the Devil rose. (Do you know it? Every shade of carmine and pink and violet.) He was deeply sunburnt. You can imagine the rich colour scheme.*

There were two further but smaller exhibitions, one at Aldeburgh in 1974 and another at the Snape Maltings in 1977.

It seems appropriate to show these remarkable works again at the Festival to mark the visit of Sylvia Townsend Warner; we feel they are, in any case, worthy of a second or even a third view . . .

He never saw his work on exhibition; he lived in seclusion, alternating between spells of stupor and of absorbed activity. He was at work on the largest, most animated and most ambitious of the needleworks, the Dunkirk panel . . . when he died in 1943. (Programme of readings and music in Sylvia's honour at the 1977 festival.)

On March 30 1978, Sylvia wrote to Peter Pears, just a month before her death,

This may be my last letter. I want to send you my love and my thanks for all the beauty that your music has meant to me . . . And keep an eye on the Crasks [sic] . . . I've just been told that your singing of Die Schöne Müllerin . . . was beautiful, deeply felt and a hymn to Ben. Sing on, my darling.

And now here am I, trying to gather work for a Craske exhibition. The show opens in Norwich in the spring of next year and will then go on to the Peter Pears gallery as part of the Aldeburgh Festival and maybe elsewhere, but that is not yet sorted. This time *The Evacuation of Dunkirk* will be included, the loan forms are filled out and even an insurance valuation of five thousand pounds has been agreed on. It would be nice if the back of the work can be shown as well as the front, because then people could see the energy of the stitches and the effort that John Craske put into saving thread, by the use of knots and little leaps and jumps.

When I spoke to the man who now owns the Shell Museum, he said that he thought *Dunkirk* belonged to him and it turns out that it had been loaned to the museum for a year in 1975 and remained there until 1986, by which time it felt like a possession. He said he couldn't possibly agree to unpin the *Panorama of the North Norfolk Coast* from where it hung on a high wall above the glass showcases, but never mind.

I still need to make arrangements to borrow the three little embroideries that are kept in a box in a storeroom that belongs to the East Dereham Historical Society, and two others along with a painting in the archive room of the Dorset Museum, as well as the works held in the Sheringham and Cromer museums. The daughter of Richard Hughes who wrote *The Fox in the Attic* has a painting which I need to ask about and so does Tanya Harrod's brother-in-law. Those, along with the doctor's collection and the work held at the Snape Maltings and at The Red House should provide some fifty works in total; I haven't counted them as yet.

I didn't know when I started out on this book and I still don't know now, if John Craske was an important artist or an unimportant artist. I am not sure if it matters either way; his work made life meaningful for him and he went on doing it, almost to the moment of his death.

I am sitting here at my desk, looking out of the window at the sunshine on the grass and at the bright luminosity of the leaves on a different oak tree than the one under which I found my husband lying not all that long ago. The plum tree close by has produced a froth of white flowers and the quince that I planted in January, its roots taking hold among the ashes of a much loved man, is also in flower. I counted thirty-two delicate little cups of white petal, tinged with pink. I realised I had never noticed quince flowers before, it was only the fruit I had seen.

Visiting Hans

June 2014

I've been mowing the grass around the place where
Herman was lying. He is still quietly there in my
mind staring up at the sky, but now he cannot see
the sky, or not much of it, because of the thick
canopy of young leaves on the branches of the oak
tree above his head. (From my notebook, May 2014)

I am sitting in Hans's studio in a house in a garden not far from
Montpellier. The smell of oil paint and cigarettes. The buzz of flies
turned sleepy in the heat of the window panes. And through the window
I can see tufty grass, a few straggled bushes and then out and beyond
towards the hazy silhouette of distant mountains. A procession of thin
clouds moves across the empty blue of the sky.

I am surrounded by the silent presence of stacked canvases, their
backs turned to show a uniformity of pale cloth streaked with sisal. The
dates of their completion are written in bold numbers – 3.5.13; 7.9.13;
19.1.14 – and next to that is the artist's signature in capital letters.

The white wall facing me is empty, pricked with a mass of little
holes as if they were the nesting sites for insects and that is where nails
or screws can be fixed at different levels, for the canvases to be placed
in position and stared at.

Hans's partner died last September. Denis was his name and he had
reached the age of eighty-five, but that did not diminish the loss of him.
For the final three months he lay in a sort of dream of helplessness with
no strength to move even his hands, no speech to define his thoughts,

although once, when the care worker leant close to him and whispered *à demain*, he replied with careful enunciation, *à demain*, the words seeming to float into shape from a long way off.

Hans had known Herman very well, as a fellow artist and as a friend. Now he and I talked about our husbands and what death does to the living who were there to witness it and how the images of the last hours play over and over again through the mind, like a little film running in a loop.

Hans said that on the day before his death, Denis was transfigured. The colour returned to his cheeks and there was an energy in him that looked almost like youthfulness. He was in bed, propped up with pillows, and he was staring at the blank white wall that faced him, staring at it as if he could see something extraordinary happening there, the unrolling of a vast and complex adventure. For five relentless hours he kept on staring, sometimes in amazement and sometimes with awe, but never allowing his concentration to waver. And then during the night he died without a sound and Hans found him in the morning.

Before that final chapter, Denis had been taken into hospital. Hans went in every day and sat beside him and tried to avoid the shock of tubes and bleeping machines. Then he would go home to lie down exhausted, but without the quiet needed to fall asleep.

He thought he must do something or else he would go mad and so he started to make a painting of the oak tree at the back of the garden. It is quite an ordinary tree, dignified but unremarkable. The three fused divisions of its trunk carry a chaotic mass of branches that seem to be always changing their minds as to which direction to follow in search of more light.

He chose a position for himself so close to the tree that he was beneath its canopy and from there he could look forward at the entirety of it and upwards into the branches overhead, the sunlight shining

luminous through their leaves. He took me to the exact place where he
had set up his easel, so I could see what he had seen.

He had started with pencil drawings, one almost every evening on
sheets of paper measuring 89 x 116 centimetres. First the strong body

of the trunk and then he moved outwards, one part connecting with the next until he had a picture that was almost three metres wide and more than three and a half metres deep. He told Denis what he was doing, his words floating down onto the silent figure of the man he loved.

On June 21 he began painting, using the same format and the divisions he had made in the drawings. He had difficulty getting the trunk right and twice he over-painted, which is something he rarely does. But then it worked and he could move on. Once he had got going, he tried to complete each painting within a few hours of a single day, but it was not always possible. He said he liked the way the tree and its branches remained constant, while the sky changed from storm clouds to wispy clouds, from wind to stillness, from the near uniformity of a pale blue expanse to a range of pastel colours sliding into each other. 'I was so much inside that which I see, I have no thoughts, I am only busy seeing a painting. I just make, and it's a good thing. It's the only time I am free in my head and this helps me a lot, to be concentrated on the object I see,' said Hans, struggling with the English language.

Denis was brought home early in July. Hans would show him each new painting, holding it up before the bed, so it could be stared at in silence. The nine canvases were completed on July 26

Denis died on September 2 and Hans couldn't stop crying. Herman telephoned him and listened to his sobbing and told him he must work. 'Only work will get you through,' he said.

In September Hans found the courage to enter his studio even though he felt sick and dizzy standing there. He collected easel and paints, brushes and cloths and made a single painting of the oak tree which had become a companion to him: the crooked branches seemed to tremble with something like terror against the placid blue of the sky. Then he made a painting of a tiny flowering plant that was growing close to the road just outside the house.

The weeks moved on and he went on working because work is what he does to live. Between February 26 and March 12 he returned again to the oak tree. By now all its branches were bare, the lines of growth crooked and cramped, turning it into a monument to its dead self, stripped of every protection; but still the sky was alive, dancing with movement. 'I felt I was a winter tree,' he said, 'a tree without leaves.' This time he made six panels, each one in the same measurement of 89 x 116 centimetres.

On one day of my visit, Hans took me to the place from where he had recently made paintings of a mountain called Pic Saint-Loup. It had once been a single and vast excrescence of limestone, but then in

some long ago time it was split into two halves by a meteor and now one half hangs in a long curtain of pink, yellow and grey rock, while on the other side of the valley, the other half is a great bubbling dome that leads to a sharp spike, the *pic* of its name.

Hans drove the car rather erratically, swooping into little turnings he thought he recognised and then swooping out again because his memory had served him wrong. We parked and followed a path through a vineyard and as far as the edge of a forest of Mediterranean oak. We stopped beside a rather friendly boulder that was still covered with streaks of oil paint from when Hans had cleaned his brushes on it. I noticed a very black stripe among the colours, much thicker than the rest, but when I touched it with my finger I realised it was not paint at all; it must have been the excrement of some animal, a polecat perhaps.

We set off again in the car as Hans searched for another familiar parking place. And when he had found it, we followed a steep path until we reached a point from where we could see the mountain emerging

like some inchoate mass of energy from out of the froth of low trees that surrounded it. Just close by there was a stone memorial commemorating a geologist whose name I forgot to write down, but anyway he died somewhere near here, having, as it said, dedicated his life to the study of the life to be found within stones.

From this position, Hans had made three paintings at different times of different days: one of the mountain in the drifting yellow light of the dawn, one in the brightness of midday and one in the apricot of the evening, when all the shadows of shape and substance had gone with the dropping of the sun, so that the mass of rock seemed two-dimensional.

My visit passed quickly. We met a very coherent and humorous ninety-three-year-old poet called Pierre who once spent three years in prison in Cuba and who wore his striped shirt open in an unexpected décolleté to reveal the thin and creased skin of his hairless chest. He had just borrowed Virginia Woolf's *Orlando* from the local library

because he had never read it, even though he had read everything else she had written.

We met a woman who had arranged for Hans to collect a pot-bound passion flower and when we got back with it we released its tight mass of roots and put it in the earth by the house and already on the next morning it looked happier, its single mad flower of frilled blue and yellow and black exuberant and somehow defiant.

Over the days, Hans and I talked a great deal about life and death and love and loss and we laughed a lot as we talked and then I came back here, back to the garden that I know, back to the last pages of this book and to the words that keep me moving forward step by step into the uncertainty of the future.

Suffolk, June 17 2014

ILLUSTRATIONS

Unless otherwise specified, all paintings and embroideries are by John Craske.
All photographs of Craske's work were taken by Andi Sapey,
unless otherwise stated.

ACKNOWLEDGEMENTS

My thanks to all the people who have brought me closer to an understanding of John Craske and his world:

The staff and participants at Barrington Farm Art Barn, Wallcott

Ruth Battersby Tooke, Curator of Costume and Textiles at the Norwich Castle Museum

My friend Ronald Blythe, for early conversations about men embroidering after the First World War

Judith Bond, archivist at the Dorset County Museum

Dr Nicholas Clark, Librarian at the Britten–Pears Foundation

David Cleall, who knows the history of Roughton Heath

My friend Ian Collins, who with his profound knowledge of the arts of East Anglia and his love of Craske's work helped to get me started

John Craske's great nephew, Trevor Craske, and his wife Liz, who have been wonderfully supportive

Piero Donat at Fine Cell Work

Philip Duigan, who gave me access to the fascinating family collection of Craskes that had belonged to his grandfather Dr John Duigan

Wendy Gill, Curator of the Shell Museum in Glandford, who provided a stepladder for
 getting closer to the *Panorama of the North Norfolk Coast*
Caroline Harding, Curator of the Britten–Pears Foundation
Peter Haring Judd, first cousin of Elizabeth Wade White, who came to visit my husband
 and I in Italy and shared fascinating archive material along with his own memories
 of Valentine and Elizabeth
Claire Harman, whose biography of Sylvia Townsend Warner was an invaluable resource
Tanya Harrod, with her wide-reaching understanding of the history of crafts in England,
 introduced me to friends and family connected to John Craske and his work
 Derek Hockaday gave an endocrinologist's assessment of Craske's possible medical
 condition
Dr Morinne Krissdottir, Honorary Curator of the Sylvia Townsend Warner and Valentine
 Ackland Archive at the Dorset County Museum
Bari Logan, whom I first met in the late 1970s when he was Prosector at the Royal
 College of Physicians, for explaining the functioning of the pituitary gland
Joseph McBrinn, who shared his specialist knowledge of the history of men
 embroidering
Stuart Mclaren, who shared his researches into Einstein's short stay on Roughton Heath
Philip Miles, Curator of the Sheringham Museum (The Mo)
Penny Minney
Neil Powell, Pro Vice-Chancellor (Academic) at Norwich University of the Arts, a
 Craske enthusiast
Keith Shaul, who talked about life at sea and gave me permission to include his short
 story, 'The Old Man and the Boy'
Bob Thurston, who spoke eloquently of his father's encounters with Einstein
Peter Tolhurst, former editor of the Sylvia Townsend Warner Society Journal and
 another Craske enthusiast
Candy Whittome, who introduced me to several Cromer fishermen and their families
Harry Young, General Manager at the Snape Maltings Concert Hall, has been kind and
 helpful

Thanks to everyone involved with the preparation and publication of the book: my
publisher and friend Dan Franklin, Clare Bullock at Jonathan Cape, my former agent
Gill Coleridge and my present agent, Victoria Hobbs, and Peter Ward, who designed the
book so beautifully.
 Thanks to the friends and family who were involved in the process of getting
Threads written and completed: Juliet Ackroyd; Martin and Naomi Bonger; John Cox;
Alex and Thea Curry; Harriet and Simon Frazer; Emily Gwynne-Jones; Lucy Hughes-
Hallett; Serena Inskip; Jayne Ivimey; Bob and Jacky Linney; Fiona Makkink; Natasha de

Meric; Hans Rath; Basil Saunders and Andrew and Adrienne Smiley. And thanks to my husband Herman Makkink, who shared so much of it with his characteristic humour and enthusiasm.

BIBLIOGRAPHY

Clare Harman, *Sylvia Townsend Warner: a Biography,* Chatto & Windus, 1989
Clare Harman (ed.), *The Diaries of Sylvia Townsend Warner,* Chatto & Windus, 1994
Sylvia Townsend Warner, *With the Hunted,* selected writings edited by Peter Tolhurst, Black Dog Books, 2012
Sally Festing, *Fishermen,* David & Charles, 1977
Valentine Ackland, *For Sylvia, an honest account*, Chatto & Windus, 1985
Jacob Epstein, *Epstein: An Autobiography,* Studio Vista, 1955
Banesh Hoffmann (with the collaboration of Helen Dukas), *Einstein,* Paladin, 1975
Candy Whittome, *The Last Hunters,* Full Circle Editions, 2012
Ian Collins, *Water Marks: Art in East Anglia*, Black Dog Books, 2010

I am grateful to the Estate of Sylvia Townsend Warner and the Estate of Valentine Ackland for permission to quote from their writings, and Peter Haring Judd for permission to quote from the Elizabeth Wade White papers.

I would like to thank Arts Council England, the Wellcome Trust and the Society of Authors for their generous financial assistance towards the completion of this book.

INDEX